THE
# MAKING OF AMERICA
SERIES

# SOUTH BEND
## CROSSROADS OF COMMERCE

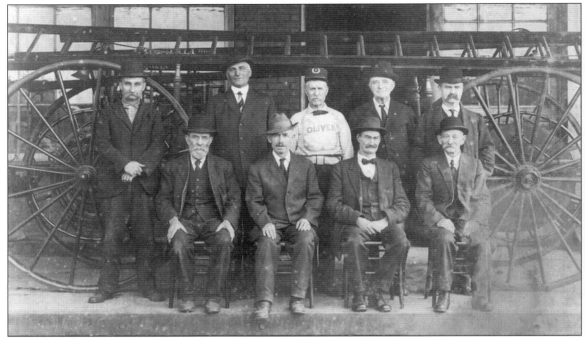

*Although they appear to be somewhat old to be firefighters, these spry 1890s Oliver Company firefighters were prepared to do their duty.*

THE
MAKING OF AMERICA
SERIES

# SOUTH BEND
## CROSSROADS OF COMMERCE

## JOHN PALMER

ARCADIA

Published by Arcadia Publishing,
an imprint of Tempus Publishing, Inc.
2 Cumberland Street
Charleston, SC 29401

Printed in Great Britain.

Library of Congress Catalog Card Number: 2002114991

For all general information contact Arcadia Publishing at:
Telephone 843-853-2070
Fax 843-853-0044
E-Mail sales@arcadiapublishing.com

For customer service and orders:
Toll-Free 1-888-313-2665

Visit us on the Internet at http://www.arcadiapublishing.com

Front cover: *The chamber of commerce was less than a decade old when this 1916 photograph was taken. With over 400 members, the chamber enthusiastically supported any project that boosted South Bend's economic growth. A pumpkin contest was great fun for all. Behind the pumpkins is Robertson's Department Store.*

# CONTENTS

# Acknowledgments

This book would not have been possible without all of the kind remarks and great help that I received when compiling the information. Many people shared their thoughts and suggestions with me, as well as their stories.

Special thanks go to Mary Waterson, my fellow co-worker in the St. Joseph County Public Library Local History and Genealogy Room for the past ten years, who will always have a special place in my heart for her kindness and putting up with me for all those years.

Thanks go to John Kovach, archivist at St. Mary's College and part-time colleague in the Local History/Genealogy Room, whose suggestions always proved helpful.

I owe Dave Blodgett a great big "thank you" for making this book special because of his wonderful sketches.

Over the years, I have had the great pleasure of working with local historians and genealogists on many projects, and I am proud to have been a part of their work. Thank you David Bainbridge of the Northern Indiana Center for History and Carol Bainbridge of the Fort St. Joseph Museum for your encouragement.

Thank you Oliver Freeman for your story on Vincent Bendix.

Thanks to Father Charles Lavely for his invaluable information on Saint Patrick's Church.

I must not forget Noel Bauwens, who let me be part of his production crew several years ago when we worked on his video project, *Michiana: Crossroads of Empires*. Boy, did I learn a lot about video production!

Thanks Mark Davis and crew for letting me sharpen my writing skills in the *South Bend Area Genealogical Society Quarterly*. I hope that I have put them to good use here.

# INTRODUCTION

Many excellent history books have been written about St. Joseph County, Indiana and about South Bend. The *Gazetteer of St. Joseph Valley of Michigan and Indiana for 1867* by Timothy Turner contained brief historical information, as well as many pages of advertisements by all of the leading manufacturers, hotels, livery stables, attorneys, schools, carriage and wagon builders, etc. The *1875 Illustrated Atlas of St. Joseph County, Indiana*, published by Higgins, Belden and Company, provided much more detail. This was followed by a 971-page *History of St. Joseph County, Indiana* published in 1880 by Chapman Brothers. In 1901, Anderson and Cooley published *South Bend and the Men Who Have Made It*. Timothy Howard soon followed, in 1907, with a two-volume history noted for its detailed accuracy. Then, in 1923, John B. Stoll wrote a one-volume *History of St. Joseph County*.

Not much was written on South Bend for nearly a half century, until Jack Detzler wrote three small books covering the first three decades of the twentieth century. In 2001, Kay Danielson compiled an excellent photographic history of South Bend, simply entitled *South Bend, Indiana*.

Anita Glenn, in association with the *South Bend Tribune*, has compiled *South Bend Remembered*, containing hundreds of photographs covering 1900 through 1950. John Davenport's book on the history of St. Joseph County and her surrounding counties should be published soon.

Several excellent books have been written about the Polish, Greeks, and Belgians in this area. Gabrielle Robinson has recently written a history of the German community in Saint Joseph County. The African-American and Jewish communities are both actively involved in historical preservation and we look forward to seeing their information published. The Swedish community can be proud that the Gloria Dei Lutheran Church Archives are available for research at the Northern Indiana Center for History. While the Hispanic community has not had a long history in this area, they are also exploring their contributions to South Bend history. The Native American, French-Canadian, Irish, and Italian contributions to South Bend history have not yet been explored.

Given the wealth of information already available and the limited word constraints of the publisher, it is difficult for this author to even attempt to compare this present volume with those previously written. All this author can

hope to do is fill in the gaps that other authors have missed and concentrate on the high points in South Bend history, choosing wisely the little items that fill in these gaps.

This book will cover some of the historical information found in the other books, but this author hopes to keep that coverage to a minimum.

South Bend, Indiana can trace its historical roots back long before its legal founding in 1831, finding its ancestry in Canada, Detroit, Chicago, St. Louis, New York, Fort Wayne, Niles, Indianapolis, and perhaps dozens of other places whose names have long been forgotten.

For thousands of years before the white man came, other men had been living here—Native American groups, some roving, some settled, who hunted and trapped, fished, and farmed, the different bands trading furs, pottery, and other goods with one another.

Then came the French traders and explorers, striking out from their settlements in Canada. French priests may have first visited the area in the 1660s. Robert Cavelier de La Salle made his first entrance into the Valley of the St. Joseph in 1679, searching for the Mississippi River. He returned in 1681, gathering the Miami Native Americans in council and offering to escort the Miami to Kaskaskia (near present-day St. Louis) where they would be safe from marauding bands of Iroquois from New York.

The first missionaries were French, coming from Canada, and slowly establishing a mission called St. Joseph (near Niles, Michigan) about 1686. Later, the military established a fort here and called it Fort St. Joseph.

Most of the early history of the St. Joseph Valley centers around Fort St. Joseph and the land north of South Bend, and it was nearly 130 years between the establishment of Fort St. Joseph and the establishment of South Bend. It was 40 years between the final destruction of the fort and the first house built in South Bend, but the area at the south bend of the river has always played an important part in Michiana history.

Fur traders from Fort Wayne, working for New York companies, helped found South Bend; many of the county's earliest permanent settlers came from New York, Pennsylvania, and Ohio.

Notre Dame was founded by a French priest from Paris who served both northern Indiana and southern Michigan. Land upon which Notre Dame rests was purchased by bishops in Louisiana and Kentucky.

African Americans settled in South Bend before the end of 1840. Hundreds of Scotch-Irish and Pennsylvania Dutch poured into St. Joseph County from Ohio and Pennsylvania in the 1840s and 1850s. The 1870s through the 1890s saw South Bend's population grow with the large number of Polish, Irish, Belgian, Hungarian, Italian, and Jewish immigrants. In the early 1900s, African Americans, Greeks, and more Italians came to fill still-open positions in South Bend industries, where workers for war production were in critical shortage.

By the middle of the century, field laborers of Hispanic and Mexican heritage began harvesting crops in St. Joseph County. Today, descendants of some of these

families as well as refugees from Cuba and other South American countries have formed a strong community in South Bend. Cambodians and Vietnamese have also found South Bend a pleasant place to call home.

South Bend has a vice president (Schuyler Colfax) and the grandparents of a president (William McKinley) buried in our city cemetery. Also buried in the same cemetery are a Congressional Medal of Honor winner and a hero of the War of 1812.

Though a small city, by 1919, South Bend was one of the largest industrial manufacturers in the United States, with its products shipped all over the world. The city's motto was "South Bend: World Famed."

But South Bend's history did not begin with man. We must go even farther back if we are to find the beginning of the story. . . .

*The St. Joseph River near the La Salle Street Bridge is where it all began. The building in the background is where Alexis Coquillard had his first trading post. The river changes its course near this point, flowing northward.*

# 1. FROM THE BEGINNING TO OUR FIRST SETTLERS

In the beginning, time had no meaning; there were no days, no hours, no minutes. The world evolved slowly, changing over millions of years. These millions of years have been separated into unequal lengths called eras, the largest units of time. The Azoic, Archeozoic, Proterozoic, Eozoic, Paleozoic, Mesozoic, and Cenozoic Eras contain all geological time, and almost every era is further divided into small unequal units called periods.

It is in the Paleozoic Era where we find the roots of South Bend's history. The Paleozoic Era began about 600 million years ago and ended about 230 million years ago. Scientists have divided this era into seven periods (from oldest to youngest): the Cambrian, Ordovician, Silurian, Devonian, Mississippian, Pennsylvanian, and Permian. Indiana bedrock ranges from Ordovician to Pennsylvanian, while St. Joseph County bedrock begins with Ordovician but extends only to the Mississippian Period.

The oldest rocks are in the eastern part of the state, while the youngest are in the southwestern portion and are composed of all three types of rock: igneous, sedimentary, and metamorphic. Igneous and metamorphic rocks make up Indiana's lower portion of bedrock, while sedimentary rocks form the upper portion.

Sedimentary rock formations in this region were formed in three major geologic environments: shallow to moderately deep seas in very ancient times that repeatedly invaded the central lowlands of the continent; on land during glacial ages when many types of deposits were laid down by melting glaciers; and during late glacial and post-glacial times when deposits accumulated in a succession of large, freshwater lake stages and were reworked by the wind and waves.

The oldest known consolidated rocks underlying St. Joseph County are of Ordovician age, consisting of dolomite, limestone, and shale—remains of a marine seabed where excellently preserved fossils of bryozoans can be found (a bryozoan is a sack-like creature containing three layers like those found in flatworms, with a body closed at one end and bearing a ring of tentacles at the other).

*Thousands of years ago, the great St. Joseph and Kankakee Rivers were one. As the icy waters melted, an ice jam changed the course of both rivers, forming the south bend of the St. Joseph River.*

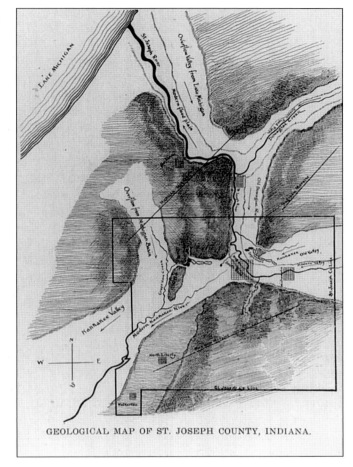

GEOLOGICAL MAP OF ST. JOSEPH COUNTY, INDIANA.

After countless millennia of rising and falling, the land finally pushed through the ocean for good in the Cenozoic Era. Fine textured mud slowly became shale and limey ooze changed into limestone. Rain, wind, snow, sunshine, and frosts bathed the forests and plains, and low flat swamp lands were engulfed by heavy rains.

The land now at the bottom of the Great Lakes was much like the area in the Ohio Valley today—flat plains and ridges, trees and plants, all drained effectively by river systems. There were no large lakes at first. But then came the ice!

Until recent times, most scientists considered the Ice Age to have begun in the late Cenozoic Era and the reasons for the appearance of glaciers, which covered more than 28 percent of the Earth's surface, were not clear. However, recent investigations have given scientists a new view of the Ice Age.

Today, dozens of ice ages are known to have existed before the late Cenozoic Era, including at least four major ice ages that occurred in Precambrian times more than 2.8 billion years ago. Because of the shifting continental plates, the

North American continent was near the equator much of this time and seems to have escaped most, if not all, of these pre–Cenozoic Era ice ages.

During an ice age, snow accumulates faster than it can melt, creating large glaciers of snow that continually thaw and re-freeze as they are exposed to the sun's rays. Everyone in St. Joseph County knows how snow becomes much heavier after the sun warms it and it re-freezes. These same conditions continued for thousands of years until the snow became so heavy that its weight caused the bottom of the glacier to become much more fluid than the upper portion.

As the bottom became more fluid, it began to slide over the rocks, trees, and land. The upper portion, still more rigid than the bottom, did not slide as easily, and crevices were formed where the upper portions broke apart from each other.

In North America, the glaciers originated in northern Canada, slowly traveling over thousands of years, growing thousands of feet high, until at one time they covered almost 4 million square miles. The Great Lakes lay smothered under an ice sheet that may have been as much as 1 mile high.

Scientists classify glacier activity in the United States from the late Cenozoic Era to the present time into four glacial stages and three interglacial stages. All of the names for these stages originate in the upper Mississippi Valley because it is here that we find the clearest records of glacial activity. Ranging from the oldest to the youngest stage, they are: the Nebraskan Glacial Stage, the Aftonian Interglacial Stage, the Kansas Glacial Stage, the Yarmouth Interglacial Stage,

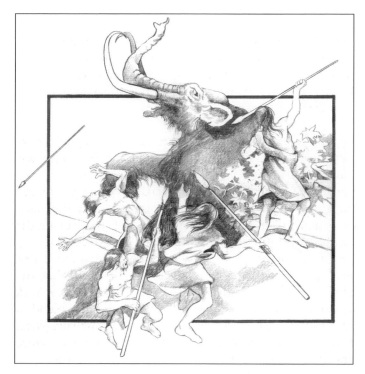

*Mastodon herds followed the retreating glaciers, gorging themselves on new lush vegetation. Following them were nomadic hunters, using the mastodons as their food supply. (Sketch by David Blodgett.)*

the Illinois Glacial Stage, the Sangamon Interglacial Stage, and the Wisconsin Glacial Stage.

The last glacial advance, the Wisconsin Stage, appears to have occurred from about 90,000 years ago to about 10,000 years ago. Ice sheets spread south from Canada, moving slowly until about 21,000 years ago when they reached the Shelbyville Moraine, where they stopped. Almost two-thirds of Indiana was covered by this glacier. Since this was the last glacier, much of the surface drift over Illinois, Ohio, Kansas, and other areas resulted from it.

During the Wisconsin Stage, two great ice sheets, the Huron-Saginaw and Ontario-Erie Lobes, blended with ice from the Lake Michigan Lobe in lower Michigan and Northern Indiana. Parts of these glaciers met in St. Joseph County and created our present land structure.

The Wisconsin glacier slowly retreated from the Ohio River Valley about 7,000 years ago, creating an ice block or dam. The dam forced the melting waters to join already swelling streams and rivers so that the Mississippi River was perhaps at least 5 miles wide near the mouth of the Ohio River, and fish and whales from the Gulf of Mexico could easily swim upstream. At the same time, as the North Bay and Niagara Falls outlets were opened up, fish and whales from the Atlantic Ocean made their way to the Great Lakes.

Though somewhat outdated by time and interpretations of new discoveries, perhaps no more graphic description of South Bend and St. Joseph County in those few thousand years of post-glacial time will ever be found to compete with Dr. Hugh T. Montgomery's early twentieth-century remarks:

> Where our city now lies nestling in a beautiful valley, partially surrounded by hills, a wonderful river once flowed, a stream three miles wide and one hundred feet or more in depth, flowing from east to west. And from the north a great tributary whose mouth was three miles wide emptied its waters into the main stream.

When the glaciers melted and the ancient rivers vanished, St. Joseph County was left much as it is today, with the county located in parts of three drainage basins: the St. Joseph, the Kankakee, and the Tippecanoe.

Following on the edge of the Wisconsin retreat, woodland musk oxen entered Indiana. These cold-loving animals may have been the first to enter the state. Later, herds of mastodon seasonally wandered over northern Indiana, seeking the new lush vegetation, and with them came elk, caribou, and the giant beaver.

Fir and balsam were some of the earliest trees to thrive in the cool climate. Later, deciduous oak forests gradually gained dominion over the area as the climate became warmer. Grasslands expanded, spreading east and across the area as far as New York state and blending with the oak forests, until St. Joseph County became a blend of two biotic provinces—the dry and wet prairie sections of the Prairie Peninsula (most notably seen in the Kankakee Marsh areas) and the Carolina biotic province consisting of birch and maple deciduous forests, dominated by oak and hickory.

Archeological evidence indicates that Native Americans began living in the Great Lakes region during the final years of the Wisconsin Glacial Stage—in the Michigan peninsula approximately 11,500 years B.C. and in southern Michigan and northern Indiana about 11,000 B.C.

Fire-cracked stones, earthen burial sites, pottery, and tools indicate the St. Joseph Valley was an excellent location for early occupation. It was situated near the border of two sub-cultural areas—the Great Lakes sub-area and the Ohio Valley sub-area of the Eastern Woodlands—while the Upper Mississippi Valley sub-area of Illinois also influenced lifestyles, with groups entering the area using the Kankakee River and Marsh.

Archaeological sites can be found everywhere, but the local natural environment, including climate, food resources, and water determined, how heavily Native Americans occupied the area. As a general rule, river valleys are the most productive sites. Native Americans had no horses before European contact and either walked or paddled watercraft.

During the thousands of years in which Native Americans inhabited the Great Lakes area, the climate underwent several dramatic changes and the people adapted by evolving their subsistence and social patterns, eventually creating distinct cultural phases from big-game hunting to gathering-collecting, and from living in simple camps to semi-permanent villages, then permanent villages.

No one knows much about the early Native Americans who came into the Great Lakes region. Their needs were simple and their life consisted mainly of hunting animals for food. Their skeletal remains, clothing, and tools were too fragile to remain for 11,000 years.

Some archaeologists have suggested that this early culture may have been a "pre-projectile point" stage of development in which crude percussion-flaked tools such as scrapers, flakes, and pebble choppers preceded the use of arrowheads, spearheads, and knives. These early Native Americans would have lived in very small groups, perhaps no larger than a few families. Camps were temporary as they followed the wandering herds.

In the United States several related cultural phases involving the use of lanceolate projectile points appear to have ranged from roughly 15,000 B.C. to 5000 B.C., firmly establishing themselves by about 10,000 B.C. and flourishing until about 8000 B.C. In general, these phases or complexes have become known as the Paleo-Indian, or Big Game Hunting Tradition, and are distinguished by how projectile points were made and the kinds of other stone objects found with them.

Fluted projectile points are classified into several phases, including Clovis, Folsom, and a related type called Plano. All three types of projectile points have been found in St. Joseph County, indicating that the Paleo-Indian lived along the edges of the prehistoric St. Joseph and Kankakee Rivers.

During the Plano or Aqua-Plano phase (about 7000 B.C. to 4500 B.C.), the glaciers retreated and water levels fell, especially in Lakes Michigan, Huron, and Superior, due to new drainage outlets created by the retreating ice. The Native Americans using the Plano point would have had a small social unit, temporary

camps, and simple needs. However, it was during this time that the mastodon and mammoth were becoming extinct, causing these groups to slowly shift from nomadic year-round wandering to seasonal food-gathering patterns, with fish becoming increasingly important as the groups settled near the shores of glacial and post-glacial lakes. Although some plants may have been included in their diet, no evidence has yet been discovered by archaeologists. Agriculture as we know it did not exist, nor did pottery, basketry, or weaving. Lightweight stones with shallow centers were used as food plates.

The Archaic Tradition spanned from about 8000 B.C. to about 1000 B.C. There are many local variations of this tradition and none of them are well understood. In the Great Lakes area, it is thought that the Archaic Tradition may have been a part of the Aqua-Plano Phase.

As the prairie expanded from Illinois through northwest Indiana into Michigan, the population within the Kankakee Valley increased. Though the sites were small and widely scattered, the people were now seasonally mobile, no longer nomads following big game herds. Food stations—areas where life could be sustained because both animals and plants were in large quantities—began to play an important part in the lives of the early Native Americans. This method of seasonal mobility has been termed "the seasonal round."

Archaeologists have found little difference between the Early Archaic phase and the Folsom or Aqua-Plano phases. Early Archaic people began to adapt better to their woodland environment by about 4000 B.C.

*These small shells, arrowheads, and animal bones are only a few items that prehistoric Native Americans traded through their far-ranging trade routes. Other items included copper from Michigan, obsidian from Colorado, turtle shells, small stones for necklaces, and porcupine quills.*

*Over the centuries, nomadic hunting groups slowly developed into small semi-permanent and then permanent family groups and small villages. Native Americans continued to hunt gib game and small animals, but also learned to cultivate various kinds of plants for food. (Sketch by David Blodgett.)*

The Middle Archaic appears to be the time when regional characteristics first developed. There was an increasing trend away from seasonal rounds to semi-permanent and even some permanent residences. In Indiana and Ohio, life was sustained by hunting and fishing, while the mussel became a main food supply. Evidence suggests that the dog was domesticated during the Middle Archaic.

The Middle Archaic developed two distinctive cultures in the Great Lakes region: the Boreal Archaic culture, from about 5000 B.C. to 500 B.C., and the Old Copper culture, from about 5000 B.C. to 1500 B.C.

The decline of the Old Copper culture marked the beginning of the Late Archaic Period, which lasted to about 1000 B.C. Although there were many complexes associated with this state of the Archaic Tradition, only one is of importance to the history of St. Joseph County. This complex—called the Red Ocher Complex—originated in Illinois and marked the first true beginnings of burial ceremonies, perhaps influencing the burial traditions of both the Early and Middle Woodland Traditions.

The Late Archaic marked the slow beginning of a transition to the Early Woodland Tradition. Habitation sites continued to be small in northern Indiana, but there are indications of intense occupation in southwestern Indiana. Some archaeologists suggest that it was during this time that trade networks first developed. There may have been some contact between Indiana people and Mesoamerican cultures.

The intense collecting pattern of the Eastern Woodlands climaxed about 1000 B.C. and is seen in the Adena Culture. Identified as part of the mound building culture, the Adena spanned about 1000 B.C. to about 200 A.D.

Adena pottery was crude. The earliest pottery in Indiana is thick, heavy, and convase. Usually cord or some type of fabric was overlayed on the fresh clay to mark the insides and outsides with decorative patterns. Local varieties of early pottery include Fayette Thick in the southeast, Baumer in the southwest, and Marion Thick in the west and central portions of Indiana, the Wabash drainage, and the Great Lakes region.

The presence of mounds in northwestern Indiana indicates that the Adena had entered the area, creating settlements that could have been used as base camps in an attempt to better exploit the Kankakee marshlands. Later, mounds were also erected in the uplands to better exploit both areas.

Mounds near Walkerton indicate that an Adena settlement may have existed for some time before it was taken over by a group closely related to a Wisconsin variant of the Hopewell culture. It has been suggested that this town may have acted as a hub or a capitol for nearby smaller villages, which had no mounds.

The Hopewell Complex best represents the Middle Woodland Tradition. There is little difference between Adena and Hopewell culture except for burial practices. Several archaeologists believe that the Hopewell first developed in the central southern Illinois area and then spread through Indiana to the Ohio Valley.

The Ohio Hopewell traditions are related to the Hopewell traditions in Illinois, and while it is possible that St. Joseph County may have received some influence from the Ohio Hopewell, there is overwhelming evidence that the Illinois Hopewell often visited the area.

Hopewell burial mounds usually included a large number of foreign or rare materials, which were obtained in trade. Trade networks had developed over the centuries, but the Hopewell expanded on the already existing routes and created new ones. Hopewell mounds include grizzly bear teeth from the Rocky Mountains; obsidian from the Yellowstone Park area of Wyoming; hornstone from Indiana, mica, quartz, crystal, and chlorite from the southern Appalachians; copper from the mines at Isle Royale and Keweenaw; large marine shells from the Florida east coast; ocean turtle shells; alligator teeth; shark teeth; and barracuda jaws.

The existence of highly developed trade networks suggests a loose confederacy of Hopewell villages that extended from the Atlantic to the Kansas plains and from the Gulf of Mexico to northern Wisconsin.

Some archaeologists have suggested that the Hopewell culture may have existed in the Kankakee marsh area from 500 A.D. to 1100 A.D. During this time, the Upper Mississippian people may have moved into the area, though no large camps have yet been discovered.

Related to the Late Woodland Tradition were the Middle and Upper Mississippian traditions, which were apparently an outgrowth of the Woodland traditions blended with an influence that is believed to have come from Mesoamerica. The Mississippian traditions were the most developed of the Native American traditions.

Dating possibly as far back as 500 A.D., this tradition was based upon the gradual shift toward agriculture as the major source for food. Maize, beans, corn, squash, and probably tobacco were cultivated.

Northern Indiana is a blend of Woodland traditions and Mississippian influences, which, because of their geographic location, have become known as the Upper Mississippian Tradition. Upper Mississippian people may have moved into the Kankakee area as a result of warming temperatures between 800 A.D. and 1200 A.D., which allowed cultivation of beans and corn. It was during this period that tribes began to develop into the cultures that were first encountered by the Europeans.

Although several prominent archeologists, including Eli Lilly and Glenn A. Black, visited St. Joseph County in the first half of the twentieth century, they did not intensively survey the area. Black spent the summer of 1937 in South Bend looking for Hopewell mounds. Recent surveys indicate a large number of early Native American sites in St. Joseph County. Many original sites were destroyed when white men first came into the county and plowed the area for crops. Other sites were explored at the beginning of the twentieth century by early members of the Northern Indiana Historical Society, and some of their reports were printed in the South Bend newspapers. Accidental finds were also reported in the papers.

Early explorations were often amateurish and much valuable archaeological information was unknowingly destroyed. Grave robbers and others seeking Native American artifacts have also destroyed valuable information in their attempts to obtain artifacts for profit.

In order to protect the remaining sites in St. Joseph County, this book will not reveal any Native American sites not already reported in local newspapers, such as the following from the Mishawaka *Enterprise*, May 29, 1900:

> A workman named Fries, employed in excavating for the St. Joseph and Elkhart dam near Hen Island, east of Mishawaka, found imbedded under ten feet of earth and five feet of grave, a copper spear head which centuries ago was used by some warrior on the mound builders tribe. Over the spot stood an oak tree two feet in diameter.
>
> The Implement of warfare is eight inches long, the shaft and blade hammered out of copper, flat on one side, with a rib running down the center of the opposite. The end was hammered and bent to fit the shape of the spear. It is sharp on both edge and worked out in a neat and workmanlike manner, its widest part is an inch in breadth, then tapering down to a sharp point.

The South Bend *News Times* reported the following on October 18, 1925:

> Jesse and Carl Litchfield, of Teegarden, dug into a mound on the farm of Grove Vosburgh, near Potato Creek, north of Walkerton, recently, and found several human skeletons. They believe them to have been white

*Extensive Native American trading networks had existed for perhaps 2,000 years or more before the French and English found their way into the St. Joseph Valley. Many Native Americans welcomed the new trading partners, but distrust and anger developed when the new arrivals soon began to claim the land as their own. (Sketch by David Blodgett.)*

men, buried perhaps 500 years ago. Armour, of copper, part shown here, was found encasing skeleton of huge man, believed to have been at least nine feet in height.

Archaeologists have not been able to determine when the first trade routes were established. However, evidence found in graves and at camp sites suggests that they first developed during the Archaic Period and that a wide trade network, possibly extending across most of the United States, flourished as long as 2,000 years ago.

Items were traded and acquired either because they were things of beauty or were essential for improving a lifestyle. Trade continued after the decline of the Hopewell, but it appears that there was a decline in the variety of materials offered for trade. Most of the early trade routes involved rivers and streams, or trails near them.

The St. Joseph River and Kankakee River systems allowed trade items from Canada to find their way far to the south, and copper from Michigan could be found in Mexico. Only one short land trip between the St. Joseph and Kankakee Rivers was necessary for Native Americans to take their trade goods from Canada to the Gulf of Mexico.

The importance of the St. Joseph–Kankakee River portage, as well as the Great Sauk Trail crossing the St. Joseph River, made St. Joseph County and the surrounding area a very important center of trading activity. The area was well known to Native American groups as far away as Rhode Island. In 1680 and 1681, Robert Cavelier de La Salle recorded meeting Abenakis and Mohegans from the

east, Shawnees from the Ohio Valley, and seven or eight tribes from Manhattan and the Virginia borders here. Several major land routes passed through or near St. Joseph County, including the Sauk Trail, the Potawatomi Trail, and the Dragoon Trail.

The Potawatomi Trail passed through what became South Bend, probably crossing the river near present Jefferson Street. In earlier times, the white men called these trails the Edwardsburg Road and the Crumstown Road. Today, the Edwardsburg Road east of South Bend is known as South Bend Avenue, or State Road 23, while the area in South Bend is known as Prairie Avenue. Crumstown Road is now known as Crumstown Highway.

Before the coming of the white men into St. Joseph County, a small Native American village was established near Crumstown. A small group of Potawatomi continued to live here through the 1880s.

The Dragoon Trail, also known as Dragoon Trace, came from the west through Chicago and crossed St. Joseph County near New Carlisle, then went down through South Bend and southeast for a short distance until it followed the base of the Mishawaka Hills and continued a more easterly course.

In South Bend, the western part of this trail was originally called Michigan Avenue, and became the spur of the Michigan Road that lead to Lake Michigan. This was later developed into a highway known as the Lincoln National Highway and still later as U.S. 20. In the downtown South Bend area, the western part is now known as Lincoln Way West. The part of the trail that lead southeast away from South Bend also underwent several name changes. For many years, it was called Vistula Avenue and later Lincoln Way East in South Bend.

Chief Raccoon had a village on the section of Dragoon Trail now known as Ewing Avenue. Originally, it was located near Riley High School, but he later moved it to Osceola.

Although trading may have been one of the activities of the Native Americans living in St. Joseph County, it was not their only activity. However, this was soon to change. On the eastern shores of the great continent, new trading partners were beginning to make their call.

# 2. Conflict of Empires

The French explored Canada as early as 1534 when Jacques Cartier sailed up the gulf of the St. Lawrence. Several years later, the Dutch and English were beginning to plant colonies on the eastern shores. While those two nations had come to colonize the new continent, the French were mainly after trade, exchanging cloth and other European goods for Native American furs.

Although the French, Dutch, and English established trade with the Native Americans at a very early time, it was more than 100 years before the French slowly worked their way down into the Lake Michigan area, eager to establish religious missions and trading partnerships with local Native Americans. Indirect evidence suggests that French missionaries may have been in the St. Joseph Valley as early as the 1660s.

While the French set themselves up as important trading partners, it is probable that Native Americans in this area traded their furs to other groups who passed them along to the French. It was only a matter of time before the Native Americans realized the great wealth that lay within the St. Joseph Valley and various tribes began to wrestle for control of this area's trade routes.

In the East, the Iroquois had already gained control of the trading traffic and had become involved with warfare against the French, but in 1649, they attempted to extend their influence to the Great Lakes region by sending out raiding parties to defeat local tribes and establish their dominance over the area. Many native tribes left the area.

Among the many adventurers eager to seek their fortune in the vast new territory was Robert Cavelier de La Salle. Having heard of the great wealth of furs in this area and the stories that a great river flowing to the south could be reached by penetrating inland, he made preparations to explore the area, believing that the great Mississippi River was the same river that flowed into the Gulf of Mexico, where he hoped to establish a French colony.

La Salle made no mention of any Potawatomi village in any of the areas of southern Michigan or northern Indiana he explored. If there had been any villages at an earlier time, the Potawatomi may have abandoned them and fled west to avoid destruction. La Salle does mention finding a Mascoutin village near the portage. Mascoutin have long been associated with Potawatomi villages and are

legally classified as Potawatomi, although there is evidence to suggest that they are not.

By 1669, the Miami began to return to the St. Joseph region, setting up a large village near where the St. Joseph River empties into Lake Michigan. La Salle built his Fort Miami near this site in 1679. The Miami appear to have been the most powerful confederacy in the region between Lake Michigan and the Ohio River.

After several bitter frustrations, La Salle was finally able to reach the St. Joseph Valley area in 1679. Setting up a small fort that he called Fort Miami near the mouth of the river at what is now St. Joseph, Michigan, La Salle ascended the Sagwasibi River on December 3, 1679.

According to some Miami sources, the word Sagwasibi translates into "coming out place" and refers to the spot where canoes could land and be transported to the Theakiki (Kankakee) River. La Salle renamed the Sagwasibi River the River of the Miamis because of the Miami settlement. With 33 adventurers, including 4 priests and 8 canoes, La Salle began his eventful trip.

At one point, his Mohegan guide was hunting in the fields and the snow-covered ground caused the group to miss the landing place, forcing them to stop elsewhere while La Salle went ashore to find the portage to the Theakiki. He also missed it, spent an uneasy night in the cold, and returned weary the next day. In the meantime, his guide had returned and the group found the portage.[1]

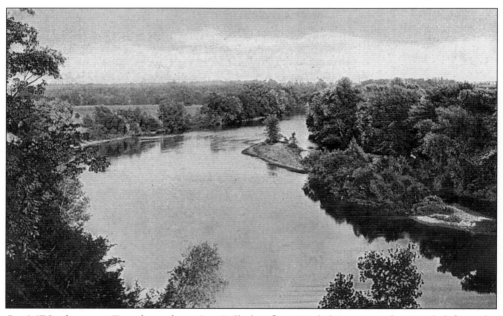

*In 1679, the great French explorer La Salle briefly visited this area as he traveled from the River of the Miamis to the Kankakee River. A prehistoric trail on the east side of the river crossed this spot and continued westward to the Kankakee River. Travelers could also take this trail further westward toward Crumstown.*

*The portage was used for centuries by Native Americans as part of their trade route between the St. Joseph and Kankakee Rivers. This short stretch of land was the only land Native Americans and French traders needed to travel from Lake Michigan to the Gulf of Mexico.*

Several historians have speculated as to the exact portage that La Salle used to get to the Theakiki River. There may have been several, depending upon the time of the season and the climactic conditions. The diary of Father Louis Hennepin states that on December 5, 1679, Father Ribourdi blazed a mark upon a cedar tree to show the spot for future explorers. In 1829, William Brookfield was hired to survey part of St. Joseph County. He surveyed the area around the portage. The *United States Surveyor General Record Plats and Field Notes for St. Joseph County, Indiana* has the following notation for section 27 of Township 38, Range 2 East: "This is the Portage of the Kankakee on the W. Bank of the St. Joseph."

His statement was based upon what he could observe of an old trail leading from the river toward the Kankakee. In June 1897, an excavation was made to clear away sand that had washed down from the bank and covered the bases of many trees in the area. As the sand was being removed, a cedar tree was uncovered with a deep blaze mark.[2]

La Salle continued down the Theakiki (Kankakee) to the Illinois River, where he encountered many Illinois villages. He spent the winter among the villagers, establishing Fort Crevecoeur, where he built a vessel capable of carrying 40 tons of materials. On March 1, La Salle left a majority of his men at the fort under the command of his friend Henri de Tonty. La Salle and a small group of men returned to Fort Miami, then continued back to Fort Frontenac, which they reached on May 6, 1680. Setting out in August, La Salle again came down the St.

Joseph River and, using the portage to the Kankakee, he returned to Fort Crevecoeur where he discovered that many of the Illinois villages that he had passed the previous year had been destroyed by Iroquois war parties. Many of the villagers had been tortured and killed. During La Salle's absence, many of his men had deserted Tonty and destroyed the fort. After a fruitless search in which he found no Frenchmen but only more destroyed villages, La Salle returned in the freezing weather to Fort Miami, reaching it in late January 1681.

The Iroquois may have used many of the previously mentioned trails running through St. Joseph County to Illinois, but it is not clear if any Miami villages in or near St. Joseph County were destroyed in the Iroquois raids. The Miami had been recent allies of the Iroquois, but Iroquois war parties returning from their destruction of the Illinois villages also attacked and murdered a small band of Miami on the Ohio River, thus creating enmity between the two groups.

La Salle finalized his plans while wintering at Fort Miami. The Iroquois had already proven to be bitter enemies of the French in the east. His plan was to unite the other Native American tribes, providing French protection for them at his recently destroyed Fort Crevecoeur, and weld them into a powerful confederation to defeat the Iroquois.

He first set out to win the friendship of 25 Abenakis and Mohegans who had been driven westward from the New England area and had a small village near Fort Miami. A Shawnee chief and his warriors from the Ohio Valley came to ask for protection from the Iroquois.

Believing that he could persuade the remaining Illinois to form an alliance with the French, La Salle left Fort Miami on March 1, 1681 and returned to the Illinois lands, where he was able to convince the Illinois to join his growing confederation. Upon returning to Fort Miami, he soon ascended the St. Joseph River to the portage, then went to the Miami village that had been established near the headwaters of the Kankakee. The Miami and Illinois were enemies, but La Salle felt that their fear of the Iroquois was stronger than their fear of each other and the Miami were encouraged to join the alliance. The Illinois agreed to attend a conference to be held later that year.

The Illinois, Miami, and seven or eight other tribes from as far away as Manhattan and the borders of Virginia met with La Salle in the Spring of 1681. According to the *Relation of the Discoveries and Voyages of Cavelier de la Salle from 1679 to 1681: The Official Narrative*, the first meeting was held at the lodge of the leading Miami chief and mats comprising the roof and sides of the lodge were removed so that everyone could hear what La Salle said. He provided 12 gifts to the Miami as reminders of his words and the New England Indians gave him four presents in gratitude for allowing them to join in the Miami alliance.

On the following morning, the Miami came to La Salle's lodge and held their own solemn ceremony, presenting five gifts to him. In making his final gift of ten beaver skins to La Salle, the chief reminded him that the Miami were poor, already having given 3,000 beaver skins to the Iroquois "to ransom thy bones," (i.e. the bones of Ouabicolcata, whose role La Salle had assumed). The chief told him, "do

not count our gifts, my brother; it is all that we have left. The Iroquois have stripped us of everything, but we offer thee our hearts, hoping that in the spring we may be able to give thee greater tokens of our love and gratitude."

There are no documents to indicate exactly where the ceremonies took place. A legend beginning in the 1880s pointed out a certain oak tree where the ceremony took place. For the next 100 years, this tree became a focal point of historical interest and was known as the Council Oak.

Three days after the ceremony, La Salle returned to Fort Miami to prepare for his trip to find the source of the Mississippi, but circumstances changed his plans and he never returned to the area. The Miami remained settled near the portage and the village grew.

As previously mentioned, the Potawatomi were either migrating into or returning back to their homelands in the St. Joseph River area by the 1680s. The Iroquois invasions of the St. Joseph region would have caused the Potawatomi to have second thoughts about returning to the area before this time, but La Salle's treaties with the Illinois, Miami, and other tribes may have given the Potawatomi an incentive for coming into the area.

Father Claude Allouez, a Jesuit missionary, accompanied the Potawatomi in their travels and it is believed that he established his mission along the River of the Miamis in about 1684. This land was near what is now Niles, Michigan.

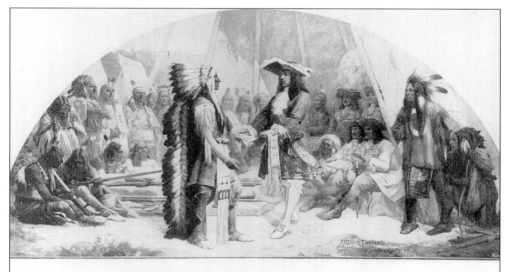

Painting In St. Joseph County Court House.     By permission of Arthur Thomas, Artist, N. Y.

LA SALLE AT THE MIAMI TREATY, MAY, 1681.

*This historic treaty was intended to unite Miami, Potawatomi, and other tribes with the French against their common enemy, the Iroquois. The original color painting was commissioned as a companion piece for "La Salle at the Portage" and still hangs in the courthouse rotunda opposite it.*

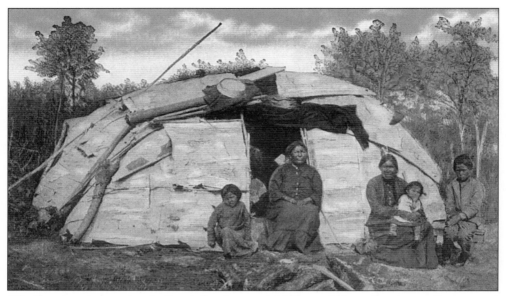

*The first American settlers in South Bend around 1830 would have found some Potawatomi living in homes like this. The homes are similar in style to what La Salle found over 100 years earlier, but French and English cloth had replaced animal skins as a source for clothing, and copper and steel bowls had replaced wooden instruments.*

On October 1, 1686, the Marquis De Denonville and de Champigny granted 20 arpents of land fronting the river to Father d'Ablon of the Society of Jesus. They named the mission St. Joseph and changed the "River of the Miamis" to the St. Joseph River.[3]

In the east, the French warfare against the Iroquois continued. The English, who long ago had become Iroquois allies, were involved in a struggle of their own against the French in Europe. This struggle resulted in the War of the Grand Alliance (1688–1697). In the colonies, this became known as King William's War, resulting in many war parties from Canada destroying New England villages, while New Englanders retaliated by destroying Canadian villages.

Fearing attacks that could result in the loss of their western lands, Frontenac, the governor-general of Canada, ordered Augustin Legardeur de Courtemanche to establish a fort among the Miami on the St. Joseph River in 1691. The fort would re-affirm La Salle's pledge of French help for the Miami and other tribes in the area against Iroquois invasions and, at the same time, establish control over three vital links: the mouth of the St. Joseph River where it emptied into Lake Michigan, the great Sauk Trail, and the Kankakee–St. Joseph River portage. It would also provide a convenient trading center for French and Indian trappers and traders.

For the next 90 years, the history of South Bend and St. Joseph County remains in the background. It was the mission and the fort that dominated this area's

history, but to provide a detailed history of the fort is beyond the scope of this book. For our purposes, it is only necessary to keep in mind that the mission, the fort, and the trading center that developed around it became the third most important post in Canada's military/trading system and influenced what would happen in what is now South Bend.

Any Native Americans living in St. Joseph County who wished to trade would have most likely gone to the fort for their supplies and would have become dependent upon the French to satisfy many of their trading needs such as guns, flints, steel axes and knives, and fine cloth. This would have caused Native Americans to identify closely with the French and with French political interests. However, the Miami also retained their own interests as well. Though friendly with the French—and there were French traders in nearly every village—there is little evidence of marriages between the traders and the Miami.

As more Potawatomi moved into the Fort St. Joseph area, the Miami slowly moved east to central Indiana, settling near the Maumee River. Some Miami moved into the Ohio Valley and their villages were still here as late as 1721 when Charlevoix visited the area, but they moved out several years later.

Some small Miami villages may have remained near the fort, and some in South Bend and St. Joseph County, but the Potawatomi became the dominant tribe in the region.

In the 60 years of active French occupation of the fort, its commanders led military forces against the Fox Native Americans in the west (the Fox Wars), the Chickasaw Native Americans in the south (the Chickasaw War), and English villages in the east (the French and Indian War). The Miami sent many warriors to help the French in the first two wars, but they were more reluctant to send large forces during the French and Indian War. However, the Potawatomi did accompany a large military expedition to Pennsylvania, where they helped defeat a young British officer, George Washington.

The military forces were usually led by French officers, but most of the fighting men were Native Americans, so it is likely that Native Americans living in South Bend and St. Joseph County were among those involved in the military expeditions.

Potawatomi migration into the St. Joseph area was not the main reason for Miami migration eastward. The Miami were primarily an agricultural people, growing squash, beans, and pumpkins. They were more settled than their other Great Lakes neighbors. Miami preferred to live in large villages of several thousand people rather than small villages. They also ate turtles, deer, beaver, and other animals. Although they fished, fish was not a large part of their diet. Their primary agricultural product was a fine white corn, which differed significantly from the corn grown by other Great Lakes tribes.

The land in this area did provide some areas for cornfields, but not enough space to satisfy the needs of the large Miami communities. The land further east around the Maumee River, the Little St. Joseph River, and the St. Mary's River was much more suitable to their needs.

In addition, they had become aware of English trade goods and that they were cheaper to purchase than French goods. English traders were coming into the Ohio and Wabash Valleys from Pennsylvania and the Miami wished to make themselves less dependent upon one source of goods.

Neither the French nor the English could depend permanently upon Miami loyalty to their cause. The various villages were often caught trying to determine whether they should support the French or the English, or remain neutral to protect their own interests. Conflict between the Miami and Iroquois continued, but the French had signed their own permanent peace treaty with the Iroquois in 1701.

After the French and Indian War, Fort St. Joseph was controlled by British traders. The American Revolution created difficult problems for the Native Americans in this area. They had first been allies of the French, then they became dependent upon English trade for their mutual benefit. When France joined the side of the American colonial government, the English became frightened that the Potawatomi would join the French.

However, dependence upon English trade and close personal ties with French relatives created splits among the Potawatomi themselves. For a time, they tried to remain neutral.

George Rogers Clark presented a new situation to the Native Americans, as well as the British. With a small band of soldiers, he had managed to capture Kaskakia in the Illinois country and Vincennes in what was now southern Indiana. He won the loyalty of the French settlements along the border. Then he began writing letters to the St. Joseph Potawatomi, warning them to remain loyal to the French or face the consequences.

Fearing that Clark would enter the Fort St. Joseph area, the English sent Thomas Bennett with 20 soldiers, 60 traders, and 200 loyal Native Americans to take command of the area. Bennett arrived at the fort on July 23 and immediately began to dig entrenchments on the river bluff. The garrison remained at the fort until mid-August when supplies began to run out, so Bennett took his garrison to Michilimackinac.

The fears proved real. Even though the fort had not been permanently garrisoned since the French and Indian War, it could still be used a base of operations for the British or the Americans. The fall of Fort St. Joseph would open the back door to attacks against Michilimackinac and Detroit. On September 23, 1779, Clark reported the following:

> I now have a detachment of about two hundred and fifty of French volunteers, Indians and a few Regulars on their march to attack a British Post at St. Josephs near lake Michigan comd by a Lieutenant and party whare their is very Considerable Stores deposited for the purpose of Imploying Savages. The party is Commanded by Captn James Shelby. Their is no doubt of his Success as their Rout is Such that their is but little probability of the Enemies being apprised of them until its to late. His orders is to demolish the Fortification and Return with the Stores, etc.

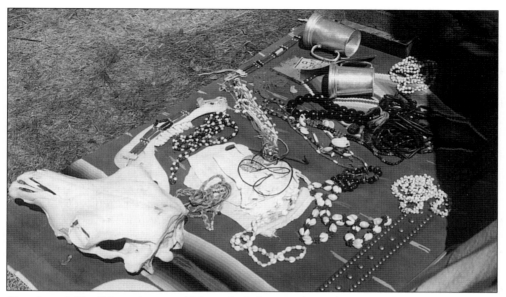

*French and English traders would have had these trade goods among their supplies in the 1700s and early 1800s. Traders would come to villages and spread their goods out on blankets, explaining the great benefits of their products. Native Americans usually traded furs for these products.*

Later, Sergeant Chapman reported that when Shelby attempted to raise the volunteers, they complained that they had no shoes and would not go to the fort.[4]

In June 1780, Patrick Sinclair, commandant of Michilimackinac, decided to remove the French from Fort St. Joseph. A census of the fort at the time of their removal indicates that there were 8 families in 16 houses, totaling 45 French men, women, and children as well as several Pawnee slaves. Some of the women were Native American wives.[5] Louis Chevallier (once the leading trader at Fort St. Joseph), then 68 years old, and his wife Mary, 70, were stripped of their property, including ten houses, good lands, orchards, gardens, cattle, furniture, all of his trade goods, and all of his papers. Two hundred Native Americans came to Detroit asking for his release. The English did not release him, but sent a blacksmith to help the Potawatomi at the village. Chevallier was sent to Montreal, where he died in 1781.

Lieutenant Dagneau De Quindre, a former French officer, was made the British representative at the fort. In December 1780, a small raiding party of 16 Cahokians, led by Jean Baptiste Hamelin, briefly captured the post. De Quindre was away at the time, but as soon as he returned, he organized a party and went after the raiders. Most of the Cahokians were captured and killed in the Battle of the Dunes (near the Calumet River) while on their way back home.

On January 2, 1781, Captain Eugene Poure of the Second Company, San Luis de Ilinuese Militia led a garrison of about 60 soldiers and 60 Native Americans out

of St. Louis with orders to destroy Fort St. Joseph. Along the way, they also received reinforcements from Jean Baptiste Malliet, who had been stationed on the Illinois River with 12 men.

This garrison is often called a Spanish detachment of soldiers. In fact, St. Louis was under the control of the Spanish king and the soldiers were loyal to the King of Spain. However, *The Spanish in the Mississippi Valley, 1762–1804* contains several lists of the military rosters of personnel stationed at St. Louis from late 1779 through late 1780, showing that most of the soldiers had French names and were the descendants of the French families who had founded St. Louis in 1764, or French Canadians who had left the British-controlled Illinois country. Louis Chevallier, son of the Fort St. Joseph trader, was the interpreter.

St. Louis was on the extreme boundary of Spanish territory and there were very few Spaniards living in the area. Almost all of the inhabitants in St. Louis and the casualties and prisoners who had been captured near Cahokia and St. Louis in a May 1780 attack were French.

The detachment spent three weeks in intense cold, travelling over 400 miles and crossing several ice-bound streams before they reached the fort. Luckily, De Quindre and many of the Potawatomi were away hunting, and Chevallier persuaded the local Potawatomi not to interfere with the attack. On February 12, the detachment attacked the fort. The garrison remained for 24 hours and

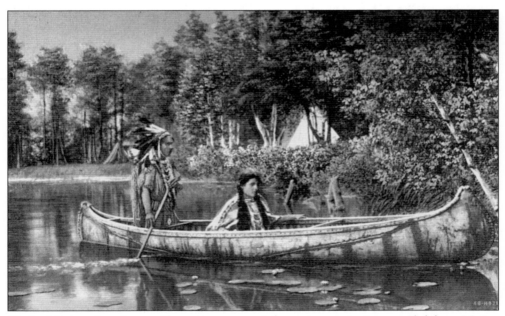

*Early Native American settlements were mainly on or near rivers and lakes. Native Americans did not have horses and relied on canoes and other watercraft for transportation of trade goods, as well as for recreation. Native American women also played influential roles in the trade system.*

Poure read a proclamation in French declaring, "I annex and incorporate into the Domains of his most Catholic Majesty the King of Spain my master, henceforth and forever the St. Joseph Post and its dependencies with the River of that name."[6]

Then they destroyed the fort. For 90 years, this mission/post/garrison had dominated all of the St. Joseph–Kankakee region. Now it was gone, but the Potawatomi village remained.

During treaty negotiations to end the American Revolution, Spain attempted to lay claim to the St. Joseph region because of its conquest of the fort, but it was not successful. Spain had previously joined the Revoluutionary War against the British.

With the fall of Fort St. Joseph, Native American trade went to a few independent traders such as William Burnett, who had established a trading post on the west side of the St. Joseph River about 1.5 miles from its mouth sometime between 1779 and 1782. He may have also used La Salle's old Fort Miami as a storehouse.

Native Americans from South Bend and St. Joseph County would have found it convenient to take their goods to him by canoe. He remained an active trader for many years, but his death date is still not clear.

The end of the American Revolution increased migration into the Ohio Valley, pushing aside any Native Americans who had claimed the land. The first permanent settlement of the Northwest Territory was made on April 7, 1788 at Marietta. Cincinnati was settled on December 28, 1788 and, less than a year later, more than 20,000 men, women, and children passed the mouth of the Muskigum River.

Resentment grew against the Americans, and the British, who still had not given up their forts in the Ohio region, remained on good terms with the Native Americans, often encouraging them to attack the new settlers. In addition, the British kept control of the fur trade in Michigan until 1795, creating tension between the American fur traders and the British trading companies from whom the Americans were required to purchase their goods.

The Miami and their allies formed a strong barrier from Lake Erie to the lower Ohio, virtually stopping westward migration. In 1790, General Josiah Harmer led a military expedition of 320 regular army troops and over 1,100 militia from Kentucky against the Miami living near what is now Fort Wayne, Indiana. Under the command of Little Turtle, the Miami fought off Harmer's invasion, killing more than 180 of his army at a point near where the current U.S. Route 33 crosses the Eel River, about 15 miles northwest of Fort Wayne. The remaining troops fled. Little Turtle continued to raise men for his army, including Miami and some Potawatomi from the St. Joseph River area.

With 1,400 men under his command, General Arthur St. Clair led a new expedition against the Miami, Shawnee, and Delaware living at Fort Wayne in 1791. Just before sunrise on November 4, 1791, Little Turtle led 1,200 warriors into battle at a place on the Wabash River later called Fort Recovery. Within four hours, half of St. Clair's forces were dead and the rest were running for their lives.

Little Turtle's casualties were only 21 dead and 40 wounded. It was the greatest Native American triumph in North America. Potawatomi and Miami from the St. Joseph area were among the Native Americans present at the battle.

It was nearly three years before the Americans sent another army against the Miami. However, this time it was better prepared and under the command of General "Mad Anthony" Wayne. Little Turtle had been watching the preparations of this army and warned the Miami and their allies not to attack it. But the combined forces of Wyandot, Mingo, Delaware, Shawnee, Miami, Potawatomi, Ottawa, and Ojibwa warriors did not listen to his advice. On August 20, 1794, the forces met at Fallen Timbers in Ohio and, within an hour, the Native Americans were defeated.

Wayne's triumph resulted in the Treaty of Greenville in late 1795, which forced the Native Americans to give up about 25,000 square miles of their territory. Among the many Native American chiefs who signed the treaty was Topinebe (also spelled Topinebee, etc.), chief of the St. Joseph Potawatomi, who was becoming an important figure among all the Potawatomi.

The Americans continued to encroach upon Native American lands and it was only a decade later that the Shawnee Chief Tecumseh began to create another Native American coalition to drive back the Americans. At the same time, tension between the Americans and the English was leading to another war.

Potawatami loyalties were still split. Both American and English government agents came into the St. Joseph region seeking an alliance. And Tecumseh desperately wanted the Potawatomi to join his confederation. The result was mixed. Some Potawatomi bands, mainly those in the western part of Indiana and those in Illinois, did support Tecumseh. The Miami and Delaware refused to join him. Tecumseh felt insulted.

In early 1807, Tecumseh had sent messengers to the Ojibwa, Ottawas, Potawatomi, Sax, Fox, Winnebago, Menominee, and Kickapoo, asking them to send representatives to a conference that he would be holding at Greenville. During April, a large group of Potawatomi from the St. Joseph area passed through Fort Wayne on their way to the conference. The conference was designed as an attempt for all of the Native Americans to decide how best to handle the encroaching Americans. It was not a war conference and Tecumseh still had hopes of peace between the Americans and the Native Americans, even though he had come to despise the Americans.

Rumors of war persisted and in an attempt to keep the Americans away from his tribe, Tecumseh and his brother Tenskwatawa (the Prophet), decided to leave Greenville to establish a new village. Main Poc, an influential chief of a Prairie Potawomi band in northern Illinois, may have suggested the new location, only a few miles from where the Wabash River joins the Tippecanoe River at what is now Lafayette, Indiana. This village became known as Prophetstown. Two hundred bark-sided houses set in neatly arranged rows with lanes between extended from the upper end of the site toward the prairie. They cultivated over 100 acres of crops.

This village was in the heart of territory disputed by the Potawatomi and the Miami. It has been suggested that the settlement was deliberately planted there as an affront to the Miami.

Although various delegates from many tribes visited Prophetstown to hear the words of Tecumseh and Tenskwatawa, the Ojibwa and Ottawa in Michigan were not interested in his ideas. They and the Potawatomi in the St. Joseph area had relied for too many years on American and British trade and, whether they liked it or not, they knew that the destiny of their tribes was dependent upon the good will of the British and Americans.

On the other hand, Potawatomi living closer to Prophetstown and further west could identify with what the brothers were saying, and many came to support him.

Tecumseh's message was one easy to understand: the lands belonged to all Native Americans, not just one tribe, and it was the duty of all of the tribes to defend it. They must unite to keep their lands, their culture, and their independence.

Although it was still a message of peace, there was frustration in Tecumseh's voice. And then in 1809, William Henry Harrison, governor of the Indiana Territory, called the Native Americans to Fort Wayne where he intended to

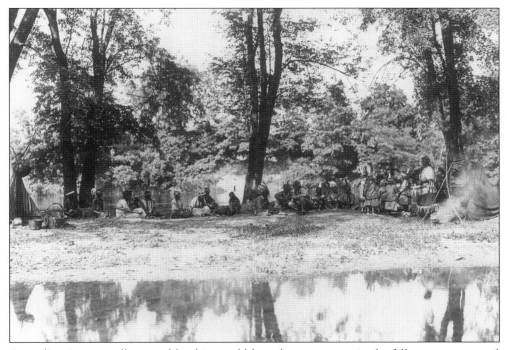

*In earlier times, small camps like this would have been common in the fall as groups moved away from the main village to prepare for winter, or in the spring as they were beginning their journeys back to the main village. This leisurely lifestyle ended when the Potawatomi were removed to the west. (Courtesy St. Joseph County Public Library.)*

negotiate another treaty for 2 million acres of their land. When it was signed, the Native Americans received $7,000 of goods in payment and an annual subsidy of $1,750 to be split up among the sellers.

The Treaty of Fort Wayne appalled the Miami, Delaware, Wea, and other Indiana tribes. Although the older chiefs were still calling for peace, the younger warriors were angry. Many left their villages to join Tecumseh.

In May 1810, a large party of Native Americans met at the Parc Aux Vaches (now Madeline Bertrand Park) on the St. Joseph River just a few miles north of South Bend. Their purpose was to see if they could come to a united agreement. Kickapoo, Winnebago, and the Potawatomi near Prophetstown and Chicago supported Tecumseh, but the Wea, Piankashaw, Miami, Delaware, Ottawa, Ojibwa, and the Potawatomi of the St. Joseph opposed war. At this time, the Potawatomi had three main settlements in this area: the St. Joseph River (near the old fort), South Bend, and Elkhart. Together, they were considered the Potawatomi of the St. Joseph.

In August, Tecumseh met with Harrison near Vincennes. The conference lasted for several days, during which Tecumseh repeated his belief that the land belonged to all Native Americans and that if the governor did not give back the land signed away in the recent treaty, there would be trouble. Harrison replied that the land was fairly purchased and would not give it back. By the time the conference was over, both acknowledged that bloodshed was inevitable.

In late September, Tecumseh traveled south to find more allies. During his absence, Harrison led a force of over 1,000 men from Vincennes toward Prophetstown. Outnumbered by about two to one, the Kickapoo and Winnebago warriors who formed most of the camp attacked Harrison in the early dawn. After a fight lasting more than two hours, Harrison's casualties amounted to about 188 men while the Native Americans lost about 50. Statistically, it was a defeat for the Americans, but it would have been worse if the Native Americans had not run out of ammunition. With no ammunition, they could not continue the fight and had to retreat. In the night, they abandoned Prophetstown and when Harrison entered the camp, he burned it and the winter food supply.

Harrison claimed the Battle of Tippecanoe as a great victory. After burning the town, he returned home. Native Americans returned to the town shortly after Harrison left, but they were hungry and needed food and supplies. Tecumseh had hoped that he might get them from the British traders. Some traders did give him supplies, but the British government remained neutral and would not support him.

On the other hand, his support did increase. About 150 Potawatomi from the St. Joseph and Elkhart areas were deserting their pro-American chiefs and joining him. Nearly 200 Miami also joined him. It is estimated that by the early summer of 1812, he had the largest Native American confederation ever assembled, ranging from the Sioux in the western states to the Creek in Alabama and Georgia. And when the time was right . . .

Tecumseh visited Fort Wayne on June 17, to meet with American officials concerning the Americans' future intentions. At the same time, the Americans

were trying to get Tecumseh and his allies to remain neutral if war would break out between the United States and Britain. Neither knew it, but before the conference was over, the United States had declared war upon Great Britain.

Whatever great plans Tecumseh may have envisioned for a Native American confederacy against the Americans changed when war was declared. Whether he liked it or not, he chose to become a British ally and for the purposes of this history, he fades from our scene.

The War of 1812 did nothing to improve conditions for the Potawatomi and other tribes living in this area. The tribes had never recovered from the split that had begun during the Revolution. Some still supported the Americans, but many had gone over to join Tecumseh. The British government was actively sending agents into the region to recruit the Potawatomi against the Americans.

Shortly after the war began, the British captured the island of Mackinac and were making preparations to take Detroit. Tecumseh took his warriors to Canada.

On August 7, 1812, Winnimeg, a Potawatomi chief, arrived at Fort Dearborn (now Chicago) with dispatches from General Hull in Detroit. He ordered Captain Heald to evacuate the fort and distribute all of the United States property contained in the fort to the neighborhood Native Americans.

The local trader John Kinzie (a Canadian) some of Heald's officers, and friendly Native Americans advised the captain to ignore the order and remain safely within the fort. They had enough food and supplies to last six months, according to one advisor. Heald ignored the advice and made preparations to distribute the supplies.

During this time, neighboring Potawatomi under Main Poc's leadership, Winnebago, and other tribes began to assemble. On August 12, they held a council, inviting Heald and his staff to attend. Only Heald and Kinzie came. Heald announced that he would distribute the supplies, ammunition, and liquor on the following day. In return, he asked the Potawatomi to provide an escort to Fort Wayne, promising them presents when they arrived at the fort.

Some time after the meeting, he changed his mind about the ammunition and liquor and had it dumped into a well. On August 14, Heald and Kinzie had another council with the Native Americans, who showed their anger that the ammunition, guns, and liquor had been destroyed.

William Wells, adopted son of Little Turtle, arrived with 15 Miami from Fort Wayne, intending to provide a reinforcement for the Americans as they evacuated Fort Dearborn and headed toward Fort Wayne. Wells was Mrs. Heald's uncle.

The garrison and settlers started out of Fort Dearborn at 9 a.m. on August 15. During this time, Kinzie received two messages from Topinebe promising safe conduct to the Parc Aux Vaches if Kinzie would join his family on board the small boat that had previously been arranged for his wife and family's safe conduct. Kinzie declined the offer. Two friendly Potawatomi protected the boat. Kinzie had been a trader at Topinebe's village for four years before moving to Chicago, and perhaps his friendship with the St. Joseph Potawatomi helped to save the family.

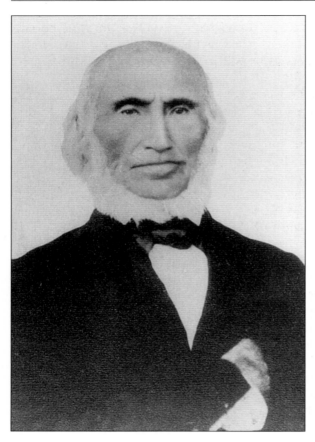

*Joseph Bertrand was an early fur trader at the Parc Aux Vaches around the time of the War of 1812. He later founded Bertrand, Michigan near the Parc Aux Vaches. His wife Madeline was the daughter of the great Potawatomi chief, Topinebe. (Courtesy St. Joseph County Public Library.)*

The garrison and settlers had barely reached the sand hills when the Potawatomi escort of nearly 500 warriors attacked. The terrible massacre is graphically detailed in *Wau Bun: The Early Days in the Northwest*, by Mrs. John A. Kinzie, daughter-in-law of the trader.

Wounded, Mrs. Heald was saved by Jean B. Chandonai, then a clerk for Kinzie, and placed aboard the Kinzie boat. The battle was brief; about two-thirds of the garrison and settlers were killed, including 12 children. The rest surrendered after asking that their lives be spared and that they be sent to Detroit as prisoners of war. The Potawatomi agreed, but killed the wounded prisoners, believing that they were not part of the agreement.

The Kinzies were returned unharmed to their house and their friendly Potawatomi protectors remained with them. The remaining prisoners were kept in their captors' wigwams.

On August 16, Detroit surrendered to the British. The Kinzies had been kind to the neighboring Native Americans and they were well respected. Although there had been a general attack on the garrison and the settlers, many Potawatomi had gone out of their way to save whoever they could. The wife of Wau-bee-nee-

mah, chiefs Black Partridge, Topinebe, and Wan-ban-see and warriors Kee-po-tah and Winnemeg were all praised for their efforts to save the Americans. Chandonai and Billy Caldwell, whose mothers were Native Americans, but whose fathers were white, were also praised.

The Potawatomi who attacked Fort Dearborn were not necessarily pro-British. They were pro-Tecumseh and more than likely some of them had been at the Battle of Tippecanoe, while others had joined Tecumseh's forces after the battle. They were definitely anti-American. However, since Tecumseh had allied himself with the British, his followers also chose the British side.

Captain Heald and his wife were sent to St. Joseph the day after the battle. Three days later, the Kinzie family was escorted to safety at St. Joseph's where they remained under Topinebe's protection until November. Then Chandonai and Ke-po-ta delivered Mrs. Kinzie and their family to Colonel McKeen, the British agent in Detroit. John Kinzie remained at St. Joseph's in an attempt to regain some of his property, but joined his family in December and was paroled by General Proctor in January.

The remaining prisoners were scattered among various Potawatami villages in Illinois and Wisconsin, but most were ransomed at Detroit the following year.

From the beginning of their contact with the Potawatomi and other Native Americans, French traders had attempted to seal trade agreements by marrying into Native American families. This gave the trader a sense of being part of the family, and at the same time gave the family with whom he married a higher status within the village. It was expected that the trader would be honest with his relatives and with those within their village.

Children of these mixed families became an important commodity as well. In many cases, they would be sent back to Canada for a proper education, and in due time, when the children were old enough, they would rejoin the traders as helpers or partners. After they gained experience, they would be sent out on their own to trade. In many cases, they would also repeat the pattern of finding a Native American woman to marry. Over time, these extended families would form large trading networks. A French trader, perhaps starting out in the 1730s, would be able to find relatives scattered from Quebec to St. Louis to New Orleans by the 1780s. Some of these children rose to become important Native American chiefs or advisors. Billy Caldwell and Jean B. Chandonai were among this group.

As previously mentioned, William Burnett, originally from New Jersey, set up his trading post sometime between 1779 and 1882. There are some indications that he may have traded at Detroit and Michimackinac before coming to the St. Joseph Region.

In 1782, he was married to Ka-kima (or Kaw-kee-mee), sister of Topinebe. Her Christian name was Angelique. They had seven children. Several of his sons became traders. One son, Abraham, joined Tecumseh and was present at the Battle of Tippecanoe.

Burnett was not the only trader in the St. Joseph region. There were at least 30 other traders in the region between 1807 and 1816, many of whom had married

into Ottawa, Potawatomi, Ojibwa, or other tribes. Among them were Joseph Bertrand, Joseph Bailly, E. Lamoraindie, and D. Bourassau.

Joseph Bertrand married Madeline, one of Topinebe's daughters, in 1804. He entered the St. Joseph country in 1807 as a trader for Charles Chandonai and, in 1808, settled on the west side of the St. Joseph River near the crossing of the Sac trail, just below the little creek later known as Pokagon's Branch. He erected a log cabin and a fur press.

As in the case of Topinebe, loyalties were mixed. Although Topinebe had not supported the British cause, he did not go out of his way to exclude British agents from coming into the region during the war. He was at Fort Dearborn and helped to save American lives, protected them at his village, and then took them to Detroit as prisoners of war, which was their request when they surrendered. And some of his warriors had already left the village to join Tecumseh.

With the fall of Michilimackinac, Detroit, Fort Dearborn, and Fort Wayne, all of the American military posts in this area were gone. But American traders, including Bertrand, were still active and the British fur traders were nearby. Bertrand supported the American cause and the British government offered a reward for his capture.

At some point, Jean B. Chandonai had decided to throw his lot in with the American cause and offered his services to Lewis Cass, governor of the Michigan Territory. He regularly took dispatches from the governor to various military groups, Native American villages, and traders.

But the British never gave up on their attempts to gain Potawatami support. In March 1813, Robert Dickson, the British Indian agent and trader, came to the St. Joseph area seeking assistance from Joseph Bailly, who had remained loyal to the British and had transported ammunition and other supplies to their Native American allies. He had hoped that Bailly would use his influence to persuade the Potawatomi to join the British cause. However, Bailly was at Quebec at the time.

In September 1813, the British surrendered Detroit to the Americans after the Battle of Lake Erie soundly destroyed the British fleet.

A small unit of Potawatomi loyal to the British, under the command of Charles Chandonai, was sent to the St. Joseph area to negotiate with Topinebe for permission to build a post or block house and to stop his nephew John B. Chandonai.

Charles Chandonai was no stranger to the area. He had been a trader at Michilimackinac as early as 1792 through 1803 and had a store near Burnett in 1804. He sent several traders into the St. Joseph country in 1807 and 1808.

Charles, along with 30 Native Americans, was ordered to bring his nephew to Mackinac. Jean B., who was carrying dispatches to Governor Cass, refused, drew a line in the dirt, and raised a gun warning that if his uncle approached him, Jean B. would kill him. Charles moved forward and Jean B. fired, killing him instantly. He explained his position to the Potawatami who accompanied Charles and ordered them to leave the area.[7]

*The memorial for Jean Baptiste Chandonai, hero of the War of 1812, shows the modern spelling of his name. Several dozen of Chandonai's descendants were on hand when the memorial stone was dedicated in July 2000. Also present were representatives of the Potawatomi Nation, the Veterans of Foreign Wars, and the Sons of the American Revolution (substituting for the Sons of the War of 1812).*

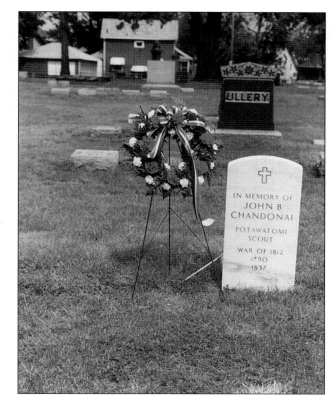

With the return of Detroit into American hands, the secretary of war decided to concentrate on western Michigan, which still remained in British control at Mackinac. On August 2, he ordered Brigadier General Duncan McArthur to raise a body of 1,000 mounted men and, with loyal Native Americans, engage those loyal to the British. McArthur's orders were as follows:

> Besides destroying the towns and crops of these hostile tribes, it is desirable to establish a post and raise one or more block-Houses at such place near the mouth of the St. Joseph's as may be best calculated for covering during the Winter the whole or part of the fleets under the Command of Commodore Sinclair.[8]

McArthur was unable to raise the amount required for the force and, on September 26, 1814, reported:

> The hostile Indians had heard of the intended expedition, that they had withdrawn from Machina (Mackinac) and its neighborhood, that 800 were collected on the St. Josephs about the 15th inst. And expected to be able to meet us with 1500 warriors at any point to which we may direct

our course by the 1st of October — that 3000 lbs. of gunpowder and lead in proportion had been distributed among those at St. Josephs, and that Dickson [the British indian agent] was daily expected with a large quantity of blankets, goods and ammunition—that the Indians at Topunabee town and all in that quarter had pulled and dried their corn; that those who had signed the Treaty were very uneasy lest they should be destroyed by the Hostile Indians or compelled to go to war with us.[9]

McArthur based his letter upon a report by John Kinzie on September 22, indicating that he expected the following:

in a few days 1500 Warriors the Indians of the Prairiees Were all called on the St Josephs to form a barrier between us and the arrival of the British Boats that were daily expected from Mackinac to bring supplies. . . . The Kickapoos Were arriving as I left St Joseph. Moran Was to leave St. Josephs in a few days with his 30 Warriors to Escort the British Expedition on to St. Joseph.[10]

On December 24, 1814, the British and Americans signed the Treaty of Ghent ending the war; however, Mackinac did not receive official news of the treaty until May 11, 1815 and the British surrendered the fort to the Americans on July 18.

Both sides agreed to recognize the borders that they had controlled before the beginning of the war. The Native Americans were allowed to keep the land they owned as late as 1811.

William Burnett ceased trading sometime during the War of 1812, but many other traders had already entered the area, including Joseph Bertrand, who was here as early as 1807 working as an agent for Charles Chandonai.

Joseph Bailly returned to the St. Joseph area after the war and operated a trading post from 1816 until 1823, when he moved further west. He had traded here for nearly 20 years before moving to his new area, thus ending nearly 90 years of family ties with the St. Joseph region. His maternal great-grandfather had been M. de Villiers, who commanded Fort St. Joseph in 1730.

# 3. AT THE BEND IN THE RIVER

On December 11, 1816, Indiana was organized as the 19th state, while Michigan remained a territory. The original boundary line separating Michigan and Indiana was a continuation of the line that had been established to separate Ohio and Michigan. However, it was soon determined that if the state line followed the previously established line between Ohio and Michigan, then Indiana would not have any shoreline along Lake Michigan. The line was extended 10 miles north to its present location.

On April 29, 1816 the U.S. Congress enacted a law providing that only American citizens could be licensed to trade within the United States. This caused great concern for the British agents still in the St. Joseph region. Some, like Joseph Bailly, applied for American citizenship so that they could continue their business.

The American Fur Company relied heavily on French Canadians to supply the manpower for their boats and continued to use them, but tried not to use them as traders. Fort Wayne had long been a major center of fur trading activity and a government factory had been established there in 1812. The American Fur Company set up operations in Fort Wayne in 1820 with Alexis Coquillard and Francis Comparet as agents. Coquillard had apparently also visited the St. Joseph Valley, but settled upon Fort Wayne as his base of operations.

In that same year, the company sent Pierre Navarre into the St. Joseph region. Navarre, who was born on February 8, 1787 in Detroit, moved to Monroe, Michigan as a young man and remained there until moving to South Bend. George Boyd, the Indian agent at Mackinac, issued Navarre's license.

Navarre and his wife Angelique settled in an area just northwest of a secondary bend in the St. Joseph River, not too far from what is now Lafayette Street. The 1875 Illustrated Map of St. Joseph County clearly shows the cabin's location. In addition to trading, he also farmed a small section of land. Archaeological evidence shows that there may have been a large Native American village on this land. It is not known if the village was still there when Navarre set up his cabin.

A small pamphlet says that he built his cabin at what is now 123 North Shore Drive, which is a little distance from where the 1875 map shows his location.[1]

In 1822, Coquillard and Comparet purchased the trading rights of the entire upper lakes region from the American Fur Company. Navarre continued to work

for Coquillard, at times trading at his small post and at times taking trade goods out into the Kankakee area as far west as Illinois. Lathrop Taylor's records show that Navarre purchased materials for several trading expeditions.

Although the British had made peace with the Americans, several of the Potawatomi groups in Indiana and Michigan were reluctant to agree to the terms. They knew that it would only be a matter of time before the Americans wanted more land. They were right.

Several treaties were made between various Native American tribes and the United States in the years between 1815 and 1821, but it was not until 1821 that the St. Joseph Potawatami were forced to give up some of their land.

The Treaty of Chicago signed on August 29, 1821 forced the Ottawa, Chippewa, and Potawatomi to give up:

> All the land comprehended within the following boundaries: Beginning at a point at the south bank of the river St. Joseph of Lake Michigan, near the Parc aux Vaches, due north from Rum's Village, and running thence south to a line drawn due east from the southern extreme of Lake Michigan . . .[2]

The entire description is several lines long, but essentially the Native Americans gave up a strip 10 miles wide all the way across the state of Indiana. In return, some tracts of land or reservations were set aside for some chiefs and some

*This building is Pierre Navarre's first cabin, according to his grandson George DeGraff. Probably built in 1820, Navarre must have found this small cabin very cramped if he used it for both his growing family and his trading headquarters.*

mixed bloods, the Ottawas were to receive $1,000 annually forever, and the Potawatomi would receive $5,000 annually for 20 years, in addition to a blacksmith, a teacher, and an agriculturist.

These last three items were important for the St. Joseph Potawatomi, for they brought in Reverend Isaac McCoy, who established Carey Mission near what is now Niles, Michigan. McCoy, who had previously set up missionary schools in southern Indiana and Fort Wayne, transferred his school from Fort Wayne to Carey Mission in December 1822. McCoy had originally intended to establish a mission that would be far enough away from the white man that the Native Americans could live in peace. However, he soon discovered that the St. Joseph Valley was on its way to development and he began searching for another location.

Carey Mission was the destination of Major Stephen H. Long when he entered the St. Joseph Valley in May 1823. Long had organized an expedition to find the source of St. Peter's River in the west. After several weeks of travel, he reached Fort Wayne, left after several days' rest, followed part of the Chicago to Fort Wayne road, then traveled alongside the Elkhart and St. Joseph Rivers on his way to Carey Mission. Of his expedition, Long wrote that he:

> Passed several small creeks, and the remains of several Indian and one French village. The former are known by the names of the Strawberry and Rum villages, and the latter by that of the St. Joseph's. Passed a trading establishment belonging to a Frenchman whose name is Rousseau. He and another frenchman, probably his partner, had squaws for wives. At this place we obtained some milk, which proved a very savory bivorage. Passed Bertrand's, a French trader who resides on the north of the St. Joseph's.[3]

William Keating, who accompanied Long, was more expressive in *Narrative of an Expedition to the Source of St. Peter's River*:

> It was curious to trace the difference in the remains of the habitations of the red and white man in the midst of this distant solitude. While the untenanted cabin of the Indian presented in its neighbourhood but the remains of an old cornfield overgrown with weeds, the rude hut of the Frenchman was surrounded with vines, and with the remains of his former gardening exertions. The asparagus, the pea-vine, and the woodbine, still grow about it, as though in defiance of the revolutions which have dispersed those who planted them here.

Neither Long nor Keating mention having encountered any active Native American villages between the time that they left Metea's village near Fort Wayne and the time when they arrived at Carey Mission. The reason for this absence is not known. Perhaps the explorers just missed the villages. However, Rum Village was known to be an active village, unless it had been temporarily deserted while

the Potawatomi were out hunting. The fact that Long mentions Rum Village is interesting. He would have gone a long way out of his travels to encounter this village, if it is the same village that was in what is now Rum Village Park.

Alexis Coquillard briefly visited the South Bend area in 1823 before returning to Fort Wayne. On August 11, 1824, Coquillard married Frances Comparet in Fort Wayne. Frances was Francis Comparet's sister. Shortly after their marriage, Alexis and Frances moved to South Bend, while Comparet continued to run his share of the partnership from Fort Wayne.

Coquillard set his first trading post up on the Dragoon Trail near where it crosses the old Native American trail leading down to the river. Today, the land has changed and the spot can best be described as near the front gate of the Century Center parking lot. There was a Potawatomi village at this same place. Later, after the Potawatomi left and the trail was graded to made Lincoln Way East, many human bones were found, indicating that there had been a cemetery near the village.

Either the original spot did not suit Coquillard or he found the post too small. In a short time, he built a larger post near what is now the corner of North Michigan and LaSalle Streets, near the St. Joseph River. The east side of the river is a relatively flat bluff, but the west side had a deep gulch that easily filled with water that backed up from the river. When the first street was placed here, it was called Water Street (now it is LaSalle Street).

At that time, the Native American trail, soon to be called Washington Street, dropped off sharply from the bluff above the river. This bluff and drop in the street were present as late as the 1960s before Century Center was constructed.

Archaeological evidence indicates that there were many Native American villages in St. Joseph County over many centuries. At least three villages are known to have existed in South Bend at the time when Pierre Navarre and Coquillard established their trading posts.

As was previously mentioned, one village was in downtown South Bend near the foot of Washington Street, not far from the river; another was in Rum Village; and a third was in the area now known as Harter Heights, not too far from Notre Dame. There was also a small Native American cemetery in Harter Heights and another behind what is now St. Joseph High School. In addition, many small villages were scattered throughout St. Joseph County. One was under the leadership of a man named Raccoon. Unfortunately, the names of the other chiefs or their villages are not recorded, except for Mash-ke and Pah-te-co-tee.

On October 16, 1826, the Potawatomi met with several Native American commissioners and were forced to give up land in south central Indiana and:

> beginning at a point upon Lake Michigan, ten miles due north of the southern extreme thereof. . . . In addition a strip of land, commencing at Lake Michigan, and running thence to the Wabash River, one hundred feet wide, for a road and also one section of good land contiguous to the said road, for each mile of the same . . . for the purpose of making a road . . . to some convenient point on the Ohio River.[4]

What the Potawatomi did not realize was that they were giving the white man the Michigan Road, a road that would bring in thousands of settlers from Ohio, Kentucky, and Virginia in a northward push that would force many Native Americans out of their homelands within ten years. The treaty gave land tracts to several chiefs and mixed bloods. In addition, it gave one quarter-section of land to each of the students currently living at Carey Mission. By the time the treaty had been negotiated, McCoy had already begun plans to remove his mission and the Potawatomi to Kansas.

With the 1821 and the 1826 land purchases, it became necessary to firmly establish the exact northern boundary of Indiana. On November 24, 1827, Edward Tiffin reported to Congress on the results of a survey taken by E.P. Kendrick. His survey shows seven scattered houses (four on the west side and three on the east side of the St. Joseph River) near what is now South Bend.[5]

One of these houses belonged to Coquillard and another to Navarre. One house belonged to Lathrop Taylor, who had been sent to the area by Samuel Hannah and Company of Fort Wayne. Taylor had been a clerk in the Fort Wayne store for several years and his sister had married Samuel Hannah. Hannah had a large investment in his Fort Wayne store, but wanted to reach Native Americans who no longer came to the area because other traders were closer.

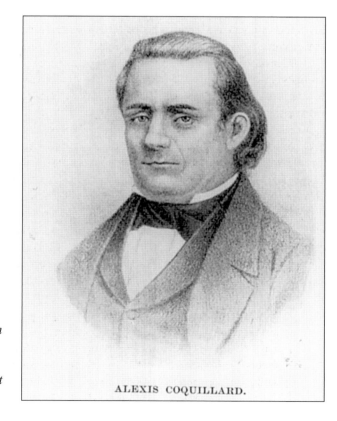

*Alexis Coquillard was the second settler in South Bend and co-founder of the town with Lathrop Taylor. Coquillard was well respected by the Potawatomi, even though he moved many of them away from their homes in St. Joseph County. Some contemporary residents said that he had a short temper.*

ALEXIS COQUILLARD.

*Lathrop Taylor was an early founder of South Bend. Taylor retired from active business around 1855 and lived a quiet life until 1892, when he died. Most contemporary residents said that he was somewhat shy and unassuming. Few history books provide much information on him and nothing on his highly public divorce from his wife, the daughter of Peter Johnson.*

The Hannah store was on or near the St. Joseph River in Fort Wayne. In order to keep their records straight, they named the store near the St. Joseph River in Fort Wayne the "Little St. Joseph's Station" and the one near what is now South Bend the "Big St. Joseph's Station."

Taylor left Fort Wayne on September 23, 1827 and arrived in what is now South Bend on September 25. According to his son Thaddeus, there were 4,000 Native Americans camped here on the night that he arrived. He originally established his store on the corner of what is now Michigan and Marion Streets, near Coquillard's trading post, but soon realized that he was not on the direct line of the Vistula Road and moved his building to the corner of what was St. Joseph Street and Lincoln Way East. (These streets were redesigned when Century Center was built.) In December 1828, he made a contract with Job Brookfield to build two houses adjoining the one that had been moved.

The clippings files in the Local History Room of the St. Joseph County Public Library contain a copy of the contract, which states that the rooms were to be:

> 16 feet square, the height the same as the one now built, one room to have a good sufficient puncheon floor, one door, one window and good sufficient chimney the other room to join the now build with joice in like manner and with one door; both rooms to be covered with good

clap-boards. Chinked and plastered on the outside with good clay; to be finished in the course of the winter. All to be done in a workman like manner.

By the fall of 1828, surveys had been done to determine the location of the Michigan Road through this area. The original intention was to have the road go north from Logansport to Michigan City. However, the great Kankakee Swamp prevented a direct route and a survey was made from Michigan City to South Bend and then from South Bend to Logansport.

By 1828, the community had become known as Southold and the area was attached administratively to Allen County. On September 20, 1828, the Potawatomi met at Carey Mission to make their third sale of land to the Americans. The first two treaties had included the land that is now the northern half of St. Joseph County. The 1828 treaty included land "beginning at the mouth of the St. Joseph, of Lake Michigan, and thence running up the said river to a point on the same river, half way between La-vache-qui-pisse and Macousin village. . . ." It ceded the southeast part of St. Joseph County. The first Potawatomi to sign this treaty was To-pen-e-bee, son of the chief who had died in 1826. The third signature on the treaty was Po-ka-gon.[6]

No sooner had the ink dried on the treaty than boundary surveys were made, setting up Congressional ranges and townships. As previously mentioned, William Brookfield was surveying northern St. Joseph County by early 1829. With the county firmly surveyed, settlers began pouring into the valley.

In 1829, the community applied for a post office and, on June 6, Taylor was appointed postmaster of Southold, Allen County, Indiana. A copy of the appointment is in the clippings files at the St. Joseph County Public Library. According to its terms: "This Post-Office is to be supplied by means of a private route . . . but the different accounts are to be kept . . . as if it were a public route. You will please state the difference from your office to the nearest Post-Offices on the route to this place and their names."

Benjamin Coquillard and his family arrived in early 1829, along with Jean Beaudway and several other settlers. In the January 25, 1897 *South Bend Daily Tribune*, Uriah Chandler, who was a lad of 14 years in 1829, recalled the following:

> in the grey dawn of a fall morning in 1829 I started out to follow the Indian trail (from Michigan City) to South Bend. In due time I came to the brow of a hill and looking down into the valley I saw an Indian village of no mean size. The Indians had tethered their ponies all along from South Bend out east of Mishawaka.

Chandler had come during the fall when the traders and Native Americans were bringing in their furs and gathering new supplies for the winter.

St. Joseph County was established in January 1830. The exact number of people living in South Bend in 1830 is not known. The 1830 federal census, taken on

March 23, covers not only all of St. Joseph County, but the lands attached to it, including what would be organized as La Porte County in 1831. The total figure of all people listed on the census is 287. However, no Native Americans or anyone of mixed blood were included.

New settlers were arriving daily. Most were coming from New York, Pennsylvania, and Ohio. Some came by way of the Erie Canal, some took ships from New York to Detroit, then the Chicago Road down to the Edwardsburg Road and into South Bend. Some were coming by way of Fort Wayne and then down the Dragoon Trail.

On October 18, 1830, Taylor was informed by the post office that the name of the settlement had been changed from Southold to South Bend. On August 1, 1831 the first elections were held in St. Joseph County. The elected commissioners were Aaron Stanton, David Miller, and Joseph Rohrer. Benjamin Potter and Thomas Skiles were elected the first constables.

After electing the county's officials, it was necessary to determine the county seat. William Brookfield, who had earlier surveyed part of the county, was assigned the task of selecting the location for the new county seat. As early as May 23, 1829, Brookfield had written to John Tipton, the Indian agent, that he proposed purchasing the land at the old portage and creating a town at that point. It was part of the Indian reserve held by Joseph Bertrand Jr. He intended to call the town St. Joseph. His entry is the first in the county recorder's book. Naturally, he selected St. Joseph as the county seat.

Recognizing the area's historic use as a portage between the St. Joseph and Kankakee Rivers, the closeness of the Sauk Trail and other nearby trails, and the fact that the Michigan Road was slowly being constructed toward this area, he may have made a logical choice. However, he also knew that the Michigan Road surveys had approved the road to come through South Bend and then turn toward Lake Michigan, and that South Bend was already a thriving community.

Coquilllard and Taylor gathered enough signatures to protest the choice of location and asked for a new set of commissioners to relocate the county seat. They also provided a total of $3,000 to various politicians. The Indiana legislature convened on December 6, 1830 and granted the petition on February 1, 1831. South Bend was chosen as the county seat.

After an earlier attempt to purchase the land near the portage had failed because of legal problems with the deed, Brookfield was finally able to complete the deal on December 6, 1830. In early March 1831, Coquillard and Taylor hired Brookfield to lay out the streets for the proposed town of South Bend and, on March 28, Coquillard and Taylor filed a plat for the town site of South Bend. With so many roads leading into the community and the river at its doorstep, the site proved very appealing to newly arriving settlers and this appeal may have doomed Brookfield's dreams.

Together, Taylor and Coquillard owned all of the original town plat. Possibly for the sake of convenience, they drew a line east and west between Washington and

*Coquillard, Navarre, and Taylor all traded beads like these with the Potawatomi. Wood, bone, and glass beads were heavily used on Native American clothing worn by both men and women. Items such as this were traded or purchased on credit by Native Americans and the traders were paid at the annual annuity meetings or at treaty conferences.*

Market (now Colfax) Street. Coquillard took claim of all land north of the line and Taylor kept claim to all land south of the line.

Brookfield was paid for his work on March 24, 1831. His plans for the portage never materialized and he moved to Texas with his wife and children, where they joined Stephen Austin's colony in June 1831. Brookfield served during the Texas fight for independence in 1836.

With Brookfield's failed attempt to establish a community at the portage, it faded into disuse and soon became part of a farmer's field. Now it is only a quaint oddity in Riverview Cemetery.

Nearly 100 years later, several artists sketched their ideas of what South Bend looked like in 1831. They show only the white man's houses, ignoring the Native American villages. A census of South Bend taken in 1831 lists 166 white people, including 86 children. They are divided into 24 families living in 22 houses and 2 tents. Many of the buildings were log cabins.

Peter Johnson, Taylor's father-in-law, was a busy man in 1831. He constructed the American Hotel on the southwest corner of Washington and Michigan Streets and later built a sawmill. Johnson also constructed a boat for use on the St. Joseph River, running it between South Bend and Lake Michigan. This was not a true keel boat. It was 40 feet long and 6 feet wide, with running boards along the sides

12 inches wide with cleats nailed on crosswise. The running boards projected outside of the gunwale and were supported by brackets, allowing the full interior for cargo. The boat's captain was Madore Cratee. This ship, the *Fairchplay*, was constructed on Washington Street and moved on trucks down to the river where it was transferred to a wooden gangway. Johnson and his crew were having difficulty coordinating their efforts when:

> There stepped upon a log at the side of the boat a clerical looking gentleman, wearing a long black coat and a high plug hat, who had just joined the launching party. He took off his hat and made a decidedly striking picture with the long black hair flying in the breeze as he shouted the necessary "heave ho, hee o-o-o—he-e-e! Heave ho, hee-o-o-he-ee!" His voice rang out in tremendous tones and echoed up and down and across the stream, and it did the business of causing the men who had their shoulders to the boat to make a strong push and a push all together and soon the first commercial craft to ride the waters of the old St. Joe splashed into the waves and sailed out into the middle of the stream. A big cheer was sent up by the crowd in which the mysterious stranger joined. Then he deliberately put on his hat and strode away without making himself known.

The crowd later discovered that he was Reverend Abner Morse, who had just arrived in South Bend to establish a college and church.[7]

*Early pioneers would have lived in simple tents like these while they built log cabins. Most log cabins could be constructed within just a few days with the help of neighbors.*

Johnson constructed true keel boats beginning in 1832 and had a series of them running between South Bend and St. Joseph, Michigan within a few years. Between 1832 and 1851 (the coming of the railroad), 21 keel boats and 23 steamers regularly carried freight and passengers on the St. Joseph River. After the dam lock at South Bend was closed, four pleasure steamboats sailed between South Bend and Mishawaka.

Horatio Chapin arrived in May and opened up the first merchandise store that was not a trading post. He also set up a warehouse just south of what is now the LaSalle Avenue bridge on the west side of the river. In the summer, Dr. Jacob Hardman settled here. Elisha Edgert arrived and became the first practicing lawyer.

John D. Defrees and his brother Joseph arrived in the fall to publish the first weekly newspaper north of the Wabash River and west of Detroit. It was called the *Northwestern Pioneer and St. Joseph's Intelligencer*. The first issue was printed on November 16, 1831.

The first session of the County Commissioners approved the construction of a ferry to be located at the east end of Water Street with Nehemiah B. Griffith as the operator. Peter Johnson, Benjamin Coquillard, and Calvin Lilly were all approved to establish taverns. An anonymous old-timer, who signed himself as Zeno, recalled in the January 10, 1885 *South Bend Evening Register*:

> In 1832 South Bend was a village containing a few log cabins and one frame house, known as Johnson's tavern. On all parts of the town plat were scattered oak trees and the intervals between were taken up with "stool-grubs" of oak and hickory. West and north of Lafayette and Washington Streets a few acres enclosed by rail fence. These acres had been plowed and sowed with oats the preceding spring, but not harvested. I remember the oats attained about a foot in height and had about three grains to the stalk. The soil was too cold and wet for any crop. Northwest of this field were several acres where frogs and toads had possession. These with whip-poor-wills and distant hooting owls made the only music hard in the night.

By 1828, the Americans had pushed far beyond South Bend, far beyond the Indiana borders to the western borders of Illinois, where they were pushing against the Sac and Fox homelands. Treaties had been made as early as 1804 with the Sac and Fox, requiring them to give up land. Some bands were still living the traditional way, temporarily deserting their villages for their annual hunts and then returning in the spring to plant their crops. For several years, there had been a series of misunderstandings on the parts of the Native Americans and the whites concerning several villages. Many whites saw the deserted villages and thought that the band was permanently gone. They plowed up the fields and set fires to the homes. One Native American returned to find his village taken over by white men. White men were even living in his house. This chief, whose name was Black Hawk, was upset.

By April 1832, Black Hawk was through with the white man's abuses and attempted to lead part of his tribe back to its own homelands. His attempts to return home led to opposition by military authorities and resulted in what was known as the Black Hawk War.

On the frontier at South Bend, the message spread like wildfire that a major Native American uprising was underway. Black Hawk was leading 1,000 warriors through Illinois into Indiana, destroying all the white villages in his path. Three forts were built in St. Joseph County; one of them was in what is now the area occupied by Century Center. Today we know the truth, but in 1832, the white citizens of South Bend were living in fear.

Imagine a warm April night. There is little noise; there is no wind. All you know is that Black Hawk is coming. To the southeast only 20 years ago, the Miami had seized Fort Wayne. There had been the terrible River Raisin Massacre near Detroit to the northeast. To the west lay Prophetstown where 20 years ago the Prophet and Tecumseh had gathered thousands of warriors to fight the invading whites. Fort Dearborn is only 90 miles away. And all around you are Potawatomi villages and thick forests. Mary Stull Studebaker reminisced about the times in the *South Bend Weekly Tribune* on March 5, 1898:

> My mother told me she lived in constant fear of the Indians, thinking they might at any time come in upon her and her unprotected children. My father was obliged to be away working on the fort. She said one day, during the scare, she heard a great commotion, bells ringing and men calling. She ran out to see what was the matter and there astride of a bell cow was an old woman with several men whipping on the cow, calling as they went, that the Indians were close behind, killing everyone as they came. They were settlers who lived on Palmer's prairie. They had heard the war cry and for want of a quicker and better method they were coming in that way to town for safety. My mother with the rest took her children, and started for the safe place. After going part way she came up with two other families with a great number of children, the women having their feather beds on their backs, all going to ask for protection. My mother said she was sure there would not be room for all, so she took her children and returned home, remaining there in fear and trembling until my father returned and said the Indians had been stopped and then peace and quiet once more reigned.

The Black Hawk War lasted only a few short months, but its memory still drew fears. Andrew Jackson and his administration passed the Indian Removal Act of 1830, requiring all Native Americans to move west of the Mississippi to designated Native American lands. By early 1832, the Chickasaws, Creeks, and Cherokees had been removed from their southeastern homelands. Black Hawk's actions had only made things worse in an already painful situation.

In early 1832, the American government ordered its agents to negotiate treaties with the Potawatomi, Miami, and other tribes for their removal from Indiana and Michigan. On October 26, 1832 the Potawatomi met with American representatives at the Tippecanoe River and signed a treaty that sold all of their Indiana land from the Illinois border to the borders of the lands previously given up in the treaties of 1821, 1826, and 1828. Small sections of land were held back for reservations.

A separate treaty on October 27 dealt with the Potawatomi lands in Michigan. Here too the Potawatomi gave up land, but did manage to hold on to some for reservations. However, tribal annuities did increase by $50,000 and they received $168,000 in trade goods.

The Native Americans at Rum Village knew that their time had passed. They had buried their stones and supplies in the ground in late 1831 and never returned.

The great St. Joseph Valley fur trade days were rapidly closing. They had existed only as long as the Native Americans were willing to do most of the trapping for the white man in exchange for materials that they could use, and it could only exist as long as the Native Americans had territory in which to trap. Now they had no furs for trade and no land.

On November 10, 1832, Father Stephen T. Badin purchased several pieces of land from the Michigan Road commissioner. These lands included a lake. Having served the Potawatomi villages in this area for several years, and having previously

*Although the Potawatomi and Miami lived in peace with South Bend's settlers, pioneers never forgot to keep up their vigilance. A poor marksman was a poor defender of his family and a poor provider of food. The fear of Black Hawk reminded pioneers how important it was to have a good militia.*

*Early blacksmiths would have made these handy items for local residents. The Treaty of Chicago provided that a blacksmith would be put at Topinebe's village to repair broken hoes and other necessary items needed by Native Americans.*

established a small mission at Pokagon's village, he now decided to establish a mission at the lake. He would call it St. Mary's of the Lake.

On December 29, 1832, Badin notified John Tipton that he had applied to the Indiana State Legislature to incorporate an orphan asylum "for the children of any denomination or description and to endow the same with lands of the quality of 300 acres."[8] On February 2, 1833, the legislature approved his request. Just exactly who the "orphans" were is not clear. The Potawatomi would not have allowed their children to become orphans. If something happened to a child's parents, a relative or the clan chief or the village chief would adopt them. The white families were short on help and any child who was unfortunate enough to be orphaned would probably have found a new home within a very short period of time. Badin labored at the mission for several years before becoming involved in other matters and he was replaced by several successors.

The Black Hawk War had scared not only the American settlements, but also the Native Americans who were at peace. Many villages were forced to move and, as a result, no crops had been planted. By early 1833, a large number of Potawatomi from Illinois as well as Indiana had gathered at the Logansport home of William Marshall, the Indian agent, asking for permission to remove to Kansas.

The Kansas removal was not a new idea. As early as 1826, Reverend Isaac McCoy had suggested moving Native Americans beyond the influence of the

white man. In 1828, he had made a preliminary investigation of the Kansas area with Nagawatuk, Shawanikuk, and Jean B. Chandonai, all representing the St. Joseph Potawatomi.

The Native Americans at Logansport waited anxiously to begin their migration. The War Department ordered Abel C. Pepper to head the migration. However, a series of unforeseen circumstances caused nearly a two-month delay in the departure. By that time, many of the Native Americans had returned to their own villages, disgusted with the delays. Of the many hundreds who had originally asked for the removal, only 67 finally completed the trip.

In September 1833, many of the Native Americans who had left Logansport went to Chicago to attend the treaty negotiations then underway. When the negotiations ended, more land was lost and most of the Potawatomi leaders agreed to take their villages to the west. After the treaty, Pepper attempted to purchase small reservations from the Native American chiefs who had been lucky enough to have received them in previous treaties. Pepper purchased these for the government, which would then sell the land to the white community. In return, the chiefs promised to move their villages west as well. Many of the chiefs and their tribesmen had accumulated large amounts of debt that they hoped could be settled with their annual annuity payments and the sale of their lands.

Alexis Coquillard was one of nearly 300 traders who attended the September 1836 annuity payment, waiting for the money that was due to them for the goods that they had sold to the Potawatomi since the previous payments.

In 1837, Pepper made another effort to remove the Potawatomi from Indiana and Michigan. He was partially successful. Lewis Sands, who had assisted Pepper in the earlier migration, was in charge of this migration. Hundreds of Native Americans left Indiana and Michigan. Lead by Topinebe, the son of the chief who had died in 1826, 168 of the St. Joseph Potawatomi left their St. Joseph River homes for Kansas. A provision in the 1833 treaty had allowed Pokagon's band to stay because they had become "civilized" Christians.

While the Potawatomi lands were melting away before their eyes, South Bend was growing beyond early expectations. The January 9, 1916 *South Bend News Times* reported the following:

> In the early days the business section of the city was between Market (Colfax) avenue and what is now Lasalle avenue, perhaps on account of being near the wharf which was at the foot of LaSalle avenue. All merchandise in those days came from Chicago by boat and the foot of LaSalle avenue was the station for freight and passengers.

Between 1831 and 1836, the Union Hall, Lilly's Tavern, and the Michigan Hotel were all built as taverns or hotels to aid new settlers. Only one building was brick. A frame building about 60 feet wide and 80 feet long was constructed near what is now Western Avenue and Taylor Street. The owners, John T. McClelland, John Brownfield, and Johnson Horrell, had planned to use it for a glass factory.

Although the sand had proved of high enough quality for glass making, the clay used as part of the process was not suitable and the project was abandoned.

In 1833, the *Matilda Barney*, a flat-bottomed stern-wheel steamboat, made its first trip from St. Joseph, Michigan to South Bend and for the next few decades, steamboats commanded cargo transportation on the St. Joseph River. S.C. Russ built the "Eagle House" hotel in 1834. It was later used as a school, then turned into a private residence. South Bend was first incorporated in 1835 and its first election was on October 3. The elected trustees were William P. Howe, Horatio Chapin, Peter Johnson, John Massey, and James A. Mann. Chapin was chosen president of the board.

In 1835, Garrett V. Denniston, Joseph Fellows, and a group of New York investors, including Martin Van Buren, purchased the hydraulic rights to the east side of the St. Joseph River from Coquillard. In 1836, they obtained a charter to build a dam across the river. A race had been started and lumber for a mill had been placed at the foot of the race. Unfortunately, the Panic of 1837 wiped out their investment.

The following existed, according to the *National Union* from August 14, 1869:

> In May 1836, a census of the village was taken, showing about 50 two story houses, 125 one-story houses, stores and shops, and 800 inhabitants. A year later, a correspondent enumerated "about 1,200 inhabitants, 13 stores and groceries, 3 apothacary shops, 3 physicians, 3 attorneys, and a printing office." We might add that there were 3 taverns, 4 tanneries, 2 cabinet shops, 2 shoe shops, 3 tippling houses, and several blacksmith shops.

William Millikan established the *South Bend Free Press* in 1836, only a few years after the *Northwestern Pioneer* and *St. Joseph's Intelligencer* failed. By 1837, according to the *National Union*:

> Christian Emerick had an establishment where beer and cakes were vended to the famishing, and a liquor store was in blast under the direction of one Wolf, where old sledge and poker were the common amusements.
>
> A bottle of corn juice sat upon the counters of some of the stores, of which all thirsty customers partook at their pleasure.
>
> B.F. Price had his cabinet shop on the bank of the river, and W.L. Barrett, a most worthy and estimable citizen was the jeweler of the town. Beyond these, there was not much done in the way of manufacturers. A saw mill belonging to old father (Samuel) Studebaker stood at the mouth of a small stream just above town, and supplied most of the lumber to the citizens, while for flour resort was had either to McCartney's mill below town.
>
> The physicians were Dr. S.B. Finley, Drs. W.R. Ellis and Son, who were doing the principal business.

*Pioneers had crops to plant, families to feed, and houses to build, but they still had time for games. A cold tumbler of creek water was just the thing to drink after a hard day of plowing the fields.*

William Brookfield's failed attempt to develop St. Joseph at the old portage did not end the dream of uniting the St. Joseph River and the Kankakee River to provide transportation from the Great Lakes to the Mississippi. In 1836 and 1837, Alexis Coquillard made several attempts to develop a canal between the two rivers. The Kankakee and St. Joseph Valleys divide near what was then known as Kankakee Pond (later renamed La Salle Lake). The elevation is much higher here than at the level of the St. Joseph River. Coquillard believed that he could use the fall for water power.

Starting near his mill on the St. Joseph River, near South Bend, Coquillard had workmen dig a canal to the Kankakee. The canal ran southwest through the north lot of the Turner Hall grounds on North Michigan Street, then west along what is now Navarre Street, turning southwest through the city cemetery to Washington Avenue at Birdsell Street, then through what was low ground and continuing west. A portion of the original canal can still be found in City Cemetery. The soil was loose and sandy, with a large portion of muck. Unfortunately, the engineer had miscalculated and the water flowed west instead of east in his race. A coffer dam of timber and lumber was built to form a bulkhead that would turn the water in the right direction. After much heart-breaking work, Coquillard realized that it was a disaster.

In addition to his financial loss on the canal, the Panic of 1837 drove Coquillard into bankruptcy. He had already borrowed large sums of money from banks, pledging his property as collateral on the loans. The banks took possession.

In the summer of 1838, John N. Harper, his brother Abraham R., and Jonathan H. Smith erected a large building. They used one half of the building for their dry goods store, while the other half was a drugstore operated by George Rex.

> The lumber for this building was rafted down the Elkhart and St. Jo rivers from Decamps' Mills, and the foundation was constructed on large, heavy timbers, enough being used to build two or three common houses, our mechanics not then being aware that our stone here could be used for building purposes. Subsequently, however, the old timbers having rotted away, a stone foundation was put in the upper part of the building and used by John Harper for a residence, and was thus occupied for nearly fifteen years.

A lot had happened during that first decade. John Brownfield had become the leading dry goods merchant, Horatio Chapin entered the banking industry, and the *Northwestern Pioneer* and *St. Joseph's Intelligencer* and its successors had folded. With Father Badin's interests shifted elsewhere and the death of his successors, the orphanage and mission of St. Mary's of the Lake itself became an orphan.

Lathrop Taylor had traded with the Native Americans, but the largest percentage of trade was now coming from the increasing number of settlers.

*Pierre Navarre's second cabin is shown here on its original site before being moved to Leeper Park. The date of its construction is not known. At least one photograph identifies this as the Leeper Cabin, probably because it was on Samuel Leeper's property, near his home.*

Alexis Coquillard had become wealthy trading with the Native Americans, but he had lost almost everything.

In 1838, Abel C. Pepper led his last group of Potawatomi from Indiana. The preceding weeks had been a terrible time for both the Potawatomi and Pepper. By the time the Potawatomi were ready to move, typhoid had struck their camps. But Pepper forced the Potawatomi to move anyway. The long agonizing removal resulted in the deaths of 42 Native Americans as well as of Father Benjamin Pettit from the Mission at St. Mary's of the Lake. The harsh treatment of the Potawatomi during this migration earned a name that is still used today: the Trail of Death.

Typhoid struck not only the Potawatomi camps, but South Bend as well. "By fall every man, woman and child in S. Bend had the fever and ague," reported one observer who had come after the epidemic subsided.[9] After the disaster of the 1838 removal, Pepper resigned his position of superintendent of emigration.

In February 1840, Brigadier General Hugh Brady was appointed superintendent of removal. His method for removing the Native Americans was simple. He cut off their allotments, forcing them to either starve or agree to removal. Alexis Coquillard was enlisted as a removal agent and given the contract for provisions. The removal camp was located in South Bend, where Coquillard and Brady spent most of the summer assembling the large group. Coquillard and Brady left South Bend on August 17, 1840 and arrived at the Osage River Subagency on October 6.

Except for a few scattered people, there were no more Native Americans in St. Joseph County. Pierre Navarre joined the Potawatomi in their migration, but later returned to live with his daughter Frances, who married John DeGraff. Pokagon's village was just over the state line, not too far from the town of Bertrand, which had been started by Joseph Bertrand. At times, Pokagon did come to South Bend to visit old friends.

While Coquillard was making preparations for escorting the last Native Americans from St. Joseph County, Reynolds Dunn was busy preparing for the new federal census. When he was finished, his census showed 6,425 settlers living in St. Joseph County. In South Bend, there were 727 people. Among the new settlers was Peter Coleman, acknowledged as the first African-American horse doctor, having come in 1838 or 1839. Shortly after his arrival, he married Mariah White.

The rising population encouraged new enterprises. In 1841, the Society of Master Carpenters and Joiners of South Bend issued their 44-page detailed *Book of Prices*, indicating their charges for framing, rafters, shingling, flooring, and much more. Fifteen members signed the articles for the company, indicating the large number of carpenters keeping busy in South Bend. They were William Cosgrove, John Knapp, Jacob D. Smith, William D. Wilson, B.G. Cosgrove, G.B. Hagle, William Riggin, Charles Morgan, Ralph Staples, James F. McGogy, John N. Cosgrove, Joshua Ketchman, Edward Kennedey, William G. Norris, and Jeremiah Perkins.[10]

Alexis Coquillard was recovering from his bankruptcy, thanks partly to Garrett Denniston and a group of New York investors who had purchased property and water rights from him in 1835, but lost it in the Panic of 1837. Coquillard sued in court for return of the property, located on the east side of the river and, in 1842, he began to continue the east race project.

In late 1842, Father Edward Sorin arrived in South Bend with seven brothers. Having acquired the property of Father Badin's old mission, Sorin slowly began work on his dream of establishing a university, which he called Notre Dame du Lac.

Lathrop Taylor, Abraham R. Harper, and William H. Patteson incorporated the South Bend Manufacturing Company in December 1842 and were authorized to complete the dam project started by Denniston in 1835. The dam was finished in 1844, with mill races on both sides of the river. The East Race was nearly 2,000 feet long, while the West Race was nearly 1,000 feet. A lock was put in on the west side of the river at the foot of Washington Street and opened into the West Race. It was shallow and the gates had been faultily constructed. Heavy boats were dragged through it and, in 1894, it was filled.

Christopher N. Emerick laid out the town of Lowell in 1846, covering the area from Washington Street north to Cedar Street and the St. Joseph River east to just east of Hill Street. It covered the newly constructed east raceway and reserved a large section for manufacturing.

South Bend again incorporated in 1845 and elected officers on March 3. John Brownfield was the president, Charles M. Heaton was elected clerk, Schuyler Colfax was assessor, Albert Monson was treasurer, and William Snavely was marshal.

On September 12, 1845, George Matthew's son-in-law, now an ambitious 22-year-old after arriving in town with his stepfather four years before, purchased the *South Bend Free Press* and renamed it the *St. Joseph Valley Register*, vowing that it would be Whig in political tone. The *Register* soon became the most influential newspaper in northern Indiana and its editor/owner Schuyler Colfax was elected to the United States Congress in 1855, where he would be a prominent political figure for the next 30 years.

Colfax's primary interest was always in improved harbors, communications, and transportation. His first issue, published on September 12, 1845, discussed the advantages of railroads.

Railroads were not a new issue to St. Joseph County residents. As early as 1832, John D. Defrees had encouraged the building of a railroad to the county and, as early as 1835, the Indiana state legislature had passed legislation for incorporation of the state's portion of a railroad that would run from Buffalo, New York to the Mississippi River. Under an act from the legislature, the Buffalo and Mississippi Railroad was organized to build a portion of the track from the eastern boundary of Indiana, which would run through South Bend and Michigan City. However, the Panic of 1837 made potential investors cautious and the project was temporarily abandoned.

On September 1, 1847, Colfax was appointed secretary of the Buffalo and Mississippi Rail Road Convention, which was held in Mishawaka. The purpose of the convention was to instill new life into the stalled railroad enterprise. Under the new direction of Andrew C. Litchfield, the railroad concentrated on a line that would run from the state's eastern border to Chicago. It would go through Elkhart, Mishawaka, South Bend, and La Porte. The company was named the Northern Indiana Railroad. A year earlier, Litchfield had gained control of the Michigan Southern Railroad, which had been formed to construct a railroad from Monroe, Michigan to New Buffalo, Michigan. As Litchfield became more involved with the Michigan Southern Railroad, Thomas Stanfield came forward to spearhead the Northern Indiana Railroad project.

The Michigan Southern Railroad had begun roadwork from Toledo, Ohio to Hillsdale, Michigan. The Northern Indiana Railroad would link with the Michigan Southern to form one line from Toledo to Chicago, giving advantages to both railroads.

At the same time, two competing companies, the Magnetic Telegraph Company and the Atlantic, Lake, and Mississippi Telegraph System were waging an all-out war to control telegraph lines from the east coast to Chicago. Both were desperately short on finances and sent representatives into South Bend and Mishawaka, promising large rewards if either city could provide funds for the telegraph's construction. The Magnetic Telegraph Company sub-contracted its

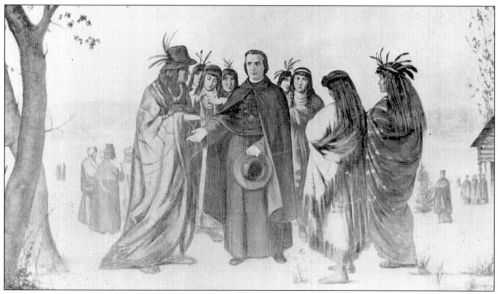

*In 1842, Father Edward Sorin found Notre Dame du Lac on the site first used by Father Badin. In its early years, the future fate of the university was uncertain. Sorin had little money, typhoid killed a number of students and priests, and several fires nearly destroyed the university.*

work to the Erie and Michigan Telegraphy Company. Their local agent was Schuyler Colfax. Colfax successfully raised the $2,000 needed and, on April 17, 1848, Miss Janette Briggs received the first telegraph message in South Bend.

Taylor sold his general store in October 1847, but continued in business as a fur trader and Indian trader through the 1850s, mostly to recover old debts.

By 1850, 1,652 people were living in South Bend, including 18 African Americans divided into 5 families: Peter Coleman, Garrett Smith, Andrew Rollins, John Claybourn, and Edward Berry. The 1850 census was the first to give an indication of ethnic groups. Altogether, the census for Portage township (including South Bend) listed 274 inhabitants of foreign stock, with several people from Scotland, Canada, and England. Only one native-born Irishman was listed. Michael Cardone, a scissors-grinder, came to South Bend from Lamolars, Italy in 1848. He may have been the first Italian to live in South Bend.

The largest group of foreign settlers to come were the Germans, who had begun arriving in St. Joseph County in the early 1840s. Many early settlers from Pennsylvania and Ohio had German names, but most were descended from Germans who had settled in those states. The census for Portage Township (including South Bend) lists 54 people who were born in Germany. Many of these were from a large group of immigrants from Augsburg, Bavaria who arrived by riverboat in 1847 and settled throughout the county.

John Koenig (King) came in 1849 with several other German settlers. In 1850, he sent for his family and, in 1852, built a brick house in the dense forest just north of town. According to the *South Bend Tribune* of June 27, 1903, "It was the first house built north of the Kankakee Race, except for Pierre Navarre's cabin and a small shanty of Mr. DeGraff near where Turner Hall now stands." After the land was cleared and streets set up, it was located at the corner of North Lafayette and West Monroe Streets.

The next five years were to be important for city expansion.

# 4. Brother Against Brother

On September 27, 1849, John Norris of Boone County, Kentucky captured his runaway slave David Powell and his family in Cass County, Michigan. Norris immediately headed south with his slaves, while Powell's neighbors organized a rescue party.

Both groups arrived in South Bend at nearly the same time around noon on a Friday. Local lawyer Edward B. Crocker was hired by friends of the Powell family to effect their release. The petition was heard by Honorable Elisah Egbert, probate judge of St. Joseph County. Armed men guarded the courthouse where emotions were tense. With the help of J.A. Liston, Norris procured a writ of habeas corpus from the State of Indiana, on the proof that the Powell family was his property. Warrants of assault and battery were filed against Norris and his men.

On Saturday, somewhere between 75 and 100 of Powell's neighbors arrived in South Bend to attend the court proceedings. Norris, seeing that he would not be able to take the family out of St. Joseph County without a fight, proceeded to file claims against Crocker and others who had defended the family, claiming that they were depriving him of his property and he wanted compensation for setting them free. David Powell and his family returned to Cass County, but Norris filed lawsuits against Edward B. Crocker, Leander B. Newton, George W. Horton, Solomon W. Palmer, David Jodon, William Willmington, Lot Day Jr., Amable La Pierre, and Wright Maudlin. Judge Huntington ruled in favor of Norris. Based upon his victory, Norris filed 12 lawsuits against 15 other defendants and intended filing suits against 25 more. But the May 1851 court session decided in favor of the defendants. Norris, not liking the results, intended to take the case to the Supreme Court, but it did not reach that level.

Indiana revised its state constitution in 1850, partly as a reaction to costly monetary losses made in investments for canals and partly as a reaction to the issue of slavery. Slavery had become an important issue as a result of new states being added to the Union. Southern slave owners, some looking for new lands for developing their cotton crops, wanted an extension of slavery to the new states, while most northern states were fighting vigorously to oppose its extension.

The desperate conditions of slavery caused many African Americans to try to escape their owners and find homes in northern states where slavery was not

*Almond Bugbee was an early South Bend abolitionist. Bugbee's other accomplishments included leading a successful rent strike. Bugbee was well respected by many citizens, but at least one person denounced him in public for his opposition to slavery.*

permitted. Caught in the middle of this controversy were the northern states that bordered slave-holding states. Clearly defined as property, slaves were required by federal law to be returned to their owners if caught.

A secret organization, the Underground Railroad, had been developed by many who opposed slavery. Its mission was to help slaves escape into the northern states, where hopefully they could remain free. The system extended to Canada, where many newly escaped slaves knew they would remain free.

The success of the Underground Railroad relied upon its secrecy. Much of the information concerning it was not made public until many years later. Many merchants were part of the organization. Peter Coleman, an African-American barber, was an important part of the railroad. Another important African American was James Washington, also a barber, who had his shop on Washington Street. When money was needed to help escaping slaves, Coleman or Washington would go out into the street and make secret signs that other members of the organization understood, and soon money would come.

George Matthews was once permitted into the back room of Washington's barber shop, where he met a group of escaped slaves who had come in during the middle of the night. Almond Bugbee, an important white merchant, was also

involved with the railroad and was once denounced in public as a traitor to his country for his support of Abolitionism.

B.F. Miller was one of the original founders of the *Philanthropist*, an anti-slavery newspaper in Brownsville, Pennsylvania. It was later moved to Cincinnati, Ohio, where Kentucky slave owners destroyed it. Miller revived it in Pennsylvania again, then moved to South Bend where he worked as an editor on the *Free Press* and the *St. Joseph Valley Register*.

Joseph Bartlett and his wife came from New England, where they had become acquainted with the famed Abolitionist William Lloyd Garrison.

Article 13 of the new 1851 Indiana Constitution forbade "Negroes and Mulattoes" from settling in Indiana, and imposed fines "not less than ten dollars nor more than five hundred dollars" for anyone who employed newly arriving African Americans, or encouraged them to remain in Indiana. Article 2 stated that "no Negro or Mulatto shall have the right of suffrage."[1] A law passed in 1852 required counties to keep a register of African Americans living in their boundaries. Very few counties obeyed the law and no registers for St. Joseph County have ever been found.

The law did not forbid African Americans who already lived in Indiana from moving elsewhere in the state. Finding their lives uncomfortable in the southern counties, several African-American families moved to South Bend. Among these families was Matthew Sawyer, a barber, and Pharoah Powell, who purchased extensive property on South Main Street. Pharoah and David Powell were not related.

At the same time, Andrew C. Litchfield and Thomas Stanfield were busy constructing their railroads, but their work had not been easy.

The Michigan Southern Railroad had a bitter rival in the Michigan Central Railroad. The Michigan Central had more influence with the Michigan state legislature and it was not until the Michigan Southern reached White Pigeon before a major setback was discovered. The charter that the Michigan Southern Railroad had received from the legislature did not allow it to construct a railroad within 2 miles of the Indiana state line.

Undaunted, Stanfield proposed that the company should furnish him enough materials to create his own independent company, the Portage Railroad. It was a very short line—only 4 miles—but it was long enough to get around the Michigan charter problem. For ten years, Stanfield leased the short line to the Michigan Southern and Northern Indiana Railway Company. In 1855, the Michigan and Indiana railroads had merged to become the Michigan Southern and Northern Indiana Railway Company.

As construction continued, speculation increased concerning how soon the railroad would reach South Bend. It was hoped that the railroad would be a great advantage for the village of Lowell, Indiana, platted in 1846 on the lands that Coquillard had recovered from Denniston. Now in the hands of Samuel Cottrell, but with Coquillard actively involved with projects, the area was especially designed for industry.

By the time the railroad crossed the state line on August 22, 1851, crews were laying a half-mile of track per day, quickly covering the 30 miles between the line and South Bend.

With the construction of a large trestle over the St. Joseph River in South Bend, large riverboat navigation ceased. However, smaller keel boats and steamers could work their way under the trestle and continued on the river for several more years.

On Saturday, October 4, 1851 the tracks reached South Bend. According to the *South Bend Tribune*, "Brilliant bonfires were the order of the evening and when at 9 o'clock, the locomotive 'John Stryker' came puffing into the midst of the multitudes who were assembled cheer after cheer rent the air, the canon also poured forth its deep-tone greeting in 48 rounds."[2] The locomotive brought three small passenger coaches and a baggage car. "All the town were there in the first place men and women and children, ministers, merchants, and mechanics, old and young, and quite a number from the country around."[3]

The first train leaving South Bend was on Monday morning, October 6. It carried 30 passengers. Seventeen cannon rounds honored its departure. On Monday afternoon, the locomotive *Goshen* brought in the first freight train, and the work proceeded to La Porte. Unfortunately, a low swampy area (now Howard Park) separated Lowell from the railroad, which ran about a half-mile south of Lowell. In fact, the railroad was even a little south of South Bend. However, its establishment soon provided reasons for newly arriving settlers to develop Michigan and Main Streets south from Jefferson.

It was not until 1870 that the Michigan Central Railroad set tracks into Lowell and manufacturers quickly took advantage of the location, making it the major industrial area for the next 70 years. Eventually, almost every major manufacturer would have their start here.

The railroad also devastated river traffic. Where once almost all goods had been transported on the St. Joseph River, the wharf area around Market Street (now LaSalle Street) slowly fell into disuse. Although businesses remained along what are now Colfax and LaSalle Streets and Michigan Street, the major economic area began to slowly shift south. The last boat sailing the St. Joseph was the *May Graham*.

B.F. Miller reminisced in the *South Bend Tribune* of April 29, 1916:

> When I first came to South Bend [1851] where the Odd Fellows hall stands was a hole in the ground and where the Oliver house now stands was Whitten's blacksmith shop and the big loping doors opened from the outside and dragged a hole in the ground sidewalk so that after a rain the hogs would wallow in it, for hogs were running all over the town. Where the Medalion hall was built was another hole, the dumping ground for all kinds of rubbish.

In 1852, Clement and Henry Studebaker set up their small blacksmith and wagon making shop at the corner of Jefferson and Michigan Streets, agreeing that

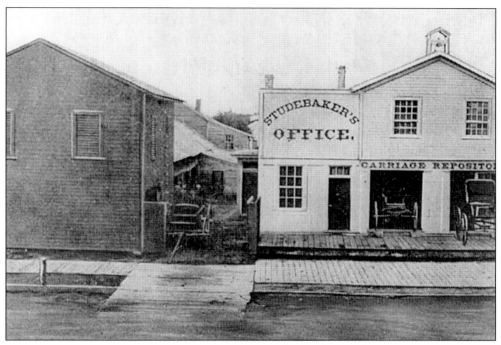

*Clement and Henry Studebaker opened their first blacksmith shop at the corner of Jefferson and Michigan Streets in 1852. The brothers moved the company to larger space shortly after the Civil War. Nearly 30 years after its founding, the company was the largest wagon manufacturer in the United States.*

Henry Studebaker would sell as many wagons as Clement could make and Clement would make as many wagons as Henry could sell. That same year, South Bend trustees spent $1,000 on a new fire engine and hose cart.

The *St. Joseph Valley Register* had already established itself as a leading voice in Whig politics and, in response, William H. Drapier and his father Ariel E. Drapier began the *St. Joseph County Forum* as a Democratic newspaper. Their first issue was published on August 13, 1853. Toting the official Democratic line, they were quick to support the right of slave owners to regain their "property" from northern states and their strong opposition to Abolitionism.

The political upheavals in Germany in 1848 forced many people to emigrate. Some came to St. Joseph County, purchased farms, and became successful. Some settled in South Bend, while others settled in Lowell, joining the small group of French Canadians who had settled in the area in the 1830s.

On September 3, 1853, the *Forum* reported the following:

> The town of Lowell . . . has begun to attract the attention of settlers. Some twenty dwellings have been erected and tenanted, and all the marsh land appears to have been thoroughly drained. The proprietors,

> Cotrell & Co., have nearly completed the water race, which is to afford
> to future manufacturers any amount of the most valuable water power.
> A substantial bridge, in connection with the water gates, has been
> completed for the crossing of the street, and the water from above the
> dam will soon flow through the race into the river below the bend.

By 1853, enough Catholic families had settled near Lowell to encourage Father Sorin to build a brick 22-foot by 40-foot brick building that served as both a school and a church. Originally called St. Alexis, it is now St. Joseph's Church. Lathrop Taylor retired from active business around 1853, preferring to live the next 40 years of his life in quiet contentment.

Christian Liphart planted the first Christmas tree in a South Bend church in 1854 and, in 1855, Frederick Glass gave a Christmas tree celebration for his children, cutting down a fine cedar on the banks of the St. Joseph River near the present Colfax Bridge, then decorating it with candles.

In 1855, Schuyler Colfax ran for Congress and defeated his political opponent and close friend Democrat Dr. Norman Eddy. Eddy was well liked by members of both political parties. His opponents tried no political campaign tactics on him.

*Schuyler Colfax was only 22 years old when he founded the St. Joseph Valley Register. This influential Whig, then Republican, newspaper provided the springboard for his political career. He was Speaker of the House of Representatives during the Civil War, and later Vice President of the United States under President Ulysses S. Grant.*

They merely suggested that the city needed him much more as a physician than as a politician. Eddy was defeated because of the Democratic national political platform that offended many in St. Joseph County.

Alexis Coquillard suffered his last tragedy in 1855. On January 6 at 9 p.m., his mill at the corner of Market and North Michigan Streets caught fire, destroying it beyond repair. On Monday afternoon, January 8, Coquillard was inspecting the mill when the beam on which he was walking cracked, spilling Coquillard onto his head as he fell to the ground. His whole weight fell on the front part of his skull, crushing it, and he died within an hour. He was only 58 years old. The days of the town founders and planners was over, to be replaced by the land speculators and merchants.

Francis R. Tutt, easily considered the richest man in South Bend, made his fortune by purchasing land on the outskirts of town, then re-selling it to newly arriving settlers, making a nice profit. Alexis Coquillard (nephew of the town's founder) also speculated on land. Thomas Stanfield remained active in railroads and the legal profession.

Between 1852 and 1859, many of the new merchants were Germans, including Christopher Muessel, who established his brewery on Pearl Avenue in late 1852. Jewish immigrants Meyer and Moses Livingston, from Frankfort-am-Main, first settled in Ohio, then came to South Bend in 1856 and opened a retail store on west Washington Street. They were among the many Jews who were escaping difficult times in Germany and Lithuania.

Godfrey Meyer came to South Bend from Bavaria in 1853 after learning the art of tinware. He worked for a short time with the Massey Brothers in their tinware and hardware business, then joined with Gottfried Poehlman to form Meyer and Poehlman, an outstanding hardware business. They did the roofing and cornice work for most of the prominent businesses in town, including the Olive Opera House and the Auditorium Theater, most of the churches, and many of the residences.

The Hebrew Society of Brotherly Love was organized on May 22, 1859 by H. Barth, Meyer Livingston, J. Seixas, and others. It purchased the south part of lot Number 3 in S.L. Cottrel's second edition to the town of Lowell for a Jewish Cemetery. The purchase in Lowell may suggest a strong Jewish settlement.

The age of heavy industrialization was still a decade away, and its leaders were now only blacksmiths and foundry workers. Ira Fox and Emsley Lamb owned the South Bend Foundry on lot 13 of the West Race. On May 5, 1855, James Oliver and Harvey Little purchased one-half interest in the foundry from Fox.

The races were to see their share of devastation before industry would permanently take hold. In July 1855, heavy rains swelled the St. Joseph River, which filled with debris. Carried downriver, the debris smashed into the headgates of the West Race, washing away the bridges and destroying most of the manufacturing plants. The South Bend Foundry, like the other plants, was devastated. However, most of the industries rebuilt and, in 1856, Oliver and Little purchased Emlsey Lamb's share of the business.

69

Settlers were beginning to clear away the thin forests west of town, creating new streets, including General Taylor and Scott Streets, named for the heroes of the Mexican-American War. Houses appeared sporadically on Washington Street, west of Lafayette Street. One of the earliest houses was the Joseph Bartlett House built between Scott and Chapin Streets in 1852. It still stands among much of its original landscape.

In the late 1850s, William Knoblock plowed up all the land bounded by Washington Avenue and Chapin, Division, and Lafayette Streets and hauled the timber away to the lumber mills.

The famed adventurer John La Montain thrilled local audiences when his balloon was launched from Washington Street on July 25, 1857, probably from the county fairgrounds, which had been purchased several years before. It was the first balloon ascent in northern Indiana. It was also the first, but not the last, of South Bend's important roles in aviation history.

In 1857, Oliver and Little exhibited their plows at the St. Joseph County Agricultural Society's Fair. Henry and Clem Studebaker exhibited their first carriage. Although the fairgrounds had proved adequate at first, by the 1857 exhibition, it was evident that they were too small to accommodate the expanding fair and, in late 1857, they were sold. Eight acres of land were purchased on what is now Portage Avenue. A small clear stream, flowing into the St. Joseph River, meandered through the new fairgrounds.

John Studebaker returned from the California gold fields in June 1858 and invested $8,000 in his brothers' blacksmith and wagon shop.

G.W. Hawes's *Indiana State Gazetteer and Business Directory for 1858–1859* reported that:

> there are two large flouring mills, making $250,000 worth of flour and meal annually, several extensive furniture manufactories, a furnace, sash and blind shop, chair shop, machine shop, saw mills, and many other establishments of a similar character. A large amount of the oak, cherry, maple and black walnut lumber, which is abundantly produced in the vicinity, is here cut up into the requisite form and shape for furniture or agricultural implements, and shipped to different markets in an undressed state. The town contains about thirty stores, many of them doing an extensive business, besides a large number of smaller shops and groceries. There are here six churches, and fine school houses are in course of erection. A Branch of the Bank of the State of Indiana here located has a fine banking house.

Lowell, which could never find its way out of the shadow of South Bend, was listed as Laurel, a suburb of South Bend.

In 1858, a fire devastated several businesses on the race. In that same year, a large frame schoolhouse on the southwest corner of Main and Division Streets was destroyed by fire. The year 1860 was another turning point in South Bend

history. John Studebaker's investment in his brothers' blacksmith shop had paid off. By 1860, they had a manufacturing shop, a paint room, a lumberyard of their own, and an office, and were employing 14 workers.

The 21-year-old George Wyman came from Painesville, Ohio in 1860 and opened a store at 120 North Michigan Street. He had already served as a clerk for several store owners near Painesville and had also attended a commercial college in Milwaukee for several months. He would eventually become one of the city's most successful merchants and one of the largest mercantile houses in northern Indiana.

The controversy over slavery had reached the boiling point and the nation was about to elect a new president. In August, the *St. Joseph County Forum* stated that it was the duty of the Democratic Party to ensure peace between the two political parties. A few months later, the country elected Abraham Lincoln as their new president.

The 1860 census shows that South Bend had more than doubled its population to 3,832 people, including 68 African Americans. Germans constituted 50 percent of the foreign-born population. The next largest group was the Irish at 24 percent. Both groups quickly took advantage of the need for manufacturing workers and settled in the Lowell area.

On Christmas Eve, 1860, the Oliver, Little, and Company plow business and two other businesses were destroyed by fire. However, by March 3, 1861, the *St. Joseph County Forum* could report that:

*The Studebaker brothers. Clement, John, Peter, Henry, and Jacob, were raised in the strict Dunkard religion, and believed in hard work and dealing honestly with their fellow men. At some point in time, they created the motto: "Always give more than you promise."*

*Father Edward Sorin had long dreamed of expanding his university, but the Civil War and difficult financial times made it almost impossible for him to succeed. He often gave free tuition for students who would help construct buildings. (Courtesy St. Joseph County Public Library.)*

The last fire on the race, which together with the one two years previous, nearly swept everything on the North or river side of the race, has, from present indications, proved a benefit to the manufacturing interests of South Bend. Messrs. Hartzell and Rider, who had both sides of their building burned almost off, have substituted for the charred sides new weather-boards, and in addition, a large two story building along side.

The Plow Shop of Oliver and Little which was entirely consumed is already partly rebuilt, and is to be a considerable larger than the original one. B.F. Price, our town President, who was also one of the sufferers, to the extent of the total loss of building and machinery used by him in the manufacture of coffins and furniture, has timbers, with workmen at work on them, covering over all the available space within a respectable distance of the foundation of what is to be an enlarged Furniture Manufactory.

Aside from those who were the sufferers in the conflagration, there has been improvements that should not be overlooked. Wenger and Co., on the upper portion of the race have enlarged the old Bowers saw mill, by an addition of a large three story Turning Shop—Messrs. Blodget and Clark who had to remove their machinery from one of the buildings which was consumed, to the old wool carding building, so as to obtain room enough to satisfy the demand of more machinery. Sigwalt and Whitman are also in this building manufacturing their Sewing Machines in a sufficient quantity to supply the demand.

The success of Notre Dame and the town's increasing population suggested to Methodists that there was enough need for another college and a committee was appointed to select a location for the proposed "Male and Female College of South Bend." The college had its origins in the basement of the First Methodist Church and, by March 1861, 8 acres at the end of Washington Street on the west side of the Kankakee race were chosen for its location. The final name selected for the college was the Northern Indiana College and it was among the first to be a co-educational college, with both male and female students living in the same dormitory.

On March 4, 1861, Abraham Lincoln was sworn in as President of the United States. In a few short weeks, the entire nation was at war. Confederate troops fired on Fort Sumter on April 12. The April 20, 1861 issue of the *St. Joseph County Forum* reported Lincoln's first call for volunteers and listed 74 members of the "Volunteer Infantry Company for St. Joseph County" under the command of Captain Andrew Anderson Jr. The May 2 issue of the *St. Joseph Valley Register* listed the names of 79 members of the "South Bend Rifles" under the command of Captain Alexander Fowler. Both groups expected that their involvement would be short.

On April 24, Norman Eddy, a diehard Democratic politician whose previous occupations had included prominent careers as a physician, newspaper editor, lawyer, and congressman, presided over a meeting at the courthouse in which a citizens' army of men over 45 years of age was formed. Not satisfied with all of his other duties, Eddy secured approval for his own unit in August 1861 and the 48th Indiana Infantry Regiment was mustered in at Goshen in December. Eddy was named the regimental colonel.

By 1862, everyone knew that it would be a long war. The Studebaker brothers received their first military contract for wagons, gun caissons, meat, and ammunition wagons.

The South Bend Soldiers' Aid Society formed and met in the courthouse every Thursday afternoon, where women prepared dressings and hospital supplies and made clothing for their loved ones. Supplies included towels, drawers, bed sacks, pillow ticks, sheets, quilts, pillow cases, handkerchiefs, and slippers.

In August, three new regiments, the 73rd, 87th, and 99th, drilled in the newly established temporary Camp Rose—the fairgrounds on Portage Avenue, partially protected by a palisade. Twenty-five Sibley Tents and a small barracks covered the

ground. Thomas Stanfield was in command of the camp. Food and bread were supplied by local merchants, including John C. Knoblock.

The *St. Joseph County Forum* wholeheartedly supported the Union cause, but it pulled no punches when it felt that there were government officials who were profiting from the war. More than once, it called the administration corrupt. An editorial on August 9, 1862 extorted:

> There is not a person or a party that has not a great work to become patriotic. That work is the putting out the fires of ambitious lust at home. We are in the heated crucible, where the gold and cross will separate. No one can come out a sterling patriot who does not discriminate between patriotic ends of action and partisan and ambitious ones, and fight against and restrain the latter from his words and actions. . . . We know our duty then, under one of the best governments; it is to use and devote our ALL in the most efficient and patriotic way possible, to sustain the supremacy of the Federal Constitution, Laws and Union under them.

On the other hand, it also criticized the Indiana state government for allowing African Americans to enter the state, citing Indiana's 1850 constitution, and reminding the *Forum's* readers that "the soil of Indiana should belong to the white man, and that he alone was suited to the free institutions."[4] Various other articles gave no doubt that the paper favored the continuation of slavery, no matter whether it was in the North or the South.

Money, always scarce, was becoming impossible to obtain. People were paying their bills in produce or labor or by bartering goods. Precious metals had been diverted to military purposes. In that year, the U.S. Treasury decided not to make more coins. With the already tight supply, some merchants began to make their own. South Bend was one of 400 cities whose merchants joined in the coinage movement.

The coins, each worth a few cents, were manufactured for John Knoblock, George Wyman, W.W. Bement, Blowney & Johnson, Samuel M. Cord, Oliver Hammond, and A.M. Purdy. They could be used at their stores and redeemed for merchandise.

On September 19, Norman Eddy was wounded in the Battle of Iuka. Shot twice (in the right arm and left shoulder), his horse fell at the same time with seven wounds. Eddy returned home in October to a hero's welcome, but never fully recovered from his wounds. With a wife, four daughters, and a son to raise, Eddy found that his medical and legal practices could not support him during the war. In 1865, he was appointed the collector for the Internal Revenue Service, thanks largely to the efforts of two of his closest friends, Republicans Clem Studebaker and Schuyler Colfax. His daughter Ellen served as his secretary.

That same fall, Mrs. William Tecumseh Sherman visited South Bend. The Shermans' daughter was a student at St. Mary's Academy, their son Willy was enrolled as a Minim at Notre Dame, and later their son Thomas also attended

*Money was hard to find during the Civil War. South Bend was among 400 cities whose merchants attempted to solve the money supply by creating their own money, which could be used for trade in their stores.*

the university. Mrs. Sherman's cousin, Mother Angela, was in charge of St. Mary's Academy.

The military activity around temporary Camp Rose ceased in late 1862 and, in 1863, Julia Scott and her family erected the first house on the north side of the St. Joseph River, near the site of the fairgrounds. Within a few short years, the area began to fill with houses.

In many places, a segment of the Democratic Party called Peace Democrats began to emerge. Although they pledged their loyalty to the Union, they urged conciliation toward the South. A small percentage became involved with the Knights of the Golden Circle, a movement considered by some to be an attempt to overthrow Indiana's government. The Republican Party referred to these Democrats as "Copperheads." The *St. Joseph County Forum* came out heavily against the Copperheads.

William H. Drapier and his father Ariel E. Drapier had been among the first to offer their loyalty to the Union cause in 1861. But the January 10, 1863 issue of the *Forum* printed Lincoln's Emancipation Proclamation, with an editorial severely lashing the President, indicating that Lincoln had changed the whole intention of the war:

> Now we ask every candid Democrat, who has given his support to the present war, whether the contingency described by Henry Clay has not arrived, so far as this war is concerned? . . . We know the tenaties who urged the President to this step say, that he "can save the Union only by abolishing slavery;" but this assertion is not only false on its face, but a

> self-contradiction in terms. The Union is made up of the rights of the
> States, as its very fundamental idea, and "slavery" is one of these rights.

Other newspapers also came out strongly against Lincoln's new policy and increased their criticism when they learned that Lincoln was going to allow African Americans to fight for the Union. By 1863, Ulysses S. Grant was beginning to destroy the Confederate forces in Mississippi, but the staggering rise in casualties was beginning to make many reconsider whether or not the war should continue.

Criticism continued through the spring. Fellow editors of the *St. Joseph Valley Register* and the *Mishawaka Enterprise* wrote editorials expressing their concern on the stand taken by the *Forum*. The *Forum*'s editorials had also been noticed by Brigadier General Miles Smith Hascall.

Hascall was no stranger to Indiana. Although born in LeRoy, New York in 1829 he moved to Goshen, Indiana at an early age. He worked as a clerk and a school teacher in Elkhart and Goshen before entering West Point in 1848. He graduated in 1852, served a short time in the army, then resigned his commission and returned to Goshen. For the next eight years, he served as a railroad contractor for the Michigan Southern and Northern Indiana Railroad, lawyer, district attorney, and county clerk. He returned to the military at the start of the Civil War, entered an Indiana unit, and rose to the rank of brigadier general. After several successful

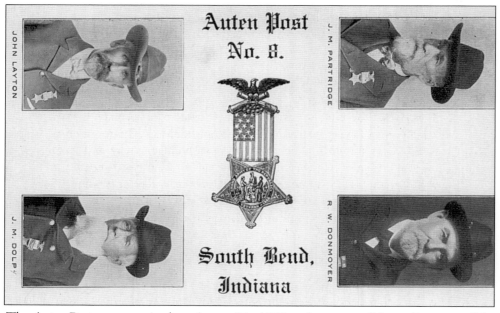

*The Auten Post was organized on August 31, 1866 and was one of the earliest posts of the Grand Army of the Republic. It was named for John Auten, the first St. Joseph County, Indiana soldier to be killed in the Civil War.*

military victories, he was transferred to the Army of the Ohio in early 1863, and was briefly put in charge of the District of Indiana. It is quite likely that he personally knew Drapier as well as several other Indiana newspaper editors.

On May 3, 1863, the *Forum* printed Hascall's Order Number 9, which he had issued on April 25. This order reaffirmed General Ambrose Burnside's General Order Number 38. Hascall wrote the following:

> All newspapers and public speakers that counsel or encourage resistance to the conscription act, or any other law of Congress passed as a war measure, or that endeavor to bring the war policy of the government into disrepute, will be considered as having violated the order above alluded to, and treated accordingly. The county will have to be saved or lost during the time that this administration remains in power, and therefore he who is factiously and actively opposed to the war policy of the administration is a much opposed to his government.

In the same issue, the *Forum* wrote a scathing editorial concerning this order and its implied censorship. Hascall then wrote to the *Forum* informing them that the paper "can now publish an article retracting all this and publish a loyal paper hereafter or you can discontinue its publication till further orders. A violation of this notice will receive immediate attention."[5]

The *Forum* responded in the May 9, 1863 issue by reporting that E. Vanvalkenburg, the editor of the *Plymouth Democrat*, had been arrested. In addition, Clem L. Vallandigham had also been arrested.

On May 16, the *Forum* printed an editorial concerning the order:

> We are bound to respect it, of course, as all men respect the Order and authority of a military commandant. . . . It has been and is a life-long principle with us, never to violate the laws, nor despise the lawful authorities of the United States of America, and it has been at all times far from our thoughts to "boast" of intention to do so. . . . Because we do not court the distinction of an arbitrary military arrest and trial, at a heavy, bootless expense to the General Treasury, and because we do not want the martyrdom that might come from the finding of a solemn drum-head court, we accept the alternative of the magistrar dixit of Brigadier General Hascall, if we may be allowed to do so, and DISCONTINUE the *Forum* neswspaper, without further "attentions" from Headquarters and without further respect to "further" Orders.

On May 23, 1863, William Drapier issued the last copy of the *St. Joseph County Forum*, informing the public that he had been constrained to do so by "notice" from the War Department. It was one of only a few newspapers to feel the full sting of Civil War newspaper censorship.

Mrs. Sherman returned to South Bend in June 1863 to attend the closing exercises at Notre Dame, remained briefly, and returned home to Ohio, making preparations to move her family to South Bend.

Schuyler Colfax, now Speaker of the House of Representatives, offered her the use of his house while she resided in South Bend in 1864. While it was being prepared for her, she stayed temporarily at the Dwight House, at that time considered the finest hotel in the city. On the evening of September 24, a crowd gathered in front of the hotel to honor her and her husband's victory at the fall of Atlanta. The end of the war was in sight.

The war effort saw many new factories develop in South Bend. John C. Birdsell moved his clover huller factory from New York to Lowell in 1864. Clover at that time was recognized as a major fertilizer, but it was difficult to separate the seed from the straw and hulls except by laborious methods, creating high prices that poor farmers could not afford to pay. Two disastrous fires in 1865 and 1867 nearly destroyed Birdsell's business, but he rebuilt larger factories each time.

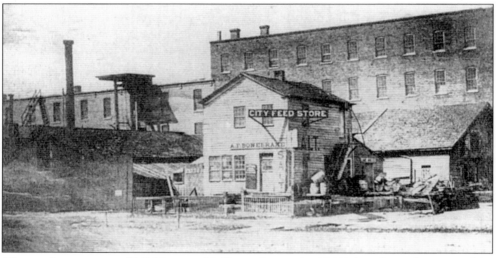

*The southwest corner of Michigan and Jefferson Streets (c. 1869) has always been one of the busiest intersections in the city. The Studebaker brothers had their first blacksmith shop near this spot. Later, they built a large carriage repository on the corner. In the early 1900s, S.S. Kresge purchased the repository and had a thriving business there for almost 60 years. Today, a small park sits here.*

# 5. From Swords into Plow Shares

With the war over, General Sherman attended the graduation ceremonies at Notre Dame in June 1865. Anticipating the war's end, the university prepared for expansion and, in June, requested Oliver, Bissell, and Company to cast 70 iron columns costing $486.85. With money still tight, James Oliver doubted that the university could pay the bill and instead wisely chose to send his son Joseph to Notre Dame, crediting his tuition against the amount owed by the university.

Father Sorin needed skilled workers for his projects and he found them in the Irish workers who had once worked on the Ohio and Wabash Canals as well as those working on the railroads that were being constructed through Indiana. He provided jobs for them and purchased land near St. Joseph Church where they could live.

Hampered by lack of growing space, Christopher Muessel moved his brewery to Portage Road, outside of the city limits. South Bend incorporated on June 2, 1865, dividing itself into three political wards. William George was the first mayor. George W. Matthews was elected treasurer, Daniel Roof was elected marshal, and Washington Saunders was elected civil engineer. Also elected were Elisha Sumption as the assessor, William Miller and John Klingel for the First Ward, William Miller and Thomas S. Stanfield for the Second Ward, and John Gallagher and Israel C. Sweet for the Third Ward. In December 1866, South Bend annexed Lowell, making it the Fourth Ward. A. Russworm and Samuel Parry were the elected representatives.

The war had taken everyone's attention and few had time to think of expansion into the American West. But mass migrations began as soon as the war ended. Farmers moved west beyond Iowa, Kansas, Nebraska, and Missouri into Montana, the Dakotas, Colorado, and New Mexico. They needed wagons for hauling and plows for breaking the soil and South Bend manufacturers were ready to supply the demand. Peter Studebaker built up one of the first big national sales organizations, with carriage and wagon repositories in St. Joseph, Missouri and San Francisco, as well as dozens of other cities.

Soon the Studebaker brothers had a four-story building a block long, a three-story finishing factory, and another factory with 36 chimneys that towered over five new sheds. A spur line from the Lake Shore and Michigan Railroad was added. The regular payroll carried 190 men.

James Oliver continued to expand his foundry and plow business, taking other iron-making enterprises as they came along, including the manufacturing of metal sleeves that protected the wooden axle spindles of Studebaker wagons.

Two bridges on Water and Washington Streets connected South Bend with Lowell. More than 30 waterwheels provided power to industries on the west side of the river.

On August 25, 1866, the Union Printing Company obtained the printing press of the former *St. Joseph County Forum* and renamed the newspaper the *National Union*. Two months later, it was purchased by D.C. Rush and Company, and Ed Molloy was installed as editor. It supported the Democratic Party, which held a minority of the voters in the county. In 1867, Molloy married Emma Barrett Pradt, who had recently divorced Louis Pradt. Together, Ed and Emma Molloy purchased the *National Union*, making Emma the first woman editor in Indiana.

Emma was no stranger to newspaper publishing. She was born in South Bend and had contributed articles to several South Bend newspapers in her earlier years. Her marriage to Louis Pradt had given her travel experiences and she had taken the opportunity to contribute articles to various newspapers. Unfortunately, he had a fondness for liquor, which finally destroyed their marriage. Emma Molloy's articles in the *National Union* stressed temperance and equal rights for women. Later in life, Emma would become a nationally known woman evangelist and leader in the Temperance and Woman's Suffrage Movements.

The Northern Indiana College received no funding from the Northern Indiana Conference of the Methodist Church and money was still tight, so actual construction of the building did not finish until the fall of 1866. The red brick structure, 50 feet wide by 90 feet long, was situated at the top of a knoll or mound, and surrounded by 10 acres of swamp (the *St. Joseph Valley Register* called it an 8-acre arbor). The building was four stories high, including a basement. A central tower on the front, rising 100 feet, included entrances to every floor of the institution. A clock and cupola finished the tower.

Elevated wooden walks were built over the swamps, providing easy access to "Swamp Hall," as it was affectionately called by its students. A new street—College Street—intersected Washington Street, and Circle Avenue was established in front of the college's main entrance. The building was dedicated on January 10, 1867.

T.G. Turner issued his *Gazetteer of St. Joseph Valley of Michigan and Indiana* in 1867, offering a brief history of the area as well as detailed information about South Bend and Mishawaka. Advertisements for over 100 South Bend merchants, hotels, music teachers, hardware stores, livery stables, lumber yards, schools, furniture manufacturers, billiard parlors, one ice cream saloon, and four photography studios dominate the book. The leading businesses were the flour mills, with an income of nearly $560,000.

The Western Publishing Company published *Holland's South Bend City Directory for 1867-8*, containing a complete list of all residents in the city and a classified

business directory of South Bend and Mishawaka. This 172-page booklet was the first detailed listing of all the city's inhabitants.

At the request of Thomas Stanfield and Alexis Coquillard (nephew of the town's founder), Leighton Pine arrived in South Bend from New York City in 1868. As a representative of the Singer Sewing Company, Pine was responsible for finding a location for its new cabinet case factory. The hardwood forests near South Bend offered a ready supply of walnut and oak. He established the plant on the east race and it quickly began to produce 1,000 cabinet sets each week.

In 1868, Oliver, Bissell and Company re-organized as the South Bend Iron Works and expanded their building to more than 15,000 square feet. They obtained the contract for casting the iron stands for Singer Sewing Machines. At the end of 1869, they were making 1,000 iron sewing machine stands a week. In that same year, nearly 190 houses, factories, churches, and other buildings were erected in South Bend.

Although a few scattered Polish immigrants had arrived in South Bend earlier, by 1868, there were 15 Polish families living in South Bend.

*Singer Sewing Machines were sold all over the world. James Oliver had received the original contract for making the cast iron frames, but his plow business soon demanded all of his attention and the frames were later made elsewhere. However, the hardwood forests around South Bend had originally attracted the company to this location and the Singer Company continued to make its wooden cases here until the company closed in the 1950s.*

*John C. Knoblock's successful careers included a grocery store, a furniture manufacturing company, a sprinkler wagon company, and an electrical wiring manufacturing company. His company made the magneto used by the Wright brothers in their first successful airplane fight in 1903.*

In order to protect the growing community, the South Bend Fire Department purchased a new horse-drawn rotary stem fire engine. The department now had three engine companies, three hose companies, and one ladder truck. Even with this amount of equipment, the department found it difficult to contain a fire in the Michigan Street block between Washington and Jefferson Streets.

In 1869, Father Sorin gathered scattered Catholic families near Plymouth, and German and Irish Catholic families on the southwest side of South Bend to form a new parish on Division Street. Although apparently outnumbered by the Germans, some enterprising Son of Erin chipped the words "St. Patrick's Church" in the woodwork above the door.[1]

Colonel Norman Eddy was elected Indiana secretary of state in 1870, but died two years later. The city turned out for one of the largest funerals ever held.

By 1870, South Bend had 7,209 residents, nearly doubling its population from a decade before. Germans, now at 55 percent, again dominated the foreign-born population. The Irish had dropped to 18 percent. The city had 237 businesses and manufacturing firms. In addition to the Lake Shore and Michigan Railroad

(formerly the Michigan Southern and Northern Indiana Railway Company), four other railways were active in South Bend or slowly advancing toward it. The following is from Turner's *Directory*:

> The business of such a point as South Bend—amounting now to a matter of over seventy million pounds freight per annum—cannot be overlooked by sagacious men, and a slight deflection will eventuate in a competition for this traffic, and much more, as the work goes on. This accomplished, South Bend is one of the foremost railroad centers of the West.[2]

Over 500 dwellings had been built during the previous two years. Over 7 million bricks were used. The census shows 73 African Americans living in South Bend at the time. On March 16, 1871, the Olivet Chapel (later the Olivet AME Church) was organized with James Hurst, Pharoah Powell, James H. Jackson, Catherine Wilson, and Alice Fowler. Reverend Janson (or John or Jason) Bundy was the first minister.

The largest business increase was in groceries and dry goods. John C. Knoblock retired from the grocery business, but soon found himself involved in a wide variety of projects. Chapin and Kuhns became the largest grocers. John Bartlett, now nearing 30 years in business, took on a partner, H.G. Miller. J.S. Lieb and Brother was the leading dry goods merchant. Meyer and Moses Livingston remained the major clothing merchant. O.H. Palmer was one of three book and stationery merchants. The city now had three banks: South Bend National, South Bend Savings Bank, and the First National Bank. W.S. Monson was the only gunsmith in town.

If the residents were pleased with a steadily growing population, they were about to be given a shock. The industrial revolution was just beginning in South Bend.

The Great Chicago Fire of 1871 devastated that city, but it was an economic boom for South Bend. James Oliver sent Joseph to Chicago to purchase all of the heavy cast iron columns from the newly destroyed buildings, soon filling all of the available space on their West Race location. He cast these into sewing machine stands for Singer and was paid in cash for his work. The working capital allowed the South Bend Iron Works to expand further, with several new buildings. By the end of 1872, they still had 500 tons of scrap iron left from the Chicago purchase. They made 3,049 Oliver chilled plows during that year, as well as 1,800 Singer sewing machine parts each week.

John Birdsell soon outgrew his original location on the West Race and, in 1872, built a new factory on South Columbia Street between Jefferson and Division Streets in front of the railroad tracks later owned by Grand Trunk Railroad. John W. Teel began to make croquet sets in a small factory on the West Race.

Studebaker's reputation as an excellent wagon maker for the Union army had provided further military contracts. Most of the Army wagons used on the western posts after the Civil War were supplied by Studebaker. Farmers, many of whom had been in the army before moving west, needed wagons and knew

Studebaker's reputation as an excellent wagon maker. Strong advertising by the company also produced increased sales.

By 1872, Studebaker had an employee force of 325 men, who had built 6,950 vehicles. In June, a major fire destroyed most of their heavy machinery and their whole stock of finished woodwork, but the brothers went back to work and, by 1874, they were employing 500 men and turning out over 11,000 vehicles. Another fire in 1874 destroyed nearly two-thirds of their buildings, but again the brothers rebuilt.

The strain on Oliver's foundry on the West Race forced him to consider new, larger facilities. On April 16, 1874, Oliver purchased 30 acres of the Perkins Farm at the corner of Sample and Chapin Streets. By the end of 1874, demand for Oliver's chilled plow was so heavy that he discontinued manufacturing all other products, including the Singer Sewing Machine stands. He moved his plant to Chapin Street, opening the new facilities on July 13, 1877. The new plant had five buildings with a total space of 200,000 square feet. It could accommodate 400 workers. Oliver was always innovative. In 1875, he hired Kate Deal, the first woman to be engaged in office work in South Bend.

The expanding population provided incentive for the establishment of another newspaper: the *South Bend Weekly Tribune*. It was first published on March 9, 1872. It was owned by Alfred B. Miller (son of B.F. Miller), Elmer Crockett, James H. Banning, and Elias W. Hoover. On May 28, 1873, the first daily issue was published. Like the *St. Joseph Valley Register*, the *Tribune* favored the Republican Party. Within a few short months, it was publishing a daily named the *South Bend Daily Tribune*. *Der Indiana Courier*, a German language paper, was also established in 1873. It supported the Democratic Party.

Financial difficulties had always plagued the Northern Indiana College and the Civil War had taken away many of its potential students. The high cost of the construction, the lack of sufficient funds to keep the college solvent, and the Panic of 1873 combined to force the college to close later that year. The property was sold at a mortgage sale, but remained empty for several years.

On January 2, 1877, fire swept the building. After reconstruction, several other companies occupied the facilities, including the Knoblock Brothers Furniture Company and then the South Bend Chilled Plow Company, which occupied it for many years, adding extensive wings to the original one-building structure and eventually turning the whole area into a massive 10-acre complex employing over 500 people.

The South Bend Chilled Plow Company was a major competitor to Oliver. Originally called the St. Joseph Reaper and Machine Company, it had been in business for several years, making reapers, agricultural implements, and plows. It reorganized under the name South Bend Chilled Plow in 1876 and 1878, with John C. Knoblock as one of its major investors. Oliver's former partner Thelis Martin Bissell became the superintendent.

The Panic of 1873 had been followed by a depression, but the depression was not felt in South Bend until 1875. It was the first year in which men were

*South Bend Chilled Plow Works expanded the Knoblock Brothers Manufacturing Company building. Nearly 500 workers were employed here by the late 1880s and the company had expanded to nearly all of the 10 acres originally owned by the Northern Indiana College. The buildings were later used by Hurwich Iron Works until a major fire and urban renewal took down the rest of the buildings in the 1980s.*

unemployed, capital was unspent, and many businesses did not make a profit. By 1877, the depression had hit South Bend so significantly that no city directory was published for 1878. The 1879 directory was smaller than any of the previous editions. The depression was a serious blow to Partrick O'Brien as well. He had come to South Bend in 1857 and became the first "professional" painter and finisher employed by Studebaker. In 1875, he organized the O'Brien Electric Priming Company, setting it up on what is now Lincoln Way West, near LaSalle Street. Sales were slow during the depression.

Reverend Valentine Czyzewski founded the first Polish church, St. Hedwig's, in 1877.

Two disastrous fires struck South Bend in 1878: six buildings in the St. Joseph Hotel block at the corner of Washington and Main burned on Christmas Eve. The Keedy Flouring Mills were also burned, but they were rebuilt as soon as possible. The telephone arrived on March 30, 1878.

On the morning of April 23, 1879, the six-story Main Building at Notre Dame, housing classrooms, dormitories, and offices, as well as the college infirmary and Music Hall, were burned to the ground. The building's dome, with its heavy statue, collapsed. By evening, only three scarred walls remained and one of these had to be torn down. South Bend shopkeepers and office workers rushed to the scene to help put out the fire, but it was too late.

Father Sorin, absent at the time of the fire, returned and vowed:

> tomorrow we will begin again and build it bigger; and when it is built, we will put a gold dome on top with a golden statue of the Mother of God so that everyone who comes this way will know to whom we owe whatever great future this place has.[3]

By the end of the decade, South Bend had become a dominant manufacturing center in Indiana with Studebaker, Oliver (South Bend Iron Works), and Singer leading the way. Studebaker was producing nearly 20,000 wagons per year, Oliver was selling close to $800,000 worth of plows, and Singer was selling over $1 million worth of sewing machines. These three companies alone employed nearly 2,000 workers. Both Studebaker and Oliver regularly sent agents to New York and abroad to recruit new labor for their factories.

With the increasing number of immigrants came an increasing problem for housing as well as other concerns. Both companies solved the problem by building houses near their factories for their employees, which they could either rent or purchase. In April 1880, Oliver purchased 10 acres adjoining the plant, on

*James Oliver had originally come from Scotland as a child and moved to La Grange County, Indiana. He lived in La Grange County for a short time before moving to Mishawaka, Indiana in 1836, where he held several jobs as a teenager before becoming a blacksmith. Among his fellow blacksmiths was the future millionaire Charles Crocker, one of the founders of the Central Pacific Railroad.*

which he built cottages for his employees. A year later, he built and donated the Swedish Evangelical Lutheran Church for his workers.

By 1880, South Bend could boast a population of 13,280. Nearly half the population (6,210) was foreign born. The Irish had dropped to 9 percent, while the Germans had risen to nearly 70 percent. However, the percentage figures are deceiving. German military expansion had overwhelmed Poland and Prussia dominated much of the region. In 1871, Germany was unified. Many of the people who were listed in the census as having been born in Prussia or Germany actually had Polish names. The Polish did not have a separate census category. It is difficult to determine the exact percentage of Polish inhabitants in South Bend, but the number was high. Other ethnic groups included immigrants from England, Scotland, Sweden, and Belgium.

Of all the immigrant groups that settled in South Bend, it was the Polish, Belgians, and later the Hungarians and Italians, who seemed mostly to congregate in ethnic neighborhoods. Many of the new immigrants were Catholic and churches soon developed in various ethnic neighborhoods. Some churches, like St. Hedwig and St. Patrick, were only a block apart from each other. After the Belgians arrived, they set up Sacred Heart Church only a few blocks from St. Hedwig and St. Patrick. And the Hungarians established St. Stephen's church, only a few blocks from all three.

Ethnic neighborhoods soon attracted ethnic grocers, bakers, laundries, physicians, and a wide variety of other merchants. It was literally possible to be born, live your whole life, and die in South Bend without ever knowing a word of English. This condition continued as late as the 1940s. Jews, African Americans, Irish, Germans, Scotch, and later Greeks seemed to assimilate into any neighborhood in which they chose to live.

In April 1880, minor labor troubles developed at the South Bend Iron Works. Fifty point molders (mostly Polish) walked off their job and threatened to mob the men who remained. Oliver quickly replaced the Polish workers with Belgians, who had only arrived in South Bend a few days earlier.

Fred and Lenhard Winkler moved from Cass County, Michigan to South Bend around this time, purchasing a log cabin on East LaSalle Street, just east of the St. Joseph River. Here, the brothers produced a sprinkler wagon, which could be used to water down dusty streets.

The first telephone exchange was started in 1880 and, by 1881, there were 280 working telephones in South Bend. Otto Knoblock, Adolph Ginz, James Oliver, and Father Sorin are all credited by various sources as having the first telephone. Some information also indicates that Frank C. Nippold of the South Bend Iron Works was the first one in South Bend to use a telephone as early as March 30, 1878.

On January 28, 1881, 20 business or professional firms were destroyed in the 100 block of West Washington Street. Elisha, Phineas, and Samuel Solomon established the city's first cigar manufacturing company in early 1881. Electric lights were installed in the South Bend Iron Works on May 4, 1881. The company employed 900 men in 1882, melting 60 tons of iron into plows.

Although Poles had run for political office in past years, Peter Makielski was the first elected Polish official, having won his election in 1881.

Anton Kertesz and his family arrived in South Bend from Hungary in September 1882. Although they knew no English, within a few days of their arrival, they were working for South Bend Iron Works. Within a few months, Louis E. Kovach and several other Hungarians also came to South Bend. Other early Hungarian families were Mr. and Mrs. Anton Kertesz with four children, Mr. and Mrs. Joseph S. Horvath and one son, Mr. and Mrs. George Kovach with four children, Mr. and Ms. Frank Horvath with four children, Mr. and Mrs. Joseph Farkas with two children, Anthony Horvath, Emery Kardos, John Pallo, Joseph P. Farkas, Joseph Papay, George Szelencey, Michael Koczan, P. Joseph Horvath, Ignatius Horvath, Michael Toth, and George and Joseph Varga.

Also in 1882, the South Bend Iron Works met further plow competition from two of Oliver's former partners, Leighton Pine (former director of the Singer plant) and E.D. Meagher, who formed the Economist Plow Works.

The South Bend Electric Company, under the supervision of James DuShane, was established and erected lights in several of the businesses and houses on Washington, Michigan, and Main Streets. The *South Bend Tribune* was one of the earliest buildings to be lighted with electricity. Water power from the old Huey mill supplied the electricity.

The fairgrounds on Portage, which had served as Camp Rose, had been sold by the county and had already been substantially filled with new houses, mostly built by their occupants. E.P. Chapin platted his beautiful grounds, Chapin Place, in September, with the idea that it would become the finest residence part of the city.

Patrick O'Brien's company also prospered. By 1882, his company had expanded and moved "way out into the country" at the corner of Washington and Johnson Streets.

South Bend merchants were pleased to see all of the new customers. Moses Livingston's store now attracted trade from everyone within a 50-mile radius of the city. Within the past two years, his trade had increased so much that by September 1882, he had to open additions to his store. The new three-story building , 44 feet wide and 85 feet deep, contained 19 departments. Seven other clothing stores competed with Livingston. The major competitors were John Hay ("The People's Clothing Store"), Kempner and Greenberg, and Simon Green. George Wyman's business was still growing strong and a newcomer, John Chess Ellsworth, had joined the list of successful merchants.

The Building and Loan Association of South Bend, Indiana was established in 1882, bringing a new innovation in banking. This innovative system allowed laboring classes to save a few dollars every week or month and eventually obtain enough capital to purchase homes. Although the system was in use in eastern states, it was relatively new to the Midwest.

Although the Northern Indiana College had failed nearly a decade earlier, the large population now living in South Bend provided William T. Boone a chance to establish the South Bend Commercial College in 1882 and supply the growing

needs of South Bend's businesses. Courses were taught in commercial law and correspondence, bookkeeping, banking, accounting, penmanship, business arithmetic, grammar, reading, spelling, punctuation, and geography. The name has now changed to the Michiana College of Commerce and it is the oldest educational institution of its kind in Indiana.

Studebaker began employing women as clerks and stenographers as early as 1882 or 1883, when Miss Emma Ford was hired as the first woman stenographer in South Bend. Clem Studebaker further involved himself with South Bend activities when the South Bend Young Men's Christian Association was organized on March 10, 1882. He served as the association's first president from 1882 to 1884.

The increasing population had long drawn the attention of St. Mary's Academy and the Sisters of the Holy Cross. Already famous for their nursing skills during the Civil War, they set out to establish a hospital. By November 1882, St. Joseph Hospital was ready to receive 30 to 40 patients in its headquarters at the vacated St. Joseph Church (the parish had erected a new church to accommodate its growing membership). The *Tribune* strongly urged "that each workingman in the city contribute a mite from his wages every pay day to the hospital fund. As they say, every working man is interested in the success of the hospital, and in no way could that interest be better shown than in contributing to its funds."[4]

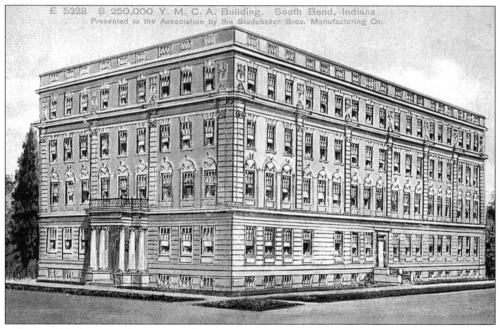

*The Studebaker Brothers Manufacturing Company provided the money to build this beautiful YMCA, beginning construction in 1902. Clement Studebaker served as the association's first president from 1882 to 1884 and realized that the original building would soon be outgrown.*

*Never too young for a Studebaker. Studebaker offered these wagons for sale through the local South Bend newspapers. Whether or not the company built all of the toy wagons is not known. The South Bend Toy Company is also known to have made these toys, along with toy doll carriages.*

The city's suburbs had expanded so far out that in November, James and Joseph Oliver and the Studebaker brothers joined together to petition the South Bend Common Council for the establishment of a street railway. The city had already spent much of the summer grading and graveling Jefferson Street and Pearl Avenue and was considering grading Vistula Avenue.

The West Race was again visited by fire on January 4, 1883. The *Tribune* reported the following:

> The fire started in Hodson Brothers planing mills and before it could be brought under control had swept the distance of one square from Washington to Market street, burning out Hodson Brothers, Smith and Detling, Hertzell and Hartman, N.P. Bowsher, the South Bend Pulp Mill, the Bissell Plow Works and Sibley and Ware. The buildings burned were owned by Stanfield, Hertzell and Hartman, T.M. Bissell and the South Bend Pulp Company. The losses will aggregate over $100,000 with but about $25,000 insurance, and, to add to the disaster several hundred men will be thrown out of employment at the worst season of the year. Courtly Bills, who lives west of the city, picked up pieces of burned wood over four inches square one mile and a half from the fire and says there were any number of smaller pieces thirty or forty rods still further west. Farmers living three miles away informed a *Tribune*

representative they could read a paper by the light the fire made. The fire could be seen distinctly at Niles, and they supposed it was Notre Dame burning until the telegraph informed them differently.[5]

In early 1883, John W. Teel, Fred H. Badet, and Will T. Carskaddon announced that they were organizing a new industry to be called the South Bend Toy Manufacturing Company. It would produce croquet sets, ball bats, toy carts, toy wheelbarrows, and other toys. Children's doll carriages would be one of their leading products.

The Solomon Brothers were joined by cigar manufacturers A.N. Deacon, David Holland, and Samuel Pollack. By 1883, James Oliver felt that he was in a financial position to begin projects not associated with his plow business. In December 1883, he broke ground for Oliver Row, a row house of nine connected apartments on Main Street at the northwest corner of Market. The building was complete in 1885 and Joseph brought his young bride to occupy apartment number 1.

Before Oliver Row was even finished, James Oliver began construction of the Oliver Opera House Business Block on Main Street near Washington. Construction on the four-story building began on March 8, 1884 and it was opened on October 26, 1885. The fourth floor was occupied by the *South Bend Tribune*. Among its earliest occupants was a young South Bend Public Library.

In November 1884, a minor business depression slowed down plow sales for the South Bend Iron Works. With a large supply of finished materials on hand and no place to sell them, the company responded by cutting down on worker's time. The workers demanded that they be put back to work immediately. The company responded by giving part of the workers full-time work and laying off others. Wages were also cut. Those who were laid off were joined by those who refused to work for lower wages. They then threatened the workers who had continued to work. The plant was closed in early December and did not open again until December 8. A few days later, Oliver asked the striking workers to return to work. They refused. A stalemate continued until January 5, 1885 when members of the Polish Union met with Oliver and requested their jobs back. Oliver refused.

On January 12, strikers entered the plant and forced men to quit working. The following morning at 7 a.m., nearly 200 men armed with clubs and iron bars assembled in the front of the plant and refused admittance to everyone. Captain Ed Nicar forced his way into the building, but was severely beaten. He drew a revolver to hold back the crowd. A police officer who had accompanied him was also injured. The strikers broke through the factory gates and nearly 100 men destroyed windows and plow bases. Nicar called for reinforcements. Fifty Veteran Guards, armed with fixed bayonets, forced their way into the crowd. Fearing that the strike would result in a riot, firearms from local gun shops were confiscated and locked up in the courthouse. Ten men were arrested on charges of rioting and assault and battery.

Oliver threatened to leave South Bend, possibly setting up his factories in Indianapolis. La Porte, Indianapolis, Logansport, Louisville, and Chattanooga had

all contacted Oliver, indicating their interest in having him remove his plant to their cities. South Bend responded with a mass meeting on February 20, begging Oliver to remain. Later the Common Council offered to protect the property with 100 special officers. With the coming of spring, sales increased and, by April 20, the company was able to return to full-time work and the old wages.

While the strike story captured most of the headlines during these weeks, the biggest headline was for Schuyler Colfax, who had died while on a speaking engagement at Mankato, Minnesota on January 13, 1885. In 1869, Colfax had been elected vice president of the United States, to serve with Ulysses S. Grant. Unfortunately, after his election, a scandal broke out in which he was accused of taking bribes. Colfax never lived down the accusation. He returned to South Bend and stood on the steps of the county courthouse with tears in his eyes, pleading his innocence. After his retirement from public office, he earned a living as a guest lecturer, with his favorite topic being his close personal relationship with Abraham Lincoln. Colfax was on his way to deliver a speech when he suffered a heart attack.

The South Bend Street Railway had street car routes on Washington, North Michigan, Portage, and Chapin Streets by 1885, when the city invited Charles Van Depoele to construct an electric trolley car system. Even as a child, Van Depoele had long been fascinated with electricity and sought ways to use it. Following his father's advice, Van Depoele learned carpentry and migrated from Belgium to Detroit in 1868, where he set up a wood-carving business. However, after several years, he moved to Chicago and founded the Van Depoele Electric Company. He believed that trolley cars could successfully be adapted to electrical service and by 1883 he had successfully operated an electric trolley car. By 1884 he had installed a functional system in Toronto, Canada.

Baltimore had successfully installed his system on August 10, 1885. On November 14, 1885, the *South Bend Saturday Tribune* announced the establishment of his system on the Michigan Street line. Boasting, the *Tribune* reported the following:

> South Bend will be accorded the honorable distinction of being the first city in the United States to have within its corporate limits a perfect operating system of electric street railway. A system was recently introduced at Baltimore, Maryland, but it was only inaugurated as an experiment.[5]

Whether or not Baltimore's system was experimental is questionable. Baltimore claims that it ran for four years before major repairs were needed, then the city returned to horse drawn trolleys. On the other hand, South Bend also had problems with its system and returned to horse drawn trolleys by 1886.

By late 1885, Notre Dame had installed its own electrical system. Their triumph of electrical engineering was lighting the golden statue of Our Lady. According to an enthusiastic *South Bend Daily Tribune* article on November 18, 1885:

*Friends paid their last respects to Schuyler Colfax, laid out in the St. Joseph County Courthouse, built in 1854. It was the largest funeral in South Bend history until the 1930s. Colfax died in Mankato, Minnesota on January 13, 1885 while on a speaking tour. (Courtesy St. Joseph County Public Library.)*

The whole dome is the center of a halo of glory. The statue of Our Lady is 18 feet from the foot to the crown. Around the head is a corona consisting of 12 Edison incandescent stars. At the base of the statue is a crescent, or half moon made of 227 incandescent stars. In addition to these there are 94 lights in the two study-rooms of the main building and a large chandelier, making 104 in all.

In March 1886, a fire on the West Race destroyed nearly all of the same companies as the 1883 fire.

South Bend was in the middle of a prosperous decade when disaster struck again. On September 22, 1886, the new fairgrounds (now Potawatomi Park) opened its fifth annual fair. Rain had pelted the city for the past week, but had ceased in the early morning. However, by 1 p.m., the clouds had again gathered. At 2 p.m., the wind began blowing from the southwest and a few minutes later, a peculiar looking cloud could be seen coming from the north following the Niles Road on the Notre Dame side of the river. As the cloud reached St. Mary's

Academy dust began rising from the ground. The wind strengthened a little, then suddenly fell. At 2:15 p.m., a light rain began falling. Then hail began to pelt the ground. In less than five minutes, hailstones the size of walnuts and some the size of hens' eggs covered the ground.

Almost every glass window on the north side of every house and business was shattered. Unprotected horses bolted into the streets, knocking down anything in their paths. Hail slashed through thick wooden siding, window curtains were ruined, and children became hysterical. At the fairgrounds, a tree blew down across the Economist Chilled Plow Company building, but no one was injured. At the corner of Main and Washington Streets, hailstones found after the storm still measured an enormous 11 inches in circumference and were thought to be larger when they had first fallen.

Between 12,000 and 15,000 panes of glass were broken at the South Bend Iron Works. All the glass in McDonald's Photographic Gallery was destroyed. Studebaker carriage painters, who only days ago had finished painting finely detailed carriages for the fair, now huddled with other wagon workers beneath unfinished and half-painted vehicles as jagged glass from 10,000 panes slashed dangerously close.

All the churches in the city were heavily damaged. The skylights at the *Tribune* printing office and bindery were smashed and the glass and hail drove down on

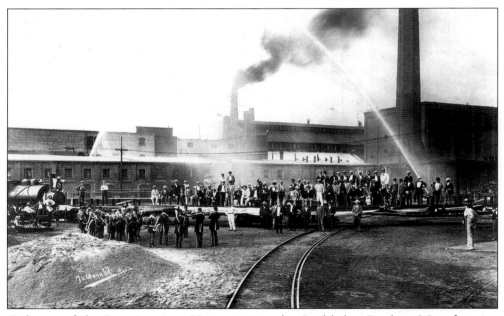

*Delegates of the Pan American Union visiting the Studebaker Brothers Manufacturing Company in 1889. They also visited the Singer, Oliver, and Birdsell factories. The nationwide tour paved the way for local manufacturers to expand their markets to Central and South American countries.*

unprotected girls. The Oliver Opera House suffered no broken panes, but the hail slashed through the tin roof and water poured through onto the furniture below.

Dead English sparrows cluttered the ground and a tin roof 24 by 30 feet square contained 163 holes. At Notre Dame, between $800 and $1,000 damage was done, but the church's stained glass windows had been spared by a wire netting protection. The Notre Dame commissioner requested 850 pounds of putty to repair other broken panes.

Within seven minutes, the storm was over, but cleanup took months. Dan Payne, a local glazier, ordered two rail car-loads of glass from Pittsburgh.

Later, on December 29, 1887, the four-story South Bend Toy Company was destroyed by fire. The company erected a larger plant on High Street.

In February 1889, Clem Studebaker finished construction of his new four-story residence, Tippecanoe Place. A staunch Republican, Studebaker had worked hard to help his friend Benjamin Harrison win the presidential elections. Whether or not he asked any political favors from Harrison is not known, but on April 24, 1889, Studebaker was selected to be a delegate to the First International American Conference. The United States had maintained diplomatic relations with almost all of the South American countries, but had not considered commercial relations with them to be economically important. However, the expanding industrial economy needed new markets and the South American countries were waiting. Tariff issues, as well as other concerns, eventually led to the convening of the countries in Washington on October 2, 1889.

Harrison chose a cross section of Republicans, Democrats, and Protectionists, as well as those favoring free-trade, to attend the conference. Among the delegates were Andrew Carnegie, Cornelius N. Bliss, and Clem Studebaker, while the South American countries chose their best lawyers, senators, and key government officials. Before the actual conference began, the delegates were given an exhaustive 42-day tour of the large industrial cities of the United States. The tour began on October 3.

On October 9, while at Worcester, Massachusetts, Studebaker received word that Tippecanoe Place had been destroyed by fire. Studebaker returned immediately to South Bend to find that already over 150 large loads of debris had been hauled away and dumped in the city park. The walls and chimney still stood, supported by heavy timbers propped against them. He worked feverishly to repair the mansion, setting up a temporary roof over the second floor and wiring the delegates to come ahead to South Bend.

Studebaker had worked hard to get South Bend put on the tour list: the tour committee had resolved not to visit any city whose population was under 50,000 people. But Studebaker argued that, though South Bend had a mere population of 20,000, the city turned out more manufactured products per capita than any other city in the nation. It had the largest plow, wagon, sewing machine, and clover huller factories in the world. To prove his boast, Studebaker vacated a space 50 by 200 feet in his carriage repository north of the post office and allowed the South Bend and Mishawaka manufacturers to display their products in it.

Inside the repository were the products of South Bend Woolen Company, A.C. Staley Manufacturing Company (knit goods), Wilson Brothers (shirts), Singer Sewing Machine Company, Roper Furniture Company (from Mishawaka), Alexis Coquillard (carriages and buggies), South Bend Cement Works, South Bend Seeder Company (seeders and potato-pickers), John Chockelt (wagons and carriages), Boyd and Hillier (sash, doors, and blinds), Charles Steele (harness), C. Liphart (furniture), O'Brien Varnish Works, N.P. Bowsher (combination feedmills, speed indicator, etc.), Sibley and Ware (drill-presses and combination pulleys), E.S. Reynolds (paper-pulp and paper), Stephenson Brothers (wooden pumps and turned-wood work), Mishawaka Knit-Boot Company, South Bend Toy Company, Mishawaka Pulp Company, A. Russworm and Sons (leather goods), A. Wells and Son (sliding blinds), Amber Bone Company (dress-stays), Birdsell Manufacturing Company, South Bend Medicine Company, Dr. Whitehall and Dr. Miles (patent medicines), and Flora A. Jones, who displayed a complexion reviver.

Outside the building were the exhibits of the Perkins Windmill Company (of Mishawaka), the Bissell Chilled Plow Company, the South Bend Chilled Plow Company, the Economist Plow Company, and the St. Joseph Manufacturing Company (of Mishawaka). Berger and Susley showed a patent cultivator and the Westervelt Company was represented by a riding plow, drawn by a pair of goats.

At 8 a.m. on Saturday, October 19, Mayor Longley, Studebaker, Joseph D. Oliver, J.B. Birdsell, and the rest of the members of the reception committees were at the Michigan Central Depot where the delegates had arrived a few hours earlier, but were sleeping. The steam whistle of the Singer works, followed by five minutes of whistles and bells from almost every factory and church, announced the beginning of a procession that carried the delegates across the Jefferson Street Bridge and west on Jefferson to Michigan Street, where the carriage repository was inspected. As the delegation entered, Richard Elbel performed an original composition, the "Pan American March" on his piano.

From the repository, the delegation next visited the Studebaker Wagon Works, then the Wilson Brothers factory, and then the Oliver Chilled Plow Works. From the Oliver Works, the delegation traveled north on Chapin to Washington and east on Washington to the charred Studebaker mansion.

As Tippecanoe Place was inspected, one newspaper correspondent wrote the following:

> it was a curiously pathetic sight to witness the stars and stripes and flags of other Pan-American nations flaunting gayly in the sunlight against a background of fire-scarred walls and blackened chimneys, and as the party entered the house and saw the terrible havoc wrought by the fire in the once sumptiously finished home, they freely expressed to their host their profound sympathy.[6]

After lunch, the party moved to the Singer factory and, about 2 p.m., traveled out to Notre Dame where they met Father Sorin. The Hayne Cadets, nearly 100 strong, presented arms. Then the party traveled to St. Mary's where they boarded the train for Chicago and another 26 days of travel.

It wasn't until 1890 that electric street car service was tried again. This time successful, the company introduced it on the North Side, Mishawaka, Washington, Lafayette, and South Michigan Street lines.

Already successful as a grocer, furniture manufacturer, and plow manufacturer, John C. Knoblock combined with his son Otto M. Knoblock and partners William H. Miller and H.G. Miller to establish the Miller-Knoblock Wagon Company on July 29, 1890. Their primary product was sprinkler wagons. They located their factory at 1108 High Street.

By 1890, South Bend had grown to 21,819 people. The native-born population was 15,659. Early immigrants were having their own children now and although they still had foreign names, they were born in South Bend and were native American citizens. The foreign-born population was 6,160. The African-American population had risen to 283. Whether or not it had been planned, by 1890, ethnic communities were everywhere in South Bend. Their placement was heavily influenced by where they worked. The first factories had settled near Lowell, and Irish, French, and Germans were the main settlers in this region.

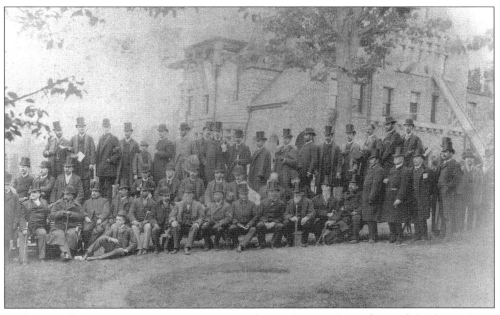

*Delegates of the Pan American Union pose for a photograph in front of the burned out Tippecanoe Place, the Clement Studebaker Mansion. None of the delegates were prepared for the destruction that they saw. By the time they arrived, more than 150 large wagonloads of debris had already been dumped in the city park.*

NATIONAL UNION

OF THE

UNITED BREWERY WORKMEN

OF THE UNITED STATES.

National-Verband der Vereinigten Brauerei-
Arbeiter der Vereinigten Staaten.

No. } *31.*
No. }

BOOK OF MEMBERSHIP.
Mitgliedsbuch.

Name : } *Henry Henning*
Name : }

Where Born ? } *South Bend Ind.*
Geburtsort : }

When ? } *July 15th 1874*
Geburtstag : }

Initiated : } *6 March 1902*
Eingetreten am : }

in L. U. No. } *272* Branch : } *Brewery Workers*
in L.-U. No. } Branch : }

Locality : } *South Bend Ind*
Ort : }

*Charles Gebauer,* } Secretary.
} Sekretär.

Press of S. ROSENTHAL & Co., 15–27 W. 6th St., Cincinnati, O.
1901.

*South Bend had several breweries. Most workers were German and joined a brewery worker's union. Each worker had a small booklet in which they pasted stamps to show that their dues were current.*

Studebaker and Oliver provided houses for some of their workers, who lived roughly in the areas between Walnut Street and Fellow Street and Indiana Avenue and Sample Street, creating German and Polish communities. There were a number of Swedes who lived in the area around Lafayette Street to Michigan Street, and Sample Street to Ewing Avenue. Some Hungarians also lived here, but most of them lived a little farther south and west, along Ewing Avenue to Indiana Avenue and Main Street to Olive Street.

Many Irish worked for the O'Brien Electric Priming Company, but a large number of the workers were Polish who lived in an area west of Meade Street to Walnut Street, and from Western Avenue to Lincoln Way West. This area overlapped part of the area covered by the Poles who worked for Studebaker and Oliver. A large German community lived between Lincoln Way West and Portage, settling on Meade, Sherman, and Van Buren Streets, Cottage Grove Avenue, and the area formerly occupied by Camp Rose.

Both the Birdsell Manufacturing Company (with several hundred workers) and South Bend Toy Company (employing about 200 people) may have drawn heavily on workers living near their factories. Few Polish or Hungarians settled there in any kind of ethnic pattern.

Wilson Brothers Shirt Company had originally come to South Bend in 1883 and soon outgrew its second-floor location in downtown South Bend. The company purchased land on Sample Street from Oliver, with the stipulation that it would hire 1,000 women within 10 years. The company drew its workers from the same ethnic groups as Oliver and Studebaker. By the turn of the century, it was employing 950 women and 75 men and making 2,600 shirts each week.

Each neighborhood had its own shops, bakeries, banks, restaurants, and laundries. The corner of Washington and Walnut was a bustling, thriving community of Poles and Hungarians. A small line of scattered businesses developed on Michigan Avenue (now Lincoln Way West) from Williams Street West. Businesses on Michigan Street expanded south beyond Tutt Street. Near this area, a small group of citizens tried to form the town of Myler. As the population rose, so did social problems. The Woman's Missionary Society of First Methodist Episcopal Church responded to this need by opening Epworth Hospital in 1891 as a home for "unfortunate girls."

By 1890, Germans had become the largest single ethnic group in the United States and their tradition of beer making and drinking increased the number of saloons. The Anti-Saloon League was established in Oberlin, Ohio in 1893 as a response to the increasing number of saloons nationwide. The league soon had a vital partnership with the Women's Christian Temperance Movement and strong supporters like Emma Molloy, who preached against the dangers of alcoholism. South Bend reflected the national trend in the increasing number of saloons. In 1880, there were 18 in South Bend. In 1891, there were 75. By 1900, there were 100 "sample rooms."

Taking advantage of a recently passed Indiana statute, South Bend replaced the town marshal with an organized police force headed by a superintendent of police. On March 25, 1893, the Board of Police Commissioners appointed City Marshal Benjamin H. Rose as the first superintendent of the metropolitan police force.

The Polish National Alliance Library started a small library of Polish language books in 1893 and housed them in the Z.B. Falcon Building at 1103 Western Avenue. In that same year, the 48th Indiana Infantry held its annual reunion in South Bend, passing in review before Norman Eddy's house on Main Street. His wife and family reviewed the parade.

Another panic hit the United States in 1893. In fact, it was more than a panic; it was the worst financial disaster ever to occur in the United States up until that time. It began as a small contraction in the economy in early 1893 that recovered by June of 1894, grew a little until December 1895, then dipped again and did not recover until 1897. Nationwide, agriculture had given way to manufacturing as the major source of employment, although the number of farms increased. Labor saving devices, a slow turn to mechanical machinery such as Birdsell's clover

huller, and better agricultural techniques, such as Oliver's chilled plow, allowed more food to be grown on less land. Corn, wheat, and cotton flooded the markets, driving down prices. Farmers were unable to make payments on wagons, plows, and farmsteads. In turn, banks could not receive money and had no capital to invest in new ventures.

Everywhere employment tumbled, sales were low, and, in some areas, frustrated workers struck railroads and factories. Studebaker closed its plants for over five weeks, then took back only a limited number of employees. By the end of the year, sales had fallen nearly $400,000. The economy did not begin to recover for nearly two years, yet immigrants continued to move to South Bend. It has been estimated that nearly 10 percent of the American work force was unemployed for nearly six years.

By 1896, the economy had slowly begun to improve and Thomas Sarantos opened his own peanut stand on the Corner of Washington and Michigan Streets. That same year, the Indiana Department of the Grand Army of the Republic, a political organization organized by Union soldiers, held their annual reunion in South Bend, amid parades and much ceremony.

Jerzego W.F. Kalczynski inaugurated the *Goniec Polski* (*Polish Messenger*) on June 27, 1896. Published in Polish, it remained politically neutral and was a major newspaper until it ceased publication on December 20, 1964. The public library opened its own building at the corner of Main and Wayne Streets in 1896.

The sinking of the United States Naval ship *Maine* in 1898 had taken South Bend by surprise, but its citizens were ready to fight and the 157th Indiana Infantry, under the command of Colonel George Studebaker, was the first unit to be called to military service. Although mustered in and sent to the southern states for training, it never left the United States. The Studebaker company received a contract to provide 500 wagons for the war. Though heavily involved with wagon and carriage making, by 1899, Studebaker had become involved with building bodies for electrical cars made by other companies.

The Winkler brothers had used up the last of their available property by 1894 as demand for their sprinkler wagons increased. They sold the patent for their sprinkler wagon to the Studebaker brothers in 1899, then bought 25 acres of land west of South Bend, where they built a three-story factory for producing stake trucks, sprinklers, bakery, furniture, ice, coal, and oil wagons. By 1920, the brothers had died and the property was sold.

Although South Bend had many fine hotels over the previous decades, including the St. Joseph Hotel and the Dwight House, James Oliver felt that they had outlived their times and a new hotel was needed. On December 21, 1899, Oliver opened the Oliver Hotel, "the best and most magnificent hotel in Indiana, one of the finest in the United States, and the best in any city of 40,000 inhabitants in the world."[8] The six-story fireproof hotel was Italian Renaissance, embellished in gold, yellow, and green. The banquet hall was paneled in crimson silk, the ladies parlor done in Louis XVI style. Although the building had cost nearly $600,000, the room rates ran from $2 to $5 per day.

# 6. A New Century

The year 1900 was the beginning of a new century and further city expansion. Nearly 14,000 new people had been added to the census, making South Bend's population 35,999. The African-American population had increased to 572. The leading immigrant groups were now the Polish with 3,171 and the Germans with 2,402. There were 733 Hungarians and 236 Irish. Sweden had 549 immigrants in South Bend. Belgians numbered 411 and there were 421 Canadian immigrants. A smattering of other countries contributed populations of less than 50 people each. There were 19 Italians living in South Bend.

A few Greeks lived in South Bend before 1900, but most did not start arriving here until after the turn of the century. Although they came from all parts of Greece, most of those coming to South Bend had lived in southern Greece. Some also came from Turkey, Crete, and the islands. Many were self-employed, opening up restaurants, candy stores, fruit stores, and shoeshine parlors. They did not set up an ethnic community, but easily blended into whatever areas they choose, including German, Polish, and Hungarian neighborhoods.

Like other European immigrants, Greeks also went to work in the factories. But they remained only long enough to accumulate enough money to start their own businesses. Greek immigrants Eustice, Andrew, and Pendel Poledor established the Philadelphia in 1901. At first a small confectionary and candy-making store, by the 1950s, the store had grown into a three-story ice cream shop where teenagers spent long afternoons over large sodas and ice cream.

John Chess Ellsworth had successfully managed to compete with the old merchandising firms of George Wyman and Moses and Meyer Livingston. By 1901, he was considered to have the most extensive and up to date dry goods establishment in the city.

In 1901, the South Bend Iron Works was incorporated and the name was changed to the Oliver Chilled Plow Works. In that same year, a survey showed that there were 8,310 factory employees living in South Bend. Studebaker employed 2,225 of them, Singer employed 1,667, Oliver Chilled Plow Works had 985, and there were 678 working for Wilson Shirt factory. These figures differ from the total number of employees mentioned elsewhere in this book because these only state the workers living in the city limits, not those living outside of the city limits.

On February 27, 1902, the Anderson Chilled Plow Company at 212 West Ewing Street was completely destroyed by fire. The Singer Sewing Machine Company made plans to move from its factory on the St. Joseph River to 50 acres of land on Division Street between Walnut and Olive Streets. The factory was completed in 1902. By this time, they had nearly 3,000 workers. Many Poles and Hungarians were employed by Singer and could be found living on both sides of Division Street from Sample Street to Washington Street and roughly from Chapin Street to west of Meade Street.

Most Hungarians did not arrive in South Bend until between 1900 and 1910. As more Hungarians arrived, they began a slow migration into areas between Walnut Street and Main Street, Ewing Avenue, and a little north of Indiana Avenue.

The large population meant more street improvements, lights, sewers, and a variety of other expenses incurred by the city. At the same time, expanding work required more room and, by 1901, it was plainly evident that a new city hall was the only answer. But the added expenses had already eaten into the city's treasury and there was no money for the hall. James Oliver promptly stepped forward and built it at his own expense. Then he sold it to the city for $1.

The Young Men's Christian Association had outgrown its second building at 122–124 South Main Street by the turn of the century. On December 31, 1902, the Studebaker Brothers' Manufacturing Company offered to build the association new facilities at the corner of Main and Wayne Streets across from the public library. The new building was finished in 1905.

The Miller-Knoblock Wagon Company announced that it would cease production of sprinklers and other wagons to devote its energies and plant exclusively to the business of making electrical motors and dynamos. The name was changed to Miller-Knoblock Electrical Manufacturing Company. Two new departments were created: one would be a copper drop forging plant for making commutator segments used by the company in its commutators, and the other would be a magnet wire covering plant for making insulated wire. There were no copper drop forging establishments west of Cleveland and only three magnet wire plants west of New England.

Although the company did not remain in business for many years, it contributed greatly to aviation history. In 1903, Orville and Wilbur Wright were searching for a magneto that would enable them to keep their motors working properly while they experimented with attempting to fly an aircraft. On December 17, 1903 at Kitty Hawk, North Carolina, they made their first successful flight using the Miller-Knoblock magneto No. 188.

The company may have also been instrumental in bringing George Cutter to South Bend. Cutter, already established in Chicago, had been involved for many years with Thomas Edison and others in electrical inventions. He had been a major salesman for the Thomas-Huston Company.

Cutter moved his factory to South Bend, possibly as a result of the large amount of copper wire readily available for making street lamps. Within the next

*In 1901, South Bend was desperately short of city office space and James Oliver provided the money for the construction of this new city hall. Oliver also oversaw the construction details. When the construction was finished, he sold the building to the city for $1.*

decade, his street lights would be lighting all of South Bend and part of Mishawaka, and were shipped around the world. His factory was later used as the garages for South Bend street cars and is now the Transpo bus garage. Shortly before his death, he sold his business to the Westinghouse Company, and continued to manufacture street lights for them.

Cutter lights were used extensively in the newly developed Leeper Park, now recognized as a historic landmark because of its early use of the "Park and Boulevard" system, developed by famed landscape architect George Edward Kessler. Kessler remodeled Leeper Park and the surrounding area in 1912. Cutter established a close relationship with Kessler and, from that point on, Kessler used Cutter lights in almost every park that he created.

Clement Studebaker Jr. became involved with his own company in 1902. With several investors, he bought the Columbus, Ohio Watch Company. In 1903, the company was in new headquarters on Mishawaka Avenue, operating under the name South Bend Watch Company. It also produced watches under the name Studebaker Watch Company.

A business men's club had been organized by 1902 and the South Bend Metropolitan Police Force was officially named the South Bend Police Department. In his annual report, the chief of police indicated the need for sub-stations to cover the growing suburbs. The city had over 3,000 miles of streets to protect.

In 1863, Peter Navarre, son of Pierre Navarre, had sold the Navarre estate to land speculator Alexis Coquillard. Coquillard then held onto the land until 1866, when it was purchased by Samuel Leeper, who farmed it. Large deposits of yellow clay were discovered and the property was developed into a brickyard in 1882. The bricks proved to be an excellent source for constructing Notre Dame's buildings as well as providing paving bricks for Washington Street. In 1902, the Home Improvement Corporation purchased the land and, by the end of the following year, had filed a plat for the Navarre Place Addition, which included an area from Michigan Street west to Lafayette Boulevard and from the river to what would develop into Angela Boulevard. Navarre's (probably second) cabin was eventually removed from the property and placed in Leeper Park.

In 1904, the Studebaker Company purchased the Garford Manufacturing Company of Ohio and put its own automobile on the market for the first time. George A. and Willard Robertson opened a small store at 127 S. Michigan Street, and the Birdsell Manufacturing Company was rapidly expanding, producing 15,000 wagons and 1,500 clover and alfalfa hullers every year. It had nearly 600

*This image shows police patrolling the river, c. 1900. Many people lost their lives on the river when their canoes and small boats ventured too close to the dam and were swept overboard by the heavy currents.*

factory workers. A small area called River Park was developing about halfway between South Bend and Mishawaka, hoping to make itself into a successful city. The Kelley Business School, friendly rival of the South Bend College of Commerce, began in 1906.

James Oliver passed away on March 2, 1908. Later that same year, the loosely organized businessmen's club reorganized as the Chamber of Commerce, whose main function was to promote every aspect of South Bend business and culture.

By 1909, there were 218 industries in South Bend employing 13,609 workers. With the desperate need for more electrical power for city merchants and for operating heavy machinery, the St. Joseph River was harnessed with a dam. Unlike previous dams, it had no lock, virtually ending river navigation between Mishawaka and Niles. Dams had already been established along the river in Elkhart, Mishawaka, Niles, and Berrien Springs. An efficient electrical rail system also ran through South Bend from Chicago to Elkhart, with several small feeder lines.

Nearly 18,000 more people were living in South Bend by 1910, making the population 53,684. The African-American population was now up to 604. The foreign-born population was again led by the Germans (5,347), followed by the Hungarians (3,829). Russians, who had a population of only 40 in 1900, now had a population of 1,125. Many of them were Jews escaping religious prosecution. The Polish population was not listed, but was most likely included in the German and Russian statistics. The Italian population had increased to 121, making it one of the fastest growing ethnic groups in the city.

Religious advocates had a wide variety of services to attend in 1910. There were three Jewish synagogues: Temple Bethel, Sons of Israel Synagogue, and Abos Sholm Synagogue. There was one Adventist church, four Baptist churches, three Church of the Brethren, three Christian churches, one Christian Scientist, one Episcopal church, six Evangelical churches, one Free Methodist, three Lutheran churches, seven Methodist Episcopal churches, including two African Methodist Episcopal churches, five Presbyterian churches, one Reformed, one Salvation Army, one United Brethren, and eight Roman Catholic churches. Swedish could be heard in one Baptist, one Evangelical, and one Lutheran Church. German could be heard in Lutheran, Evangelical Lutheran, Methodist Episcopal, and Roman Catholic services. Hungarian could be heard in Presbyterian and Roman Catholic churches. Polish could be heard in several Roman Catholic churches.

South Bend schools coped with the language problems by teaching students in German, Hungarian, and Polish. Many Catholic churches also had their own schools and taught in their native languages.

Greek immigrants Theodore and Angelo Tsiolis established the LaSalle Confectionery at 530 East LaSalle Street in late 1910 or early 1911. In his book *The Greeks of Michiana*, Milton Kouroubetis lists over 200 businesses started by Greeks between 1915 and 1980.

St. Stephen's Roman Catholic Church was erected on the corner of Thomas and McPerson Streets in 1910, replacing the small St. Mary's German Roman

Catholic Church where they had been worshiping earlier. The South Bend School System bought Joseph Oliver's house in 1911 and promptly tore it down to make a new high school.

In February 1911, gypsy violins were playing while 2,000 people dedicated the Magyar Haz (Hungarian House) at 316 South Chapin Street. Also, 30,000 people witnessed Rene Simon's flight in South Bend in 1911. It was the city's first recorded airplane flight.

The Hungarian language newspaper *Magyar Tudosito* made its first appearance on June 14, 1911, but only lasted until 1919. It was replaced by the *Varosi Elat*, which first appeared on April 25, 1919 and continued to be published until January 30, 1953.

On May 14, 1913, the *South Bend Tribune* reported the death of George Wyman. The article gave Wyman a large tribute, just one of many that he would receive. "It is probable that the dry goods houses of the city will close during the hours of the funeral," the paper reported.[1]

Local breweries had long been sponsoring baseball teams and the free advertising had increased business. In 1913, the Muessel Brewing Company decided to extend its advertising campaign by sponsoring a local football team. It chose the Norwegian-born captain and end of the Notre Dame football team as its coach. By the end of the season, Knute Rockne's team was undefeated and had only one tie.

By 1914, South Bend had ten banks and five building and loan associations. Two of the associations were Polish (Sobieski Building and Loan Association and Kosciuszko Building and Loan Fund Association). The Chapin State Bank, on the corner of Chapin and Division Streets, was the only bank to have Polish officers. It was also the smallest bank, with capital stock of only $50,000. No other ethnic group had its own bank or building and loan associations.

There were 190 "sample rooms" and 17 cigar manufacturers were established in South Bend. Among the largest were the Goetz Cigar Company and Michael Hazinski, which produced over 1 million cigars every year.

Singer employed nearly 3,000 workers in its Western Avenue location in 1914. But it would soon lose most of its overseas customers as war broke out in Europe on June 28, 1914. Oliver also shared the same fate. By September, the plant was running only 60 percent of capacity and, by December, the plant was employing only 2,000 workers four days per week. Oliver had lost 1,000 workers.

Studebaker and Oliver continued to provide housing as quickly as possible. Some of the housing shortage was absorbed by "hotels," which in many cases were nothing more than a neighborhood grocery or retail store with four or five rooms on the second floor. Officially, the city had 11 hotels for visitors spending time or for those who preferred living a more leisurely life, and an unknown number of "hotels" scattered in various ethnic neighborhoods. There had been complaints of a housing shortage for years, but nothing had officially been done about the matter. Some neighborhoods still had no running water or electricity. Some areas were nothing more than shacks.

The *South Bend News Times* ran an expose on inadequate houses and slums on April 4, 1916. For such a small town, it seemed that few people knew of the horrible conditions. On the west side of the city, according to the *Times*, the worst section was "Maggie's Court":

> Maggie's Court opens off the six-hundred block of Division St. It is entered through a narrow passage way between a fruit house and a meat market and runs back to Taylor court, a distance of 150 feet or so. It is an open court—nothing but a big back yard—all of which is owned by one man. The fruit house is a comparatively new two-story building, the lower floor being used for the storage of fruit, while on the second floor two families live. The meat market on the opposite side of the passageway is a one story building set on the front of a two story residence recently sold by the owner of Maggie's court to a Jewish family. At least two families live in the residence part. Back of this is a second two story building occupied for living purposes by one family

*Michael Hazinski's cigar company on Chapin Street manufactured over 1 million cigars every year for many years. Hazinski was also president of the Chapin Street Bank, the first city bank to be owned by any ethnic group.*

*By 1890, South Bend was beginning to spread out into many beautiful suburbs, including Chapin Park. All of these beautiful scenes failed to show the poverty and close quarters shared by groups on the west side.*

and back of that, across an intervening open space is a double shack occupied by two families. Back of the fruit house is a two story dwelling in which one family lives and back of that, directly across from the two story shack, is a row of three plaster-covered shanties—a total of nine buildings and at least 11 families.[2]

Water came from a pump in the center of the passage between the row of shacks. The *Times* continued:

A few feet from the pump is an open cesspool, looking into which you can see, not five feet from the surface of the ground, a pool of gray, slimy water with bits of decaying matter floating around on top. Sewerage consists of a series of filthy privies not more than six or eight feet from the back doors of the houses. In summer time the court swarms with children. The only place they have to play beside the street through which the railroad runs is the court filled with rubbish, ash piles, old lumber—a large assortment of nobody's dirt.[3]

Other areas singled out were at the intersection of Prairie Avenue and Scott Street, Napier Street behind St. Hedwig School, and an area between Division and Napier Streets near Perkins and Pine. The corner of Division and Arnold was

severely criticized: "At the rear of the lot on which these houses are built is the common privy, a vault over which stands a ramshackle shanty with 12 entrances, six on one side and six on the other. As many as 54 persons have been known to use this."[4]

The east side was also criticized:

> Running off from the north end of Emerick St., is Neddo court, an unpaved alley long known in the annals of the Associated Charities and other like organizations as "Little Italy." On a narrow strip of land between the alley and the river are located some nine houses, some of them occupied by one family, some by two, some by three. In one of them lives three families, one Negro, one Italian and one Hungarian. All these families share in common the horrid alley and the uninviting "yard." One woman who has lived there 40 years showed us with a certain amount of pride how she had helped build out the land in that length of time by throwing her trash on the embankment. She pointed out that whereas the distance from her back door to the river bank hadn't been more than six or seven feet 40 years ago, it is some 10 or 11 now.[5]

The *Times*'s diatribe continued:

> We have brought to the city thousands of workmen and annually tempt more to come without making any adequate provision for housing them and protecting them and ourselves from the scourge of physical and moral filth which arise from congested conditions. Their wages are such that they must map small rents. Property owners in the district where these workmen live have taken advantage of this necessity to erect and maintain living quarters unfit for human habitation for which they exact rentals entirely above a just interest on their investments. The owner of Maggie's court gets $8.00 a month, we are informed, for each of the houses on the rear of his lot.[6]

A month later, Dr. C.S. Bosenbury, secretary of the Board of Health, went before the city council to request $2,000 for a housing survey.

# 7. INTOLERANCE

Europe had gone to war in 1914 and many Americans knew that it was only a matter of time before the United States was drawn into the conflict. By 1916, St. Joseph County citizens were being urged to plant more crops and raise more chickens. One main concern was the protection of the food crop, especially potatoes, from bugs. A bulletin was issued with a recipe sure to protect the crops, as reported by the *South Bend Tribune* of June 16, 1917:

> From six to eight pounds of arsenic of lead is gradually added to several gallons of hot water with constant stirring for at least 10 or 15 minutes. It is best to do this the day before it is to be used in spraying. This is enough to make 100 gallons of spray. Two quarts of glucose added to the formula for each 100 gallons will glue the poison to the foliage. Of course, it is highly important that the spray is applied in a very fine mist which will cover every part of the plant. One thorough application will do more than half a dozen carelessly applied applications.

At 6:30 a.m. on October 23, 1917, a light 75-millimeter French howitzer cracked angrily. Battery C, 6th Field Artillery of the American Expeditionary Force had just fired the first American shot one-half mile across No Man's Land into the German trenches. Three of the four men in the unit were German Americans. The unit was commanded by Alexander L. Arch of South Bend, Indiana.

At first, some believed that the shot had been fired by Sergeant Frank E. Logan, a homegrown South Bend lad of Irish descent, but research proved that he was not a member of the unit. Then another South Bend lad, John Howard Pittman, was named as the American sergeant. However, a *Tribune* interview with his mother indicated that he had only recently completed basic training and had just been promoted to corporal.

Finally, the *Tribune* was informed that Arch had given the order. Arch, born in Austria-Hungary in 1894, was eight years old when he immigrated to South Bend. He worked for several years at Studebaker before entering military service in 1913.

America's entry into the war changed everything for South Bend immigrants. The large ethnic communities were suddenly thought to be potential hotbeds of

*Sergeant Alex Arch gave the order for the first American shot fired in World War I. Arch was born in Austria-Hungary and emigrated to the United States as a youngster. The remaining members of the gun crew were all German Americans.*

intrigue and old time citizens saw foreign enemies everywhere. For the first time, it was no longer a "good thing" to be German or Hungarian. To prove their patriotism to their new country, German was no longer spoken or taught in school. Churches whose services had been in German now offered English only. Parents stopped speaking German at home. Fearing deportation, immigrants who had not already done so flocked to the courts to obtain citizenship papers.

Every manufacturer in South Bend was desperately short on labor and the labor market had shrunk when the war nearly stopped all immigration. Women eagerly took jobs, wishing to show that they too wanted to participate in the war. Yet even with the addition of women to the workforce, some companies still needed more help. They found their answer in the African-American populations in Kentucky, Tennessee, and the Deep South where most labor was low-paying agricultural work. These African Americans soon found higher wages and better working conditions in South Bend.

In October 1918, government officials from Washington, D.C. arrived in South Bend to survey the severe housing shortage. The South Bend Police Department was instructed to distribute a questionnaire to all stores, laundries, railway offices, hotels, restaurants, and other businesses employing more than three people. The questionnaire asked what the line of business was, the number of males and females employed, both white and African American, the number of women doing work formerly done by men, and payroll information.

During the next two months, several hundred workers were expected to move to South Bend to fulfill government contracts. The survey showed that there were 203 empty houses, some of which were in desperate need of repair. The government officials assured Mayor Franklin Carson that another 200 houses would be built by the government.

During the last stages of the war, an unknown disease attacked both sides of the trenches. Most people called it the Spanish Influenza, but the Spanish called it the French Influenza. It was neither. Historical evidence indicates that the influenza most likely originated at Fort Riley, Kansas in early 1918. Several cases of the influenza were reported in St. Joseph County in early September, when many troops were beginning to come home, but on October 3, Dr. E.C. Hansel, president of the St. Joseph County Board of Health, reported that there was no epidemic in St. Joseph County at the present time.

Over the next several days, however, the *Tribune* reported several cases of local soldiers and sailors who had died of the disease either in military installations or overseas on the lines, as well as an increasing number of local residents. The January 1, 1919 issue of the *Tribune* reported death statistics for 1918: 54 South Bend residents died in September, 216 died in October, 159 in November, and 120 in December. According to the *Tribune*, "pneumonia, in most cases developed from attacks of influenza, caused the death of 824 persons during the year and influenza is reported as the direct cause of seven deaths." Eventually, 600,000 Americans died from the disease.

*South Bend loved parades. This early parade, possibly around 1916, showed true patriotic spirit. Parades were held in downtown South Bend on various holidays every year. A small ethnic festival or summer parade still takes place in early summer.*

Peace was announced at 2 p.m. on Monday, November 11. The entire city was decorated with flags and patriotic symbols. Factory whistles blew and church bells chimed. Even before the official announcement, thousands had gathered in front of the courthouse to form a parade. The *South Bend News-Times* estimated that 50,000 people had participated in a formal parade that began in front of the Chamber of Commerce at 7:30 that evening. Two bands led the group to Leeper Park, where they lit a huge bonfire that could be seen several miles away.

Passage of the 18th Amendment to the Constitution of the United States in 1919 prohibited the manufacture, sale, or use of intoxicating liquors. The amendment had only a minor affect on Kamm and Schellinger or the South Bend Brewery. They bottled soft drinks. No sample rooms were listed in the city directory, but many of the owners remained in business as restaurants, cigar stores, or other assorted businesses. Muessel closed.

The postwar boom and demand for automobiles allowed Studebaker to again expand its facilities in 1919, relieving some of the job shortage. At the same time, it created a housing shortage. The Chamber of Commerce estimated that 4,000 houses would be needed within the next two years.

Brash Vincent Bendix arrived in South Bend in late 1919 with a dream. He was already famous and receiving a nice income from his royalties, having invented the automatic starter drive for automobiles in 1911. Chevrolet began using his starter in its cars in 1914. Bendix's bold lifestyle and flair contrasted sharply with solid South Bend residents and his desire to establish an automobile plant rankled the Studebaker Company, which wanted no local rivals. Despite the opposition, Bendix purchased the three-story Winkler building and began to go to work making automatic starters.

The 1920 population had risen to 70,193 with the African-American population doubling to 1,269. The Polish population was now the largest foreign-born population at 4,229. Hungarians comprised the second largest group at 3,229. The number of foreign-born Germans dropped from 5,347 in 1910 to 1,741 in 1920. However, it should be remembered that the Polish had no census count in 1910 and their number was included in the count of Germans.

The Belgian population was 667. The Italian population rose to 193. Russians had dropped from 1,125 to 642, again possibly reflecting that many of the Russians in the 1910 census may have been Polish. Other ethnic groups recognized by the census had less than 500 people each. Although heavily outnumbered population-wise, there is no indication that African Americans lived in intentionally segregated neighborhoods, but instead were widely dispersed in a variety of neighborhoods, or had intentionally moved near other African Americans, just as the Polish, Hungarians, and other ethnic groups had done.

By 1920, Studebaker, Oliver, and Wilson Shirts were employing more than half the workforce in South Bend. The Stephenson Underwear Company, Birdsell Manufacturing Company, and South Bend Lathe also employed large numbers of workers.

Times had changed at the intersection of Chapin and Division Streets. In 1910, both Division Street and Chapin Street were nearly all residential homes, mostly owned by Polish residents. By 1920, almost all of the residences were gone on Chapin Street from Washington Street south to Sample Street, replaced with small businesses, including Solomon Wolvosky (men's furnishings); Ivan Ispanovic (barber); Abraham Sherman (dry goods); Martin Fodor (steamship tickets); Alexander Henye (restaurant); David Feingold (clothing); Michael Gorbitz (soft drinks); Michael Dobos (shoemaker); Woodka Brothers (meats), Paul Kochavowski (grocer); Frank Wieczorek (meats); Nicholas Badowski (baker); and Morris Gilbert and Son (dry goods).

Division Street underwent the same transformation. The 1921 South Bend City Directory shows 16 banks with a capital stock of $3,431,700 and 9 building and loan associations with at least $9,850,000 in capital stock (some building and loan associations did not report their capital stock holdings).

Responding to the large increase in population, a surge in house building began in 1921 and continued through 1929, thanks largely to the cut in business taxes and an increased monetary supply from the federal government. By 1922, South Bend could boast that it was "World Famed" because of the large number of items exported overseas from local industries.

The *South Bend Tribune* made radio history in April 1922 when the company set up an experimental radio station, W9FP, in the third-floor ballroom of the *Tribune* building. The 10-watt station, started and managed by *Tribune* staff member Eugene Leuchtman, was one of the first radio stations in the country. A wind-up phonograph was placed in front of a telephone-line speaker and the first musical number played was Rachmaninoff's "Prelude in C Sharp Minor." The first formal program was on July 3, 1922. On the same date, the station's name was changed to WGAZ, short for the "World's Greatest Automobile Zone."

Ries Furniture Company of South Bend sponsored a music program on WGAZ shortly after the radio station went on the air. It was the first commercially sponsored radio program in the United States. The first play-by-play Notre Dame football game was aired on WGAZ on November 4, 1922.

In 1922, Vincent Bendix met with Henri Perrot, a French inventor, who had invented a four-wheel brake system for automobiles. Bendix returned with the American patent rights, then went about enlarging his factory. It was still a small factory in 1923, with 11 workmen and a large barren tract of land. Bendix went to work with a flair. By 1929, he needed capital to expand his plant and contacted Ford Motor Company in Detroit.

As the story was told by Oliver Freeman, a former Bendix Corporation employee, Vincent Bendix hired Sollitt Construction Company to put a large workforce on his vacant land, plant stakes in the ground, set up lines, and pretend that they were building a factory. Then he went to Detroit, persuaded Ford representatives to return with him to South Bend to see his plant already being constructed, and asked for a loan. Ford, seeing that Bendix was already well underway with construction, loaned him the money.[1]

The automatic starter and the four-wheel brake were just the beginning of Bendix's success. Within a few short years, the Bendix Corporation, also known as the Bendix Aviation Corporation, was one of the largest employers in South Bend and held patents on thousands of inventions.

By 1923, there were 1,500 Hungarians working at Oliver and 3,000 at Studebaker. For the previous 50 years, South Bend, Fort Wayne, and Indianapolis had received a large number of immigrants, while most of the rest of Indiana received few, if any. The war had brought many African Americans from Kentucky, Tennessee, and the Deep South to work in the factories. And postwar European refugees brought in more people.

This continued influx of new people brought concern to soldiers, who were returning from the war and looking for work. Prior to World War I, Indiana's workforce had been involved in agriculture. However, the increasing use of mechanized tractors and other farm equipment created a decrease in demand for farm workers, while at the same time, the demand for industrial workers was increasing statewide. By the beginning of the 1920s, over half of Indiana's workforce was involved in some kind of industry. In some cases, returning soldiers found themselves competing for jobs with newly arriving immigrants.

Overall, the state had a very small ethnic population. Most of the "foreign element" had settled in Indianapolis, Fort Wayne, and northwest Indiana, where

*Bendix Field was originally constructed by Vincent Bendix as a place where he could test aviation products. In 1931, Vincent Bendix opened his airport, which he sold to the city several years later. Bendix sponsored an annual flying contest for many years. Amelia Earhart visited South Bend several times before she disappeared on her fateful flight.*

115

*Knute Rockne's impressive record of Notre Dame football victories have not yet been beaten by any other Notre Dame coach. Before his death in 1931, Rockne set the greatest all-time winning percentage of .881. He collected 105 victories, 12 losses, 5 ties, and 6 national championships.*

manufacturing centers were major sources of employment. Eighty-two of the state's 92 counties had a foreign-born population of less than 5 percent. St. Joseph County had the second highest percentage of foreign-born population.

By 1920, the Ku Klux Klan had grown strong and David Curtis (D.C.) Stephenson became prominent as Indiana's grand dragon, also rising to prominence in the national organization. Through his charismatic influence, the state membership rose to nearly 240,000, making it the largest state organization in the nation. Over time, the Klan gained control of the Republican Party in Indiana on the state level. It may also have taken over the party on many local levels, but the *South Bend Tribune* claimed, "St. Joseph County politically has fought the Klan. Indeed it has been the outstanding county in opposing Klan candidates, nominees and party officials."

The Klan was organized in 1921 with strong anti-Catholic and anti-immigrant sentiments in addition to its more well-known anti–African American stance. The South Bend Police Department kept it under their watchful eye and refused to allow members to meet. In Indiana, the low population of African Americans and Jews worried the Klan, but not as much as the increasing number of Catholics. By 1924, there were 312,194 Catholics living in Indiana, or roughly 8 percent of the

entire state's population. (The 1920 Indiana census shows that the state population was 2,930,390.)

South Bend, like the rest of the Hoosier State, was swept up into this political arena. It had a small population of African Americans and Jews, but a large population of Catholics, due to the growing number of Polish, Hungarians, Irish, Germans, and Italians. The presence of the University of Notre Dame and St. Mary's Academy acted as lightning rods, bringing a large Catholic population to South Bend. The university also received a large amount of publicity from its football team. Knute Rockne had produced outstanding teams since his appointment in 1918 and both the team and university became nationally known.

Statewide, several Democratic newspapers had publicly come out against the Klan, but here it was the *South Bend Tribune*, a staunch Republican newspaper, that first made its stand against the group. Frank A. Miller, grandson of abolitionist B.F. Miller, led the fight against the organization, beginning with an editorial as early as December 18, 1922.

Valley Klan Number 53 was finally organized and met regularly on Monday nights. It first received newspaper publicity on January 15, 1923. W.T. Parker is said to have been the local leader and the Klan claimed a membership of between 600 and 800. By January 26, they were issuing propaganda cards, claiming that they would control African Americans and Roman Catholics. The first open-air meeting was held in April.

Nationwide, an opposing group, the American Unity League, had formed. A South Bend chapter was organized in early 1923. The *Tribune* continued with its articles against the Klan and lost some readers as a result of its stand. The *South Bend News Times* threatened to publish the names of known Klan members.

Minority merchants, especially Jews, were becoming concerned. Klansmen stood out in front of Maurice Nevel's clothing store, with arms folded across their chests, yet made no open threats. If some recollections are correct, it appears that the Jews were more concerned about the Catholic residents' safety.

On January 1, 1924, three 20-foot crosses were burned in Potawatomi Park. By February, Klansmen were publicly dispersing documents in the middle of the city. African Americans were also concerned that the AME church would become a target for destruction and Notre Dame students guarded it regularly.

The year 1924 was an election year and the state primary elections were held on May 7. Those in the Republican Party who were backed by the Klan won. Republicans without Klan support overwhelmingly lost. The *South Bend News Times* blasted the city's voters for staying away from the elections or not choosing their candidates more wisely. The Klan decided to celebrate its political victory with a large parade and picnic on Island Park in South Bend on Saturday, May 17. It invited Klansmen and women from Illinois, Indiana, and Michigan.

Police Chief Laurence Lane met with Notre Dame officials on Friday, May 16 and promised that there would be no parade, while the university officials promised to keep their students on campus. Many of the celebrants came in on that day, arriving by bus, automobile, the South Shore, and trains from Chicago

and many Indiana towns. What had started out as a parade and celebration for the Klan slowly turned into what some would later call the "Notre Dame Riot."

Nearly 2,000 people arrived to attend the parade and picnic, some parading through the downtown streets in their robes and hoods in the early morning of May 17. But Klansmen were not the only ones in town. Notre Dame students apparently formed into small squads to search out white hooded figures, then tried to take their robes. Fights broke out when unknown strangers carrying bundles thought to be Klan robes were confronted by Notre Dame students and South Bend residents mostly from the west side of the city. Students began street fights everywhere and had driven the Klan off the streets by 11:30 a.m.

Two Klansmen on the corner of Lincoln Way and Jefferson Street had their robes torn off and ran for shelter in a gasoline station. Around 1 p.m., Klansmen displayed a large "fiery cross" constructed of red light bulbs in a window of the Klan's offices on the second floor of a building on the corner of Wayne and Michigan Streets.

Over 100 Notre Dame students, joined by Polish, Hungarian, and Irish protesters began to gather, threatened the Klan and the building. The entire South Bend Police Department was called to active duty. An agreement was made, allowing the Klan to march to Island Park if they would not wear their robes. The Klan agreed and walked peacefully to Island Park where D.C. Stephenson gave his speech.

Then Notre Dame students guarded the Jefferson Street Bridge so that the Klan could not return downtown. Finally the students stormed the Klan headquarters and were confronted with a gun held by Reverend J.H. Horton of the Cavalry Baptist Church, declaring that there were women still in the building and he was trying to protect them.

Afternoon crowds found potatoes and other fruit handy weapons to throw at Klan members. Some claims have been made that at least one police officer aided the crowds by giving them sacks of potatoes. There were also claims that several police officers, in uniform, aided the Klansmen. Another 500 students left the campus and met at a pool hall, possibly in response to a rumor that a Notre Dame student had been shot or killed.

Louis Baker and his father were returning home Saturday afternoon after synagogue services when his father noticed two robed figures attacking a Notre Dame student. His father joined in the fight to aid the youth.

The local Klan called the Gary, Indiana Klan for reinforcements. Sunday being a day of rest, neither the Klan nor the students apparently continued their confrontation. However, when the Klan met on Monday for their regular business meeting, students were there in front of the office. So were the police, who managed to maintain control over the tense situation, but their nerves were strained. The Klan charged that the police force was biased, claiming that nearly 60 percent of the force was Catholic. Whether or not the percentage of Catholics was really that high has not been researched. However, a check of the police roster shows many Polish, German, Irish, and Hungarian names.

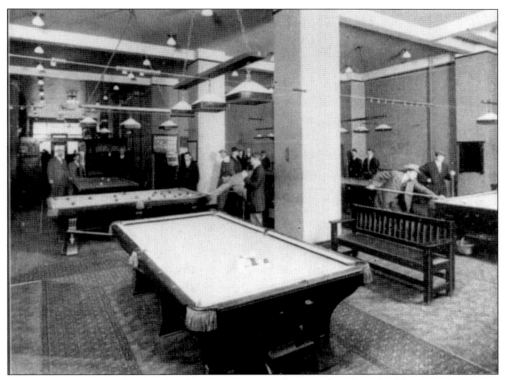

*On May 17, 1924, hundreds of Notre Dame students gathered at the Shafer and Platner emporium after hearing a rumor that a Notre Dame student had been shot or killed in a fight with the Ku Klux Klan.*

Finally, Mayor Seebirt called a conference with Klan and university representatives. From the steps of the St. Joseph County Courthouse, Father Matthew Walsh, president of Notre Dame, urged his students to remain peaceful. The riot resulted in eight arrests. Two charges were made against Klan members, but the rest were against students and others.

The fight was the high point of Klan activity in South Bend. They had already been losing membership and, by August, had to close their Mishawaka office due to lack of funds and membership. The Klan held very few events after the May picnic. The local charter was withdrawn in 1926 and their last act was in February 1928, when they burned a fiery cross in the 1100 block of Mishawaka Avenue to mark the end of their chapter.

It is not known whether or not Rockne and his Fighting Irish teams were responsible for a shift away from anti-Catholic shouting to cheering crowds when Notre Dame won a game, but it is known that those cheers were loud and long, and not all of them were Catholic.

By 1927, the economy was in an upswing and high speed rail service between New York and Chicago was the preferred choice of passengers in the 1920s.

Passengers also preferred rail service from Detroit to southern and southwestern states. Many of these trains went through South Bend. By the late 1920s, it was clearly evident that a new railroad station was needed, combining many of the individual railroad stations into one facility. As many as 116 coal-burning passenger trains passed through South Bend every day.

Forty-two of the passenger trains belonged to New York Central Railroad. Twelve belonged to the Grand Trunk Western Railroad. Both railroads decided to construct a Union Station. The plans for Union Station were first discussed in April 1927 and groundbreaking ceremonies were held in June 1928. The new station, costing over $1 million, was officially dedicated on May 27, 1929. A crowd of 30,000 was on hand for the ceremonies.

With a changing agricultural economy, the Oliver Chilled Plow Works was forced to expand its farming implements to include tractors. On March 30, 1929, the company merged with several other farm implement manufacturers and changed its name to the Oliver Farm Equipment Company.

On Friday night, June 27, 1929, WGAZ—which had changed its call letters to WSBT in 1925—presented a new program, the Polish Hour, combining fast polka music with mazurka and oberek tempos, information, advertising, and news in Polish. Francis K. Czyzewski was the moderator. Up until 1937, musical groups and orchestras often performed live. This program was still going strong until the 1990s, making it the longest running program in the United States.

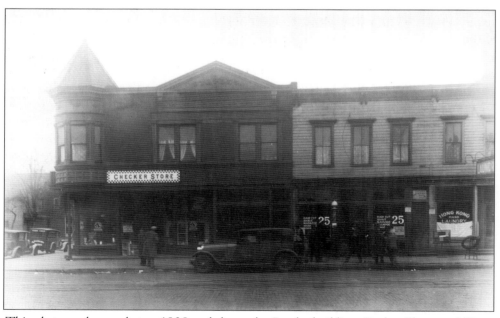

*This photograph was shot c. 1938 and shows the Staples building, Barber Shop, and Hong Kong Laundry on the southwest corner of Division and William Streets. Tracks in the center of the street were the Grand Trunk and Western Railroad. (Photo by Maurice L. Palmer.)*

On September 21, fire damaged the Granada Theater, causing $75,000 in damage. Then, in October 1929, the stock market crashed, ending the lives of many unfortunate brokers, destroying farmers, and ruining employment. Among its victims was the Birdsell Manufacturing Company, which sold many of its machines to farmers on credit. When they couldn't pay, Birdsell was forced to slowly liquidate the company. It sold the farm wagon business to a company in the South. Part of the buildings on Columbia Street were sold to the Grand Trunk Railroad for warehouse space. Allis-Chalmers purchased the clover-huller business. Birdsell made one big mistake: it continued to produce only machines that were powered by steam or pulled by horses. It never took advantage of the great change to the gasoline engine. Officially, it kept a small office open for several years, hoping to collect outstanding debts.

In early 1929, Vincent Bendix purchased acreage northwest of his plant for the construction of 500 houses for his workers. In addition, the land would serve as a private airport where he could test his aviation products. Bendix incorporated his airport on July 11, 1930 for $500,000 and opened on June 21, 1931.

The 1930 census showed 104,193 people living in South Bend. Of them, 3,431 were African Americans. Hungarians and Polish formed the largest group of foreign-born inhabitants. Foreign-born Germans had dropped to less than half of the Hungarian population. For the first time, the census showed a Mexican population of 14.

The easing credit regulations of the previous decade allowed many to start their own businesses in South Bend. There were 31 retail bakers, 122 barbers, 57 beauty shops, 33 billiard parlors, 75 building contractors, 92 dentists to take care of the teeth of those who ate candy from 38 confectionery and ice cream shops, 44 gasoline service stations, and 204 grocery stores, not to mention the hundreds of other categories listed in the 1930 city directory.

Washington Street had remained mainly residential up until about 1920, but easy credit allowed many families to start small businesses. The area between Maple and O'Brien Streets saw the most change from residential to business. The large number of businesses included Michael Krane (shoe repair), Stark Brothers (groceries), Samuel Slutsky (plumber), Max Schwartz (dry goods), John Saberniak (soft drinks), West Side Hardware, Buffalo Wall Paper Store, Slatile Roofing Company, William Antollini (barber), Bock Hong (laundry), Washington State Bank, Washington Drug Shoppe, Seifert Brothers (paints), Louis Niegodski (plumber), Bernard Streets (dentist), the West Side Hotel, Adams Engineering Die and Tool Company, and O'Brien Varnish Company.

On March 31, 1931, the plane carrying Knute Rockne from Kansas City to Los Angeles crashed into the farmland near Bazaar, Kansas. There were no survivors. Knute Rockne was dead at the age of 43. On April 1, a newsboy was hawking his papers with "Extra! Extra! Knute Rockne Dead!" Twelve-year-old Maurice Palmer, hearing the news for the first time, ran up to the newsboy and began shaking him. "You shouldn't say anything like that! What a dirty joke! And on today! You should be ashamed of yourself!" he shouted, believing that it was a bad

April Fool's joke. "No! No! It's in the headlines!" he said, showing him the paper. The shock was so painful that even 60 years later when he recalled the event, Palmer's eyes would still tear up.

From 1918 to 1930, Rockne set the greatest all-time winning percentage of .881. He collected 105 victories, 12 losses, 5 ties, and 6 national championships. Rockne had done much for South Bend, drawing hundreds of thousands of fans into the city each football season. Special trains were brought in from Chicago carrying hundreds of passengers. The South Shore made posters announcing their extra passenger services to South Bend for the Notre Dame games. Many fans stayed at the local hotels. In 1921, there were 21 hotels in South Bend. By 1931, there were 31 hotels in the city. Every restaurant, cigar store, clothing store, barber shop, beauty shop, peanut shop, bank, and other business in South Bend prospered because of Rockne's successful teams.

On Saturday, Rockne's funeral procession began at his home at 1417 East Wayne Street, then went west on Wayne to Eddy Streets, then to Jefferson Boulevard and east to Notre Dame Avenue, then to Sacred Heart Church on the campus, where the mass was held. Nearly 100 honorary pallbearers escorted the funeral procession. More than 1,400 people attended the funeral; each needed a card to get into the church.

From the campus, the funeral procession wound into downtown South Bend, then down Portage Road to Highland Cemetery. At the cemetery, cars choked Portage Road a mile in each direction, many tilted slightly on their sides in the drainage ditches. All the narrow side streets near the cemetery were filled with cars, while their drivers and passengers walked into the cemetery.

An estimated 30,000 fans poured into South Bend and lined the streets just to pay their last respects as the 100-car procession rolled slowly along. The *South Bend Tribune* and *South Bend News-Times* had extensive articles detailing the funeral. Flags fluttered at half-mast. Business was totally suspended during the afternoon service. City and government buildings were draped in mourning. Busy hotel lobbies, usually filled with the unchecked roars of Notre Dame fans, were silent. Everywhere, those who could not attend the funeral listened to it on radio. It was the first nationwide radio newscast. Rockne's death had shaken South Bend's soul.

On October 9, 1932, Father Taracius Kukla celebrated the 50th anniversary of the arrival of South Bend's first Hungarian immigrants with a live radio broadcast on WSBT. The popularity of the broadcast led to the Hungarian Hour, playing violin music, advertisements, news, and information in Hungarian. The program was still on the air as late as 1996. Hungarians assembled at St. Stephen's Roman Catholic Church on October 15, 1932 and paraded through South Bend continuing the celebration.

On November 25, 1932, South Bend leased the Bendix Airport for the city and, on October 28, 1936, South Bend officially took possession of the facility. The City Aviation Commission turned control of the airport over to St. Joseph County in 1938 and the county renamed it the Bendix Field–St. Joseph County Airport.

By the early 1930s, the Depression had set in and dollar-watching businessmen and stockholders had taken over the reigns of almost every South Bend manufacturer. Muessel Brewing Company, which had attempted to continue in operation during Prohibition by producing soft drinks, found itself in financial difficulties by the time Prohibition was repealed in 1933. On April 8, 1933, it produced its first barrel of legal beer and tried to regain its share of the market. However, it was too late and the company was sold to a Canadian brewing company in 1936. The name was changed to Drewery's Beer. The famous sprawling "Muessel" and "Silver Edge" words used in advertising were replaced by the figure of the Royal Canadian Mounted Police. The Mountie remained Drewery's symbol almost up until the company closed.

Not everyone believed President Franklin D. Roosevelt's words of encouragement. Some found other ways to achieve monetary success. Some robbed banks. Ironically, South Bend's most violent episode was at the same intersection where the Klan and Notre Dame students had clashed a decade earlier.

On Saturday morning, June 30, 1934, a brown Hudson sedan with Ohio license plates passed the South Bend Public Library twice. On the southeast corner of Wayne and Main Streets, the quiet ivy-covered red stone building was about to witness the most dangerous bank robbery ever held in South Bend. The Saturday morning traffic was busy with several dozen shoppers taking advantage

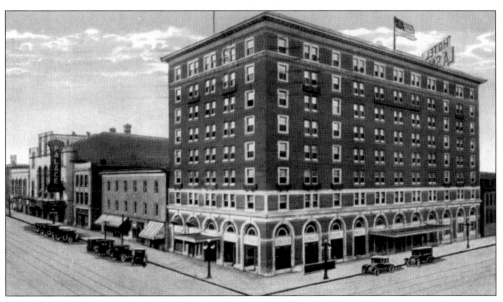

*The new LaSalle Hotel was just across the street from the bustling Chicago South Shore and South Bend passenger station. An underground tunnel connected the two buildings. Hundreds of people waited in the hotel lobby, listening to WSBT's radio announcers as they described Knute Rockne's funeral.*

123

*For many years, the United States Treasury printed money for its member banks, including the Merchants National Bank in South Bend. On June 10, 1934, John Dillinger robbed the Merchant's National Bank. Was this part of the stolen money?*

of the hot weather. No parking places were open on Michigan Street, or on the crossing street, Wayne.

Still not finding a parking place after its second attempt, the brown Hudson double parked on Wayne Street, facing west, next to a car being parked by Alex Slaby, a young amateur boxer.

"You'd better scram," Slaby was told as four men walked quickly from the Hudson, leaving it running. A second car stopped in front of the Merchants National Bank at 229 South Michigan Street and at least one man got out. Within seconds, the intersection was in the control of one of the most feared bank robbers of all time—John Dillinger, with his gang, including Charles Arthur "Pretty Boy" Floyd, Lester "Baby Face Nelson" Gillis, and Homer Van Meter. This was Floyd's first robbery as part of the Dillinger gang.[2]

There are some skeptics who doubt that it was the Dillinger gang because of the sloppiness of the operation. However, it was the most notorious gang operating in the Midwest at that time and no other proof has come forth to show that it was any other gang. In 1935, the FBI also insisted that it was the Dillinger gang. But at least three veteran authors who have exhaustively reviewed known evidence insist that it was not the Dillinger gang. Several eyewitnesses insist that it was Dillinger, but eyewitness testimony has been known to be wrong at times.

It may have been Homer Van Meter who suggested that Dillinger rob the Merchants National Bank. Perhaps he may have had a special reason for choosing that bank or perhaps it just appeared to be the easiest one to rob. Van Meter was no stranger to South Bend. Under an assumed name, he had been arrested as a youth for suspected participation in a robbery. He later returned to work at Studebaker.

According to the December 24, 1934 issue of the *Starke County Republican*, police evidence also indicated that Van Meter attempted to purchase several automobiles from a South Bend automobile agency, including one that was to have bulletproof glass. Accompanying him on this trip was Pearl Applegate, alias

Pearl Cirio, alias Pearl Frasano, from Mishawaka. She had been under observation by the police since some of Dillinger's gang had escaped from the Michigan City Prison and Dillinger had escaped the Crown Point jail. According to the article, Van Meter had written to her indicating that "some of the boys are getting out." It also says that she hid some of the gang who helped Dillinger escape from the Lima, Ohio jail where Sheriff Jesse Sarber was killed in October 1933. Her husband was James Cirio, brother-in-law of gangster "Diamond Jim" Esposito.

Van Meter was also well known for visiting potential robbery areas and drawing elaborate sketches of banks, teller cages, and escape routes. He knew that the U.S. Post Office usually made a cash deposit about 11:30 a.m. He presumed that it was a large amount. On this day, the amount was only $7,900.

A 1970 article in the *South Bend Tribune Michiana Magazine* indicated that Slaby was confronted by Dillinger with a pistol pointed through the car window. It later said that Slaby attempted to reach for the Hudson's ignition keys, but was confronted by Baby Face Nelson. Slaby gave up the idea; still suspecting that something was about to happen, he went across the street to the Colip Brothers store at 114 West Wayne Street and called the police.

By 11:30, the gang was in place and Dillinger with Floyd and another accomplice (a fat man who drove the second car and who may have been Joseph "Jerry" Burns) entered the Merchant's National Bank. After this, everything became turmoil, with eyewitness accounts conflicting each other and hazy memories, or things remembered out of sequence. Many newspaper accounts of the robbery have been printed over the years. Most contain more detail than we can supply in this short history. The following is a brief account of what happened in nearly ten minutes of gunfire.

The street was crowded with people. Baby Face Nelson stood on the southwest corner of Michigan and Wayne, machine gun in hand. Van Meter, holding a .351-caliber rifle, stood guard outside of Nisley's Shoe Store, between Wayne Street and the bank's stone façade.

"This is a holdup!" Dillinger shouted to the 20 to 25 bank customers. One man waved a pistol and another aimed a machine gun. Someone, possibly Dillinger, fired a machine gun into the air, and customers and employees dropped to the floor. C.V. Coen, vice president of the bank, immediately recognized Dillinger and dove under his desk, unseen by any of the robbers. While one robber remained in the lobby, the other two ransacked the teller's cages, forcing employees to the floor.

Patrolman Howard Wagner heard the shots fired inside the bank and left his post at the Star Store to investigate. As he approached the intersection, Van Meter opened fire, hitting the officer before he could pull his gun out of its holster. He staggered back across the intersection and dropped to the asphalt pavement, falling against Carl Voreis. Then the gunmen opened fire on the shoppers outside.

Harry Berg heard the shooting and left his jewelry store, revolver in hand. His first shot hit Baby Face Nelson, but Nelson's bulletproof vest saved his life. Nelson returned the fire with his machine gun, smashing the store's window and

forcing Berg back under cover. The same angry fire grazed Samuel Toth, waiting in a car across the street from the jewelry store. He raced his car away from the scene. His passenger Jacob Solomon, who had just left the car, was walking across the street to the jewelry store when he was struck in the leg. The bullet bounced upward into his abdomen.

Mr. and Mrs. Kenneth F. Beers had just driven up to the corner of Michigan and Wayne, and were waiting for the light to change. They were on the right-hand side of the street facing south. Nelson's raking fire smashed their windshield, narrowly missing them. Beers backed up the car, hoping to escape the firing. Both got out of the car and hid behind it.

Hearing the shots outside, Dillinger and his crew seized P.G. Stahley, manager of the Birdsell Manufacturing Company, Delos M. Coen, son of C.V. Coen, and Irvin H. Bouchard, manager of the Radio Service Company. The remaining customers ran to an employee restroom and a conference room to escape the gunfire.

Officers Sylvester Zell and Emil DeWespelaere rushed to the scene while bullets hit the State Theater Canopy and the giant shoe sign above the entrance of Nisley's Shoe Store. The rear windshield of Mrs. Goldie Kolter's car was riddled by bullets as police and robbers exchanged fire. Officer Nels Hanson took cover behind an automobile parked on the east side of Michigan Street, attempting to find a good shot. In the exchange of shots with the police, Coen was shot in the left leg and Stahley was shot in the thigh. Bouchard was grazed in the leg. The bandits tossed their shields aside and ran for the car.

Van Meter entered the Nisley store and forced its customers out, using them as shields, lining them up with their hands in the air. Someone from the Sears and Roebuck store came down the street, rifle or shotgun in hand, and started shooting at the robbers. Seventeen-year-old Joseph Pawlowski jumped on Nelson from behind, but Nelson threw the youth against a plate-glass window, shot him at close range, and started running down Wayne Street toward the Hudson. Luckily, Pawlowski received only a bullet through his right hand, but he fainted.

Following the others, Van Meter rushed down Wayne Street, but was hit in the right side of the head, and Dillinger helped him into the car. Patrol car No. 2 arrived at the scene and Harry Henderson opened fire on the car. His first shot hit the driver, possibly Floyd. He slumped over the wheel. He was pushed aside by one of the accomplices who then took the wheel. Police fired several more shots and two other bandits may have been hit, although possibly not seriously since they were wearing bulletproof vests.

Then the Hudson roared down Wayne Street, narrowly missing a car in which Miss Maxene Mollenhour was riding. Passing the Public Library on the corner, the Hudson turned south onto Main Street for a block, then turned west onto Western Avenue, where it disappeared.

The second car sped south on Michigan Street. Three police squad cars, all loaded with officers carrying riot guns, machine guns, and wearing bulletproof vests, sped south in pursuit. At some point, the bandits sprayed roofing nails onto the highway, discouraging pursuit. Motorcycle patrol officer Bert Olmstead

*Now the Dainty Maid Bake Shop, this building was in the middle of the gunfight where Homer Van Meter fought police. Dillinger brought his hostages from the bank, holding them in front of him as he shot it out with police.*

spotted both cars speeding south on U.S. Route 31, but could not keep up with the speeding vehicles.

All available ambulances in the city were called to the scene and the wounded were sent to Epworth Hospital. Patrolman Wagner died ten minutes after reaching the hospital. The robbers escaped, although their blood-stained bullet-riddled sedan was later found abandoned near Goodland, Indiana.

Many of the witnesses said that it was the Dillinger gang because they recognized Dillinger's face. In fact, though, several other criminals of the time did look somewhat like him and in the quick action could perhaps have been mistaken for him. In addition, Dillinger had received some plastic surgery on his face the month before the robbery, hoping to change his appearance. If this was Dillinger's bank robbery, it was his last one. Three weeks later, on July 22, he was gunned down in Chicago by federal agents.

Several city banks offered to cover cash losses until the Merchant's National Bank could recover from the robbery. But the bank indicated that it had sufficient reserves. The final count showed that the gang had escaped with over $28,000, but had missed a large amount of the money, including the $7,900 deposit by the post office. By Saturday afternoon, Harry Berg had a sign over his smashed window reading, "Not hurt. Open for Business."

Even though South Bend was in the middle of the Depression, manufacturing production increased and more workers were hired, but South Bend's large population still faced some critical choices and hard times.

# 8. WAR AND REMEMBRANCE

Germany invaded Poland in October 1939 and all of Europe was at war. Japan invaded Manchuria and China and was slowly pushing toward Burma, India, and the Philippines. So far, America had kept out of the war officially, but its "lend-lease" program with Great Britain had provided much needed supplies for the war torn country, which was being bombarded daily.

By early 1940, South Bend was already on a defensive status. Almost every factory had expanded. The housing shortage, however, had not significantly changed by then. According to the 1940 census, there were only 619 vacant dwellings in a total of 28,286. Empty store buildings had been transformed into family and multi-unit residences. At the same time, the city census had dropped to 101,268. The African-American population was now up to 3,555. Polish, Hungarians, and Germans counted for the largest number of foreign-born residents.

With war on the horizon, South Bend had already received more government defense contracts than any other city in Indiana ($12,984,846), requiring more workers who further increased the severe housing shortage.

Tension in the city was temporarily relieved in October when Warner Brothers released its latest motion picture, *Knute Rockne, All American*. In his book *The Wind at My Back*, Pat O'Brien recalled how Jack Warner offered him the part of Knute Rockne in the film based upon Rockne's life. "I always cast Irishmen to play Swedes or Norwegians," Warner is reported to have said.

Part of the film was shot in South Bend in May 1940. Several hundred local residents acted as extras in the film, including Rockne's children Jeanne and William. Most, if not all, of the photographic stills for the film were shot by Harry Elmore, one of South Bend's leading photographers, who had also been employed by the *South Bend News-Times*. He was a long-time fan and semi-official photographer for Notre Dame. Maurice Palmer worked as an assistant, helping to develop the photographs. "Some of them were large, maybe twenty inches wide and thirty or more inches long. It took two of us—one of the people from the studio and myself—to lift them up on each end, take them carefully out of the developer and put them on drying trays," Palmer said.

The film was shot quickly and made its world premier on Friday, October 4, 1940 in South Bend. Film producers soon realized that one movie theater would

not be enough to show the movie to the overwhelming audience expected on premier night. By the time the film was to premier, nearly 150,000 fans were expected to see it during the three-day celebration. The State, Granada, Palace, and Colfax theaters were scheduled to show it all on the same night, with half hour intervals between starting times, allowing the stars to run from one theater to another to be introduced.

Thousands of people stood outside Union Station on October 3, waiting for Pat O'Brien, Rudy Vallee, Kate Smith, Anita Louise, Ronald Reagan, Jane Wyman Gale Page, Donald Crisp, and dozens of other stars to arrive on a special train from the west coast. Bob Hope conducted the ceremonies, introducing the stars on a platform in front of the station. The Riley, Washington, and Central High School bands gave a concert while the fans waited. A public banquet was hosted by Bob Hope in the Notre Dame dining hall, where over 1,000 guests waited anxiously for the stars and other personalities to be introduced.

Studebaker provided automobiles for the stars' three-day visits and their trip from Union Station to the Oliver Hotel. On premier night, only city busses and taxicabs were allowed on the city streets. Main Street was blocked off from Jefferson Boulevard to LaSalle Avenue. Other streets blocked off were Michigan Street from Wayne Street to LaSalle Avenue, Colfax Avenue from Sycamore Street to Lafayette Boulevard, Washington Avenue from Lincoln Way to Lafayette Boulevard, and Jefferson Boulevard from St. Joseph Street to Main Street. Crowds, estimated at nearly 28,000, were overwhelmingly solid from one side of the sidewalk across the street to the other sidewalk. The *South Bend Tribune*

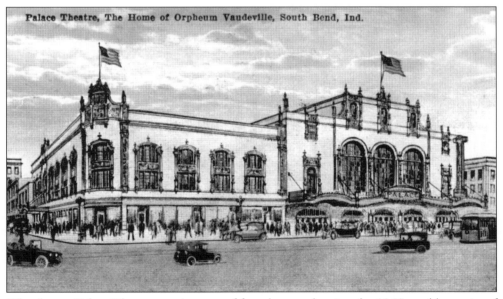

Palace Theatre, The Home of Orpheum Vaudeville, South Bend, Ind.

*The elegant Palace Theater was just one of four theaters showing the 1940 world premier of "Knute Rockne, All American," starring Pat O'Brien and Ronald Reagan.*

estimated that anywhere from $500,000 to $1 million was spent by visitors attending the premier. The euphoria lasted for several weeks before the city returned to normal.

By 1941, the federal government was planning to build two separate areas of houses for the benefit of defense workers moving to South Bend. They would not be for the residents already living in South Bend. However, after the emergency situation was over, the dwellings would probably be turned over to low income housing. Private companies were suggesting that they could build another 1,500 dwellings.

"The job of finding living quarters in South Bend borders on torture," reported the *South Bend Tribune* on March 23, 1941. Few house rental agencies had anything available. Home builders protested that defense housing programs would give defense workers houses, but that South Bend builders and supply dealers would not benefit. Already there was a short supply of construction materials like wood and metal.

The Studebaker airplane engine plant was in its early phases of construction on the south side of the city on part of the Rum Village land that Peter Studebaker had received as his wife's inheritance in 1871. The Bendix Aviation Corporation was adding new workers and buildings. The Z.B. Falcon Building at 1103 West

*This war rationing book is from 1942. Everyone received various issues of war rationing books, covering items such as meats, flour, rubber tires, and much more. Rationing was strictly enforced and there were severe penalties for violating the law.*

Western Avenue decided to remodel its interior, forcing the Polish National Alliance Library to find a new location. The 20,000 book library was the largest Polish library in Indiana. At the same time, finance companies were foreclosing on people who could no longer afford to make house payments. In one short period, 16 tenants were evicted and the township trustee was required to find new housing for them.

South Bend's recently established housing authority designated two areas of land for apartments. The first apartment building, containing 150 units, would be situated on an L-shaped piece of ground just east of the Twyckenham Drive bridge near River Park. These were reserved for white residents only. The second apartment building would contain 105 units for African Americans and was situated north of West Washington Avenue near the Chicago, South Bend, and South Shore Railroad tracks.

The housing authority also prepared two sections for individual housing. Plans called for 103 buildings containing 248 dwelling units for white families, and 16 buildings providing quarters for 84 African-American families on a 3-acre parcel of land at Birdsell, Orange, and Liston Streets. These actions may have been South Bend's first attempt at segregated housing—one that would have repercussions for the next 30 years.

All of South Bend's preparations for war did nothing to prepare them for America's entry into the world conflict. On a lazy Sunday afternoon, many residents were attending a music concert at the Palace Theater when the concert was interrupted. Japan had just attacked Pearl Harbor. Within hours, citizens were lining up, asking where to volunteer for military service. Mayor Jesse L. Pavey proclaimed a state of emergency in South Bend and ordered the police department to arrest all suspicious persons found in or near public utilities, loitering on bridges, or behaving in a suspicious manner in the vicinity of other vital points.

Nearly 500 special officers had already been sworn in months ago and were sent to guard the city water plant, pumping stations, and other public utilities. The fire department revealed that it had been training for nearly a year to combat incendiary devices.

The December 8 *South Bend Tribune* listed over a dozen South Bend residents serving in the army in Hawaii or the Pacific. Three South Bend citizens (Joseph Cygert, Bert Degucz, and Earl A. Cox) were on the *West Virginia*, which was sunk in the harbor.

The America First Committee, a national organization that had previously attempted to keep America out of the world conflict, reversed its position. Clarence Manion, a national committee spokesman for the group, declared, "America has been deliberately attacked. The complete unity for defense that has always prevailed in the country will now go into action. Every American will quickly do his or her full duty to win this war that Japan has thrust upon us."[1]

Studebaker immediately ceased production of automobiles and concentrated on making heavy trucks, automobile and truck engines, and airplane engines, and

an amphibious vehicle called the Weasel. Bendix began work on several secret projects, among which were a gyroscope for aviation use and a bomb sight, as well as gun turrets for the B-17 and B-24 bombers. Some companies had limited capacities for war efforts. South Bend Toy Company switched from making croquet sets to tent stakes and poles for the hundreds of thousands of military tents needed for the troops. Later, doll carriages were declared essential to the military home front and they were again allowed to be manufactured.

In June 1942, the war production board ordered Singer Manufacturing Company to discontinue making wooden sewing machine cases, effectively laying off 1,200 of its workers. The company then concentrated on making small wooden cases for military sewing machines, wooden holsters for pistols, and plywood sub assemblies for wooden gliders, some of which were used in the invasion of Normandy. However, it had lost nearly 30 percent of its workforce.

Oliver continued to make plows and tractors for farmers, since farming was essential to military victory. However, Oliver plants in other cities contributed by making tank turrets, parts for airplanes, and many other items. South Bend Lathe worked overtime to supply industries, high schools, and military workshops with their lathes. South Bend Lathes were on almost every naval ship.

Retired mechanics and machinists were called back to work to replace younger men who were drafted or who volunteered for military service. Some even set up their own small machine shops and made high quality brass or other small parts desperately needed in a wide variety of machines and equipment.

The mayor encouraged everyone who had even a small patch of land to grow vegetable gardens. Farmers raised more chickens, producing more eggs. Rags, metal, rubber, wood, and paper were collected for scrap drives. A Revolutionary War cannon in Riverview Cemetery was melted down for scrap.

On May 11, 1942, retailers met in the Central High School auditorium to listen to the price control regulations that would begin in a week. The *South Bend Tribune*'s May 12 issue provided an entire list of all items subject to price controls. Government control of retail prices began on May 18. Retailers were required to submit a price list of cost-of-living commodities. Stores were required to display signs showing the "ceiling price," or the highest price allowed by the government, along with the price they were charging. Criminal violations of the general maximum price regulations involved fines as high as $5,000, one year's imprisonment, or both. Bakers attempted to control prices by not cutting bread and not double wrapping bread or other products.

The Works Projects Administration Research Division had studied the housing problem in November 1941 and found that there were only 530 available vacant rooms in the city, or a habitual rental vacancy ratio of seven-tenths of 1 percent. By April 1942, neither the white nor African-American houses had been built. River Park residents took up a petition against the planned construction near Twyckenham Bridge. The Housing Authority began looking at alternative sites near Our Lady of Hungary Church, but 1,000 neighbors in that vicinity protested

*After four long years, World War II ended, but the end of the war did not solve South Bend's severe housing problems. When the war ended, many companies lost their military contracts, but workers still continued to live in South Bend, hoping that they could find employment. Studebaker was the first company to produce an automobile after the war ended.*

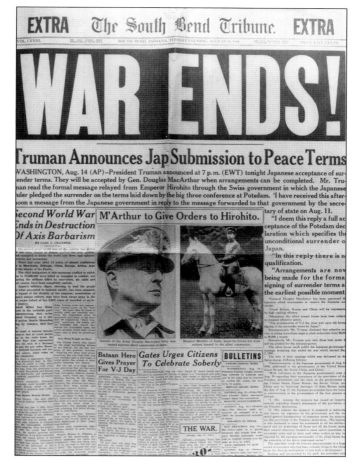

the idea. The Northwest Democratic and Civic Club protested against the Birdsell-Orange-Liston Street project.

African Americans met at the Hering House on March 3, 1942 and also objected to the Birdsell-Orange-Liston site on the grounds that it would destroy already existing African-American houses and St. John Baptist Church, forcing the owners to find housing elsewhere. They asked the Housing Authority to use vacant land.

Two weeks earlier, another group had suggested that certain sections of the city were slums and should be torn down. Those areas could then be rebuilt by the Housing Authority. " 'Maggie's Court' is a virtual breeding place of juvenile delinquency and adult crime and is the center of prostitution and diseases of every description," reported the *South Bend Tribune* on February 16.

In October 1943, the Housing Authority approved a site for 100 permanent African-American homes in an area bounded by Kenmore, Washington, and Chicago Avenues and Jefferson Boulevard. West Side residents opposed it

immediately. By 1944, 40 houses (20 two-family units) were constructed in the 3100 and 3200 blocks of West Washington Street for African Americans. Forty prefabricated war houses trucked in from Kingsford Heights were raised on the old circus grounds on Prairie Avenue south of the New York Central Railroad tracks.

Residents of the Prairie Avenue area petitioned the city not to allow more African-American housing in their neighborhood, but suggested that the city should use land at the corner of Franklin and South Streets, as well as tearing down "Maggie's Court." One hundred more houses for African Americans were brought from Kingsford Heights and placed in an area bounded by Wellington and Falcon Streets, Jefferson Boulevard, and Washington Avenue.

The housing situation worsened when on December 17, 1944, six African Americans were killed, 17 were injured, and 30 people were left homeless when a hotel at 123 West Colfax was completely destroyed by fire. Finally, by May 1945, the city began considering purchasing "Maggie's Court" for African-American housing. Citizens on Taylor Street, part of which was only 200 feet from "Maggie's Court," objected, saying that it would lower property values and put the people currently living there out of housing. The South Bend-Mishawaka Board of Realtors said that the area was unfit for housing and should be made into a playground. During all of the negotiations there were still 300 families waiting for government housing.

While the war effort brought many African Americans and farm workers into the city seeking better wages, farmers with large crops had a difficult time finding field workers to help raise and harvest the crops. Help came when field workers from Mexico and southern Texas drifted north.

In March 1944, 70 Mexicans moved temporarily to South Bend to work as section hands on the New York Central Railroad. "We feel that we are doing our bit, too, in helping America to win the War,"[2] explained Benjamin Guerra, who had come from Mexico City. They were housed in clean, comfortable quarters in railroad bunk cars in the rail yards. All of their living needs were provided by the railroad, including separate cars for a wash room complete with showers and hot and cold water, a recreation room complete with books in Spanish and English, a mess hall, storage for food, and a commissary. Although most workers returned to Mexico after the war, Frank Martinez and his family were one of the few to remain.

Paper was in short supply and paper drives were organized regularly. One paper drive in late February 1944 resulted in 128 tons of waste paper being gathered citywide. St. Joseph County offices proudly contributed over 2 million pounds of old records, including personal property tax schedules, to the paper scrap drive. The County Records Commission then investigated other unnecessary records that could be given to future drives. In late April, 209 tons of paper were collected, including more unnecessary county records. Receipts from the sale of the paper were used for the Service Men's Center.

# 9. FROM HARD TIMES TO NEW HOPE

The large number of war production workers moving to South Bend swelled the city's population to 115,911 by 1950. The foreign-born Hungarian population had dropped to 1,987 and the foreign-born Polish population had dropped to 2,209. Only 774 foreign-born Germans were living in South Bend. The largest population increase was in the African-American community, which rose from 3,555 in 1940 to 8,134 in 1950. The Mexican population had risen to 20.

When the war ceased, Studebaker immediately went back to production of domestic automobiles, the first automobile manufacturer in the United States to accomplish this task. The city condemned a large strip of land from the Singer company on Western Avenue for widening the street.

Later, television viewers were treated to a special event in December 1952, when WSBT-TV became the first UHF station in the United States to produce five minutes of "live" news. Also in 1952, Stubebaker celebrated its 100th anniversary with a magnificent parade that covered all of Michigan Street with banners, floats, the family Conestoga wagon, and many other products. The company boasted that it would still be around for another 100 years. It produced a series of books to commemorate its success as the only wagon manufacturer in the United States to complete a successful transition from building nineteenth-century farm wagons to twentieth-century state of the art automobiles.

The Korean War took soldiers away from South Bend, and again local manufacturers increased war production. But Studebaker did not stop making automobiles this time. By the early 1950s, the company was employing more than 24,000 workers in its South Bend plant. On the surface, everything looked good for Studebaker. But a closer look revealed problems. Like most other manufacturers, it had lost its overseas markets during the war and was attempting to rebuild them.

During the 1950s, a series of long strikes at Studebaker cost the company income. An ill-fated merger with the Packard Automobile Company and increased competition from Ford and General Motors slowly drained away Studebaker's sales. The problems with Studebaker's buildings—some more than 70 years old—were only the beginning. Almost every major manufacturer in South Bend was facing the same problem. The Depression had allowed for

*This image shows the Studebaker Manufacturing Company complex in 1968, after the plant closed. Although several people had hoped that other uses could be found for the buildings, many realized that they were outdated. Almost all of the buildings have been torn down. (Courtesy St. Joseph County Public Library.)*

some expansion and the war had allowed for even more construction, but money spent on expansion meant that there was no money to renovate or tear down the older structures.

Also, European and Japanese companies were now forcing their way into American markets. With only a small area of woodlands left near South Bend, Singer closed its South Bend plant in 1955. Wilson Brothers shirt factory was sold in 1957 and, by the end of the year, most of the 750 employees were without jobs as the new owners moved manufacturing to Louisville, Kentucky.

"Maggie's Court" was finally getting some attention. Most of the land had been purchased by the middle of June 1957. The area would be for African-American housing. Racial discrimination in housing had become a major problem.

A 1958 housing survey showed that only 7,568 new houses had been built since 1950. Only 735, and possibly as few as 450, had been constructed for African Americans. Fifty-six percent of African-American families lived in their own homes (compared to 70 percent as a whole). Most African-American residences were concentrated in parts of the city that were zoned for multiple-occupancy dwellings, often located near industrial areas. Many of the houses had been constructed during the war when a shortage of good construction materials created poor quality houses. Now, they were beginning to deteriorate.

Although attempts had been made for African Americans to move into other areas of the city, white residents opposed the moves, fearing a drop in their property values. Prosperous whites were beginning to abandon downtown neighborhoods and move to the suburbs. With the continued emphasis on suburban housing, shopping centers began to emerge. The Broadmoor Shopping Center opened in 1958 with 17 stores. Town and Country Shopping Center opened in 1960, with Hooks, S.S. Kresge Company, and Goldblatts's as the key stores. Belleville Shopping Center on Western Avenue opened around the same time.

A major fire swept through the empty Singer Sewing Machine Company buildings in 1960. By the end of the fire and cleanup, only three of the original buildings remained. Today, they are known as the Marycrest Office Buildings.

The 1960 census shows a city population of 132,445. The foreign-born Irish population was now up to 580, the largest number since the census was first taken. Foreign-born Italians numbered 1,150. Foreign-born Polish, Germans, and Hungarians still led the list. The largest increases were the Polish and Hungarians, many of whom were refugees fleeing Communist Russian control, and the ill-fated Hungarian Uprising in 1956. Mexicans had doubled their population to 46.

A 1961 housing survey found 935 dilapidated dwellings among the 42,656 city dwellings. As many as 37,832 of the houses were occupied by white persons and 3,161 were occupied by African Americans, Chinese, Indians, Japanese, and other Asians. In May 1961, a large tract of land from Laurel Street east to Scott Street and from Western south to the railroad tracks was scheduled for demolition and low rent housing.

The problem of housing discrimination had been addressed several times, but no clear-cut answer was apparent. In 1962, 16 banks and savings and loan associations said they were willing to provide home mortgage loans to qualified African Americans, but only nine of them said they would provide the money if African Americans were planning on moving into all-white neighborhoods. Only one institution said that it would support a "fair housing" law.

Studebaker, the first factory to bring large-scale employment to South Bend, could not cope with the complex problems involving union wages, foreign competition, and outdated factories. The last Studebaker automobile rolled off the assembly line on Friday, December 20, 1963. The company had lost $40 million on United States automobile production from 1959 to 1963 and employment had dropped to 7,000 workers. The company payroll was $45 million per year, much of it pumped back into the South Bend economy.

Before the closing, South Bend unemployment had been 5 percent and falling. Immediately after the closing, unemployment rose to 9.1 percent. Suddenly, 7,000 workers (nearly 8 percent of South Bend's working force) were out of work. There were predictions that South Bend would turn into a ghost town.

Paul Gilbert, a well respected businessman, headed a commission determined to find new uses for the old factory and jobs for its unemployed workers. Many workers moved away. Neighborhoods that had been white were now slowly

being developed by African Americans. Some hoped to find work at Bendix or Oliver Farm Equipment Company, but these companies were facing their own difficult times.

After the deaths of James and Joseph Oliver and the merger of the Oliver Chilled Plow Works with other companies in 1929, the Oliver family no longer had a majority of the company stock. As other stockholders raised their voices in determining how the company should be run, a corporate takeover emerged. By the time everything was finished, White Farm Equipment Company had purchased Oliver. The name was changed once again and production continued.

The intersection of Washington and Walnut Streets, once a prosperous area of Polish and Hungarian restaurants, barbershops, and other small businesses, slowly transformed into an African-American shopping area. By 1960, many of the businesses still had Polish and Hungarian names, but most of the shoppers were African Americans. African Americans and whites formed a local business association. And now a new population was moving to South Bend.

The rise of Fidel Castro in Cuba and the Cuban Missile Crisis launched a wave of Cuban immigration into the United States. Although many fled to Florida, a large group came to South Bend to attend Notre Dame, Indiana University at South Bend, and other smaller colleges, both as teachers and also as students.

For nearly 30 years before the mid-1960s, South Bend had practiced housing, education, and job discrimination. Some young males were deeply concerned that the city had not kept promises made earlier. On July 5, 1967, a five-hour meeting was held at the Washington Neighborhood Center, a youth center under the auspices of St. Augustine's Church. Two Chicago representatives of the Southern Christian Leadership Conference had been invited to discuss African-American history, culture, civil rights, and black power. Civil rights was an easy term to understand. On the other hand, black power was a deeply personal interpretation that each African American had to address for himself or herself.

The hot nights of July 23 through July 27, 1967 left many Midwesterners with short tempers. In Detroit, a riot that started on July 23 lasted for nearly a week. It may have been caused by the frustration of African Americans who had been forced out of their homes on Hastings Street into other overcrowded neighborhoods. Acres of houses on Hastings Street had been condemned and the land had been cleared. By the time battle-tested paratroopers and tanks had put down the riot, over 30 people were dead, 300 houses had been destroyed, and millions of dollars of damage had been done by bricks, baseball bats, and firebombs.

Violence also erupted around the country and, on the night of July 25, riots broke out on South Bend's West Side. What would happen for the next three nights was a combination of miscommunication and misunderstanding of cultures resulting in escalating violence, shootings, and firebombings that left seven African Americans wounded by police, several policemen and one fireman injured, and over $50,000 in property damages. Compared to the riots in Detroit, New York, and elsewhere, South Bend's incident was considered a "Civil Disturbance."

On the west side, a rumor that a black youth had been beaten by a group of white youths on the night of July 24 put the African-American community on edge. Whether or not the rumor was true was not confirmed. Evidence obtained later indicated that Jesse Middlebrook, an African-American youth, had been allegedly refused service on his automobile at a white service station. Someone started a fight and Middlebrook was arrested at 5 p.m. on Monday, July 24. The arrest has been pointed out as one of the sparks that ignited the unrest.

The findings of an investigative board[1] convened after the riot indicated that part of the violence may have been a community response to a Common Council meeting on Tuesday night concerning a proposed salary ordinance. As many as 142 salary items were considered, including an increase for George Neagu, the white executive director of the South Bend Human Relations and Fair Employment Practices Commission. Approximately half of the time of the session was devoted to 17 persons who spoke in favor of a salary increase for Neagu. The persons included businessmen, clergymen, and college professors. Neagu was well respected in the African-American community and it was thought that if the council turned down his salary increase, the community would react harshly. The council turned down the request. A large African-American audience was present at the session.

On July 25, Neagu said that he was tipped off that a series of disturbances was planned, but there was no proof that outsiders had come into the city to

*This late 1960s photograph shows Richey Radiator at the foot of Washington Street, a long steep drop from Lincoln Way East. Now this area is part of the lower section of Century Center and Richey Radiator has moved to Western Avenue. (Photo by Maurice L. Palmer.)*

139

orchestrate the disturbances. Having been informed of the possible trouble, the police were already on the alert for trouble and were ready to change from three shifts of eight hours to twelve-hour shifts with no days off. The disorders apparently began at around 8 p.m. when automobiles driven by whites were repeatedly driving through the Washington and Walnut intersection. African Americans became tense. As the cars continued to drive through the neighborhood, several juveniles began throwing stones at them. Then the crowd began throwing stones at all of the cars being driven down the street. Police were called to ask the drivers to stop driving through the area.

At 9:27 p.m., Gust's Tavern at 1314 West Western Avenue had its front pane-glass window broken. Then, around 9.30 p.m., a firebomb was tossed at a squad car near Harrison School at 3302 West Western Avenue. A crowd of about 40 people gathered at the scene. At the same time, a large group of juveniles had gathered at the corner of Napier Street and Western Avenue.

At 10:29 p.m., a police car spotted a large crowd at the corner of Iowa and Washington Streets. Some of the crowd were carrying firebombs. A minute later, there was a fire at the corner of Iowa and Washington. As a fire truck arrived on the scene, it was immediately hit by the stone-throwing crowd. The truck was damaged and one fireman was injured. The police responded by sending Captain Nester Stachowicz to the scene with backup units. Another group of 30 to 40 youths had gathered in the 1300 block of Western Avenue.

*This building, located at the corner of Wayne and Michigan Streets, saw a lot of history, including the Ku Klux Klan fight and the Dillinger bank robbery. It fell to the wrecking ball in the late 1960s. (Photo by Maurice L. Palmer.)*

140

Then false alarms started being sent to the fire station. Fire trucks, responding to the alarms, were struck with rocks and bottles. Six department vehicles were damaged. Police were assigned to accompany each fire unit.

Stone throwing continued at the intersections of Washington and Walnut, where a group of around 100 youths had now assembled. Barricades were set up on the streets, diverting or stopping traffic. Drivers and cars were pelted with stones. Leonard Finch from Buchanan, Michigan was injured by broken glass and Henry Giden Jr., a 16-year-old male from South Bend, was burned by a firebomb.

Windows were smashed in the Washington Drug Store, 1301 West Washington, and merchandise was stolen from the store. A firebomb was tossed at Nykos Bar, next to the drugstore, but it did not go off. When ordered to leave, the crowd at Washington and Walnut refused and arrests were made. Another firebomb was tossed at Fujawa's Furniture and Appliances Store, 1144 West Western Avenue. A firebomb was thrown into the General Hallar Post 125, Polish Veterans, at 1143 1/2 West Western Avenue. Another was tossed into Sandock's Furniture Store, 1217 West Washington, shortly before midnight, but police were able to save the building by removing the burning furniture. Several officers were pelted with stones and two were bitten by a German shepherd on a leash. Around 20 arrests were made, including whites and African Americans.

Although there was no attempt to stop the firemen from putting out the fire at the Haller Post, fire trucks were pelted as they responded to fire calls and false alarms elsewhere. A firebomb was tossed into the side of Company 8's truck, but did not go off.

Around 11:25 p.m., the front glass window of Horvath's Grocery Store, 3501 West Sample Street, was broken. At 11:47 p.m., all units were ordered to rendezvous at the Hurwich Iron Works (at Circle and Washington Streets), where they were issued riot gear, including crowd control batons and helmets. They then divided into three groups to approach the Washington and Walnut intersection from different directions. One group came in from the corner of Washington Avenue and Chapin Street, then marched into the Washington and Walnut intersection. All the street lights were out on the corner. The only light was from the fires in the nearby businesses. Police ordered the crowds to disperse, but they remained and canine units were called in. Many adult African Americans also attempted to stop the crowds.

No shots had yet been fired, but nearly 200 lawmen had been called out to quell the situation. Many of the youths who had been involved in the incident contacted Neagu to set up an appointment with Mayor Lloyd M. Allen. Allen agreed to meet with them at LaSalle Park Neighborhood Center, 2910 West Western, around midnight. Several African-American leaders and clergymen also attended the meeting. They backed Allen's request to end the violence. A large number of young African Americans also pleaded for an end to the violence.

The session was intense, with anywhere from 80 to 100 youths attending, many complaining about the lack of paved streets, high weeds, police harassment, and

141

other problems. One college student complained that he was afraid to park his car in some white neighborhoods because he would be arrested for being there. There were few places where African-American males felt that they could take their girlfriends. Some suggested that a social center would be a helpful alternative to the YMCA, which was too expensive for most of the youths to join. One pointed out that no African-American music was played on any local radio stations and that there were no African-American disc jockeys.

Some youths left the meeting, feeling that nothing was being solved. Scuffles developed between African-American youths who were attempting to stop other youths from moving from the 1200 block of West Washington. Police were ordered to remove their badges so that personal retributions could not be made against them.

About 50 to 100 African-American youths met with the South Bend Common Council at 8 p.m. Wednesday at the LaSalle Park Neighborhood Center. Also attending were Sheriff Elmer Sokol, George Neagu, and Melvin Williams, director of the LaSalle Park Neighborhood Center. Police Chief McNaughton was not present. He was meeting with Vernon S. Sutton, an administrative assistant to Mayor Allen, and 22 youth leaders at a house on the west side. The press was not invited to the meeting.

Many of the complaints raised on Tuesday night with Mayor Allen were again stressed at the Common Council meeting. In addition, many felt that the police had overreacted to the situation and arrested many innocent youths not connected with the incidents. There were charges of police brutality and violations of civil rights. When asked if they could identify the police, the youths replied that they could not identify them because the police had deliberately removed their badges so they could not be identified.

Charges were made that most of the money spent on city parks was spent for parks in the white section of town. The council and youths agreed to select a committee of 15 representatives from the west side youth who would work with the council to address the issues. When the meeting ended, councilmen promised to meet with the mayor within the hour. They felt confident that the issues could be resolved and that the meeting had been a success.

While the meeting was in session, Councilman Walter M. Szymkowiak's office was firebombed, but the fire went out before serious damage was done. Shortly after the meeting ended, a police car saw four juveniles overturn a car at the corner of Camden and Western Avenues. As it overturned, the car burst into flames. By the time the fire department had arrived, a large crowd had also come to the scene. A few minutes later, another car at the corner of Liberty and Western was set on fire. Police ordered the crowd back from the fires, but were met with a barrage of bricks and stones. Matters escalated. The police ordered the crowd to disperse. When they refused, Captain Stachowicz decided to move the crowd into the LaSalle Park Neighborhood Center. Shortly after the crowd was moved into the center, the front window was smashed and police thought that they were being fired upon by someone in the center.

*The remains of the dam are now used as a walkway for the elaborate park system bordering the river from La Salle Street to beyond the railroad bridge first built in 1851.*

Two police officers responded by firing shotguns through the center's plate glass windows, wounding six African Americans, then charging into the crowded building. Several youths inside the center ran for cover in a closet, but a policeman fired three shots at them. One shot went into the ceiling, but one also wounded a member of the group working to halt the violence. Then police began arresting people in the building. Melvin Phillips, who was attempting to escape the arresting officers, was seriously wounded by a shotgun blast.

Witnesses inside the center said that no one fired shots at the police. Charles J. Black, a youth leader who was working with Valjean L. Dickinson, (executive director of ACTION, Inc., the county's anti-poverty program), said that he had just taken a chair away from a boy who was going to throw it through the plate glass window. He managed to get it away from the boy, but someone else then threw a chair, hitting him, and smashing the window, causing the sound that police thought was a gunshot.

The crowd backed away from the windows, massing close together. Stachowicz thought they were getting ready to charge the officers and he fired his Thompson sub-machine gun into the ceiling. Police lined up each person against the wall, searched them and led them one by one from the building. No weapons were confiscated.

Meanwhile, firebombs were thrown at a number of buildings, most of which caused little damage except for broken windows. Morrow's Coin Operated Dry

*The S.S. Kresge Company building stood at the corner of Jefferson and Michigan Streets. This building was a former repository for Studebaker company wagons. Kresge occupied this building for nearly 60 years before redevelopment doomed it. (Photo by Maurice L. Palmer.)*

cleaning Laundry Center, 1015 Corby Street, was damaged by a firebomb. As firemen were attempting to put out the fire, the A&P Food Store on Howard exploded in flame.

During the night, 60 people were arrested, including several who were carrying guns. Among those arrested were many who had been working with community leaders in an attempt to ease the tension. The police made no distinction between the law breakers and those who were trying to restore peace.

Allen imposed a curfew at 10:07 p.m. Twenty people had already been injured in two nights of unrest, but no one had yet been killed. Governor Roger Branigan ordered 200 National Guardsmen to stand by in battle dress at the Armed Forces Training Reserve on Kemble Avenue. Another 700 troops were standing by in battle dress in armories at Columbia City, Huntington, and Marion in case they were needed here or elsewhere.

The curfew was lifted at 5 a.m. Thursday morning. St. Joseph County prosecutor Willam E. Voor Jr. worked with South Bend City Court Judge Phillip Potts to set up a process for expediting the large number of arrests. Many youths were released to the custody of their parents. Thirty-six African American and white men and women were released on bond or their own recognizance.

The firebomb reports had everyone concerned. Fearing unchecked fires and riots, many merchants guarded their stores 24 hours a day with loaded guns. Some stayed on their flat rooftops, where they could command the entire scene.

The violence had subsided by Thursday night and no curfew was imposed, although 15 firebombs were thrown against buildings. No major damage was done except to Sandock's Furniture Store. This was the third night that Sandock's had been picked as a target. Some of the buildings had also been targets on Tuesday and Wednesday nights. Allen asked everyone to remain calm and not to make inflammatory statements. But he kept the National Guard at the Reserve Center, just in case. Leaders on both sides continued to meet. One councilman felt that no new laws were necessary to handle the complaints. It was only a matter of providing the services that already were available to white people in the city.

On Friday evening, clergymen from all faiths asked for churches to pray for a stronger effort to ease racial tensions. Some firebombing continued Friday night, with eight bombs thrown against residences and businesses in integrated neighborhoods on the east side. There was no trouble on the west side. Western Avenue, which had been barricaded since Tuesday night, was reopened to traffic.

African-American community leaders asked for the suspension of three police officers involved in the shootings. Allen responded that no one would be suspended until a formal inquiry into the violence had been taken. He appointed Robert M. Parker, a South Bend attorney, to serve as special council in the inquiry. At the same time, articles in the *South Bend Tribune* quoted many African-American community leaders as indicating that one of the major problems in South Bend was the segregated school system. Some felt that an integrated school system would lead to better education and, in the long run, a better chance for a good job. Others were not sure. African Americans composed only 11 percent of South Bend's population and 15 percent of the school students, but many of the schools had African-American school enrollment of over 50 percent, while some schools had no African-American students at all.[2]

The special court of inquiry was held concerning the events of the July 25 through July 27 and any possible connection with the July 5 meeting. It convened for the first time on August 1 and ended on August 15. The findings were released on October 12, 1967. The meetings were held in the auditorium of the South Bend Public Library. Many whites immediately associated the two events. African-American witnesses declared that the July 5 meeting had nothing to do with the incident. Witnesses reported that the incidents were the result of too many discriminatory practices that the city had promised to end years ago. Among the complaints were inadequate housing, housing discrimination, employment discrimination, lack of public recreational facilities and parks, the segregated school system, the high school drop-out rate among young African Americans, and the high unemployment rate. A decade before, a high school drop-out had a chance of finding employment on the assembly lines at Studebaker, Oliver, Bendix, or another manufacturer. Now, thousands of skilled people were out of work and there were no jobs available for African-Americans drop-outs with no skills.

In all, there were 36 firebombs, 47 false alarms, 54 adult arrests, and 29 arrests for juveniles under 18 years old. Almost all of the youths involved were males under the age of 21.

The special inquiry concluded that among other things, although the police wore no badges, their authority was challenged. The crowd was already hostile, and the challenges only added fuel to the situation, the police department acted with a high degree of restraint in exercising their authority, and the shooting outside and inside the center were proper, given the few seconds that the officers had to respond to the situation. It also concluded that since Melvin Phillips had broken away from the police officers on three separate occasions and had run approximately 70 feet before he was shot, the shooting was justified and that the police officer who shot him was not aware that a canine unit dog was already pursuing Phillips and would have overtaken him in a few more yards.

The board concluded that "all of the evidence that both superior officers and men of the South Bend Police Department at the disorders on July 25 and July 26 carried out their assignments and conducted themselves with the highest degree of professional competency." No evidence was found to indicate that outsiders were involved in the situation or that there was an organized plan for the disturbances or anyone who could be considered the leader of the disturbances. African-American community leaders who had attempted to stop the situation could not find any one person who could command the attention of those causing the violence.

In late 1967, the police department formed a full-time Community Relations Division to improve race relations between the police department and the community.

The riot, the civil rights movement, and the misunderstood black power movement made many white families nervous. They began moving to the suburbs. As white residents abandoned the city to live elsewhere, shopping habits changed. The once crowded city streets were now becoming empty. Traffic patterns were changed to allow automobiles to flow through South Bend without stopping.

Attempting to compete with the new shopping centers, South Bend began a two-phase project of urban renewal that lasted nearly 20 years. Whole sections of neighborhoods near the downtown area were leveled. "Maggie's Court" was finally razed, replaced with a new brick and concrete apartment complex along with a large tract of individual homes.

The once thriving shopping area at Washington and Walnut Streets was completely leveled and replaced with one-story houses with large yards for low income families.

By 1969, only 12 trains a day were rumbling through South Bend. Union Station, once the glory of South Bend, was now an unwanted white elephant. In that same year, Robertson's Department Store merged with Gamble-Skogmo in a last ditch effort to keep one of the few remaining department stores downtown open.

The 1970 census for South Bend showed that the population had dropped from 132, 445 in 1960 to 125,580 in 1970. And this was after the city had annexed several suburban areas in an attempt to obtain a larger taxing base. By 1975, two Spanish-speaking neighborhoods had emerged on the west side. One was near the old Washington High School on West Sample Street. The second was between Ford and Sample Streets.

On May 1, 1971, the last passenger train left Union Station. After several years of abandonment, it was purchased by a foam manufacturer and was later sold and then sold again. Many developers have attempted to transform this grand lady into shopping centers, a restaurant, and even a part of Coveleski Stadium. Today, it still waits.

During re-development, the city's heart was taken out. In the downtown area, many small businesses, including the Griffon Book Store, were forced to move as their blocks were torn down in an effort to create a mall similar to the one in Kalamazoo, Michigan. St. Joseph Street, which had been a side street, was widened and restructured, then made a one-way street for northbound traffic. Main Street was made a one-way street for southbound traffic. Lincoln Way East was remodeled. Wayne Street, Western Avenue, and Jefferson Avenue were all reconstructed.

The bookshop closed. Next to it was the Philadelphia. In the same block was Shidler's Furniture Store. Across from them was the Coney Island. Most of the

*Everything in this block saw the wrecking ball. Only the rare large street clock was saved and is now in the First Source Bank Building. (Photo by Maurice L. Palmer.)*

small stores left the city and never reopened. Whole city blocks were torn down. The block between Washington and Jefferson Streets and Main and Michigan Streets was leveled. Blocks between Michigan Street and the river and Colfax and Jefferson were razed, and the slope that originally led down to the river from Washington Street was partially filled in and leveled from Colfax Avenue to Jefferson Avenue. Part of this area became known as "Hole Number Six."

S.S. Kresge, with its great soda fountain, closed its doors after having been in the old Studebaker Repository at the corner of Michigan and Jefferson Streets for nearly 60 years. The KarmelKorn Shop with its fresh appetizing smells moved to Scottsdale Mall. The great fresh-roasted smell of peanuts toasting in the stainless steel tumbler in the front window of The Peanut Shop at the corner of Michigan and Wayne Streets disappeared. Mr. Peanut, with his cane knocking against the window, no longer greeted bystanders. Mahowald's Luggage Shop moved to the University Park Mall. The Granada Theater, once hailed as one of the city's most ornate movie theaters, fell to the wrecking ball after old moviegoers bought lamps and ornamental plaster casts.

The East and West Races were both filled in. The East Race was later excavated and redeveloped as a world-class kayak racing course. The old town of Lowell, once the center of manufacturing, now had no manufacturers. Blocks were razed here, too. Preservationists fought hard to save buildings, but looked on helplessly as the wrecking ball destroyed most of them. A rumor circulated that the 1854

*Once the site of over 30 waterwheels powering South Bend's major manufacturers, the East Race is now a first-class kayak training site. Concrete walkways on both sides of the race lead from the Jefferson Street bridge to where the race rejoins the river near Marion Street.*

courthouse would be torn down for a parking lot. Angry citizens threatened to chain themselves across the courthouse to save it.

It took years before new construction began on some sites in the downtown area. "Hole Number Six" waited for nearly a decade for plans. In 1979, First Bank announced that it was constructing a new building in the infamous hole. Along with it would be a 300-room Marriott Hotel and a parking garage. It joined other new construction projects or newly constructed buildings. Then, in an attempt to bring back business and new construction, Michigan Street, the main business street in the city, was closed to traffic and made into a pedestrian mall. But it was too late.

In 1980, Robertson's was purchased by the Wickes Corporation. Two years later, the company tried to liquidate Robertson's, one of the last retail stores in South Bend, but plans fell through. The store moved to the smaller, vacated J.C. Penney store across the street. In the summer of 1986, Robertson's closed its doors for the last time. Only Inwood's remained as a retail store. But within a few years, it too, was gone.

South Bend Toy (by then owned by Milton-Bradley) closed its large 250,000-square-foot plant at 3300 West Sample Street in 1981. A small company purchased the rights to manufacturing their croquet sets, but on July 31, 1985, that location also closed.

Century Center shares space with the Midwest Museum of American Art on the end of Washington Street, where the ancient Native American trail entered the St. Joseph River. Behind the center are parts of the original dam. Near the dam is an artist's concept of "Keepers of the Fire," a tribute to the Potawatomi who lived here a century and a half ago. The College Football Hall of Fame sits just across the street from Century Center.

Political unrest in several South American countries during the 1980s brought in a large number of Hispanic immigrants, who joined with those already present. Now, the Hispanic population (all those speaking Spanish) is the largest-growing population in South Bend and regularly celebrates with several festivals. Heavily concentrated on the west side, it mixes readily with its Hungarian, Polish, and African-American neighbors.

By 1990, things began to improve and by the dawn of the new millennium, things had again taken on a positive attitude. Now, only a handful of the original retail stores present in 1960 remain: Dainty Maid Bake Shop, Osco Drug Store, Felix's Shoe Shop, Fannie May Candies, Mark's Restaurant, the Army-Navy Surplus Store, Witner-McNease Music Company, and Ralph's News Stand and General Store. The Cambodian Egg Roll restaurant started out in a small trailer selling food to residents watching the construction near Hole Number Six in the 1970s. Now it has its own small place next to the Dainty Maid.

Most of the banks have remained, but some changed names as they merged with other banks. Sobieski Savings and Loan is still going strong. Gilbert's Men's Store was transformed into a nationally recognized, well managed Center for the Homeless. Robertson's, after much debate, became a large apartment complex for

low income renters. The State Theater across from Robertson's is now a prominent nightclub and the J.C. Penney's building next door has also turned into a nightclub.

Transpo found a new bus lot on South Street, after selling its land to a new office complex that included health facilities and a parking garage. Much of the burned out land in the Keasey-Ohio area was used for a new Juvenile Justice Center, a new Ivy Tech State College, and a Boys' and Girls' Club.

In a bitter struggle to gain control of Allied Signal Corporation, Bendix found itself bought out by Allied Signal. Allied Signal has now sold the company to Honeywell. Many jobs were moved out of South Bend.

Today, most of the buildings in the central city are office or medical buildings. A few new buildings are now retail stores. Many are sit-down or fast food restaurants. The Philadelphia, closed for many years, now has a confectionery shop on South Bend Avenue. The Chocolate Cafe, next to Osco's, provides excellent treats for the sweet-toothed of every age. The old Studebaker and Oliver factory buildings are almost all leveled now, making way for new industrial parks. Plans are being discussed for the new Studebaker National Museum.

The old Stephenson's Underwear Factory on the East Race is now home to Madison Center, a large mental health organization. University Park Mall, once nearly surrounded by farmers' fields, has doubled in size and is at the north end of a 2-mile-long stretch of Grape Road offering a solid line of shopping centers and other conveniences. Paralleling Grape Road is Main Street in Mishawaka. It too has an almost 2-mile-long stretch of shopping centers. Together, they have drawn many shoppers away from Scottsdale Mall, which has lost both of its key anchor stores, L.S. Ayres and Montgomery Ward, and several small tenants.

The intersection of Portage and Cleveland Roads has developed into several upper-scale apartment complexes, which in turn have created a demand for a large shopping complex.

Polish, Chinese, Italian, Hungarian, Vietnamese, and Mexican restaurants can be found all over the city. Dyngus Day, Kwanzaa, Cinco de Mayo, St. Patrick's Day, the Greek Festival at St. Andrew's Greek Orthodox Church, and the Serbfest at St. Peter and Paul Serbian Orthodox Church are all celebrated city-wide annually.

The Potawatomi have an annual celebration and Pow Wow at St. Patrick's County Park, next to Madeline Bertrand Park (the Parc Aux Vaches), where one can purchase trade goods just like the ones traded by early Native Americans and sold by Joseph Bertrand, Alexis Coquillard, and Lathrop Taylor.

Today, our major highways still follow many of the original Native American trails. Parts of U.S. Route 33 from Fort Wayne to South Bend follow the original Dragoon Trail. Lincoln Way West in South Bend becomes U.S. Route 20 and slowly winds its way through New Carlisle, then joins State Road 2 (Western Avenue) west of South Bend, and heads to Chicago. The old Sauk Trail evolved into the Detroit to Chicago Road, then into modern U.S. Route 12. The highway still weaves through southern Michigan and northern Indiana on much of the original trail. Driving parts of the highway is like driving through the past, where

small towns never grew into dynamic cities like South Bend, but where proud citizens never let the towns wither away either.

State Road 23 begins near Edwardsburg, Michigan, then takes a southwesterly course, passing through newly developed suburbs around Granger, Indiana. From Granger to South Bend, the road is dotted with shopping centers, including University Park Mall. Further west, it passes across the flat lands that once were part of the Kankakee Swamp, and takes you through Walkerton, where an ancient prehistoric town once thrived.

Semi trucks have replaced horses on these highways, but they still bring cargo to South Bend for sale and trade, just as the Native Americans did for countless centuries.

Nearly 175 years ago, our town founders were filled with dreams for a prosperous town while clearing the land of its trees, stones, and other obstacles. Today's city planners look forward to revitalizing the city, clearing away the remnants of concrete skeletons, decaying brick buildings, and asphalt parking lots where prairie grasses have sprung up between the cracks, slowly spreading over the parking lots much like the prairie grasses spread over St. Joseph County nearly 10,000 years ago.

The city at the south bend of the St. Joseph River eagerly looks toward the future.

*The mighty St. Joseph River, the key to South Bend's prosperity for nearly 175 years, still retains its important function. The city celebrates its Summer Festival, several jogging events, and kayaking events along the river's banks, drawing in thousands of people every year and contributing to the city's economic welfare.*

# ENDNOTES

## 2. CONFLICT OF EMPIRES

1. Parkman, Francis. *La Salle and the Discovery of the Great West*. pp. 164–166.
2. Baker, George A. *The St. Joseph–Kankakee Portage: its Location and Use by Marquette, LaSalle, and the French Voyageurs*. p. 17.
3. Peyser, Joseph L. *Letters from New France: The Upper Country, 1686–1783*. p.43.
4. Clark, George Rogers. *George Rogers Clark Papers, 1771–1781*. p. 366.
5. *Michigan Pioneer and Historical Collections*. Volume 10 pp. 406–407.
6. Peyser, Joseph L. *Letters from New France: The Upper Country, 1686–1783*. pp 220–221.
7. Jean Baptiste Chandonai was born around 1790. Early historians have often confused Jean B. with Charles because many original letters mentioning them only list their last name, not their first name. One needs to know the time period of the letter and its contents to determine to which Chandonai they are referring.
8. *Territorial Papers of the United States*. Compiled and edited by Clarence Edwin Carter. Vol. X. *The Territory of Michigan, 1805–1820*. pp. 471–472.
9. Ibid. pp. 485–486.
10. Ibid. pp. 489–490.

## 3. AT THE BEND IN THE RIVER

1. There are at least four different photographs and postcards, each one identifying itself as Pierre Navarre's cabin. Several are so different that they cannot even be considered the same cabin at different times of use. At least one photograph (which shows the well-known house) is identified as the "Leeper House."
2. Kappler, Charles J., ed. *Indian Treaties, 1778–1883*. pp. 198–199.
3. Kane, Lucile M., ed. *The Northern Expeditions of Stephen H. Long. The Journals of 1817 and 1823 and Related Documents*. pp. 128–129.
4. Kappler, Charles J., ed. *Indian Treaties, 1778–1883*. pp. 273–274.
5. *Message From the President of the United States, With a Plat of the Survey of the Northern Boundary of the State of Indiana*. December 12, 1827.
6. Kappler., Charles J., ed. *Indian Treaties, 1778–1883*. p. 294.
7. *South Bend Tribune*. February 6, 1904.
8. Tipton, John. *John Tipton Papers*. pp. 760–761.

9. McCord, Shirley, compiler. *Travel Accounts of Indiana, 1679–1961.* p. 176.
10. *The Book of Prices of the House Carpenters and Joiners of the Town of South Bend.* Adopted Monday, May 31, 1841. p. vi.

## 4. Brother Against Brother

1. Kettleborough, Charles. *Constitution Making in Indiana. A Source Book of Constitutional Documents with Historical Introduction and Critical Notes.* p. 304.
2. *South Bend Tribune.* October 4, 1954.
3. Ibid.
4. *St. Joseph County Forum.* August 9, 1862.
5. Ibid. May 16, 1863.

## 5. From Swords into Plow Shares

1. Lavely, Father Charles. Conversations concerning St. Patrick's Church, February 7, 2002.
2. Turner's *Directory of the Inhabitants, Institutions, and Manufactories of the City of South Bend, Indiana for 1871–2.*
3. Temple, Kerry. "The Day Notre Dame Burned." In *South Bend Tribune Michiana Magazine.* April 22, 1979.
4. *South Bend Weekly Tribune.* October 28, 1882.
5. Ibid. January 6, 1883.
6. *South Bend Saturday Tribune.* November 14, 1885.
7. *South Bend Daily Tribune.* November 18, 1885.
8. Anonymous. *Life of Clement Studebaker.* Manuscript. p. 99.

## 6. A New Century

1. *South Bend Tribune.* May 14, 1913.
2. *South Bend News Times.* April 9, 1916.
3. Ibid.
4. Ibid.
5. Ibid.
6. Ibid.

## 7. Intolerance

1. Palmer, Maurice. Various conversations. Various times.

## 8. War and Remembrance

1. *South Bend Tribune.* December 8, 1941.
2. *South Bend Tribune.* March 21, 1944.

## 9. From Hard Times to New Hope

1. South Bend, Indiana Board of Public Safety. *Report of Civil Disorders, Summer of 1967.*
2. *South Bend Tribune.* July 31, 1967.

# BIBLIOGRAPHY

## BOOKS

Anderson & Cooley (compilers). *South Bend and The Men Who Have Made It. Historical, Descriptive, Biographical*. South Bend: Tribune Printing Co., 1901.

Anson, Bert. *The Miami Indians*. Norman, OK: University of Oklahoma Press, 1970.

Baker, George A. *The St. Joseph-Kankakee Portage; its Location and Use by Marquette, LaSalle, and the French Voyageurs*. South Bend: Northern Indiana Historical Society, 1899.

———. *LaSalle in the Valley of the St. Joseph. An Historical Fragment*. South Bend: Tribune Printing Co., 1899.

Bannon, John Francis. *The Spanish Borderland Frontiers, 1513–1821*. Albuquerque, NM: University of New Mexico Press, 1974.

Berthrong, Donald J. *Indians of Northern Indiana and Southwestern Michigan*. An Historical Report on Indiana Use and Occupancy of Northern Indiana and Southwestern Michigan. New York: Garland Publishing Co., 1974.

Beuchner, Cecilia Bain. *The Pokagons*. Indianapolis: Indiana Historical Society, 1933.

*Book of Prices of the House Carpenters and Joiners of the Town of South Bend, The*. Adopted Monday, May 31, 1841. South Bend: W. and J. Millikan, Printers.

Brown, Edythe J. *The Story of South Bend*. South Bend: South Bend Vocational School Press, 1920.

Clark, George Rogers. *George Rogers Clark Papers, 1771–1781*. Springfield, IL: Illinois State Historical Library, 1912.

Clifton, James A. *The Pokagons, 1683–1983. Catholic Potawatomi Indians of the St. Joseph River Valley*. Lanham, NY: University Press of America, 1984.

Conner, Elizabeth Triana and Phalen, Rev. John. *Hispanics in South Bend*. South Bend: 1983.

Coquillard, Mary Clarke. *Alexis Coquillard—His Time. A Story of the Founding of South Bend, Indiana*. South Bend: Northern Indiana Historical Society, 1931.

Critchlow, Donald T. *Studebaker: The Life and Death of an American Corporation*. Bloomington, IN and Indianapolis: Indiana University Press, 1996.

Cunningham, Wilbur M. *Letter Book of William Burnett*. Fort Miami Heritage

Society of Michigan, 1967.

Dales, Elizabeth and Edsall, Katharine. *A Brief History of South Bend, Indiana 1820–1969. Information About its Economic, Political, Educational, Religious, and Social Development*. South Bend: South Bend Public Library, 1970.

Daughters of the American Revolution, Schuyler Colfax Chapter. *Historic Background of South Bend and St. Joseph County in Northern Indiana*. South Bend: DAR, 1927.

Detzler, Jack J. *South Bend, 1900–1910. The Awakening of a Small Town*. South Bend: Northern Indiana Historical Society, 1959.

———. *South Bend, 1910–1920. A Decade Dedicated to Reform*. South Bend: Northern Indiana Historical Society, 1960.

———. *South Bend, 1920–1930. The Emergence of a City*. South Bend: Northern Indiana Historical Society, 1984.

Eckert, Allan W. *A Sorrow in Our Heart. The Life of Tecumseh*. New York: Konecky & Konecky, 1992.

Edmunds, R. David. *The Potawatomis: Keepers of the Fire*. Norman, OK: University of Oklahoma Press, 1978.

Esslinger, Dean R. *Immigrants and the City. Ethnicity and Mobility in a Nineteenth-Century Midwestern Community*. Port Washington, NY: Kennikat Press, 1975.

Faulkner, Charles H. *The Late Prehistoric Occupation of Northwestern Indiana. A Study of the Upper Mississippi Cultures of the Kankakee Valley*. Indianapolis: Indiana Historical Society, 1972.

Fotia, Elizabeth R. *The Mexican-Americans of the South Bend–Mishawaka Area*. South Bend: Indiana University at South Bend, 1975.

Gilbert, Will. *God Gave Us This Country. Tekamthi and the First American Civil War*. New York: Atheneum, 1989.

Gordon, Rev. B.F. *The Negro in South Bend: A Social Study*. South Bend: Privately printed, 1922.

Hennepin, Louis. *A Description of Louisiana*. Readex Microprint Corp., 1966.

*History of St. Joseph County, Indiana, Together with Sketches of Its Cities, Villages, and Townships, Educational, Religious, Civil, Military, and Political History, Portraits of Prominent Persons, and Biographies of Representative Citizens*. Chicago: Charles C. Chapman, 1880.

Hope, Arthur J. *Notre Dame, One Hundred Years*. Notre Dame: University Press, 1943.

Howard, Timothy Edward. *A History of St. Joseph County, Indiana*. Chicago: Lewis Publishing Co., 1907.

Hunt, George T. *The Wars of the Iroquois. A Study in Intertribal Trade Relations*. Madison, WI: University of Wisconsin Press, 1967.

Kane, Lucile M., editor. *The Northern Expeditions of Stephen H. Long. The Journals of 1817 and 1823 and Related Documents*. Minnesota Historical Society Press, 1978.

Kappler, Charles J., editor. Indian Treaties, 1778–1883. New York: Amereon House, 1972.

Keating, William Hypolitus. *Narrative of an Expedition to the Source of St. Peter's River*.

Philadelphia: H.C. Carey & I. Lea, 1824.

Kellar, James H. *Introduction to the Prehistory of Indiana*. Indianapolis: Indiana Historical Society, 1983.

Kinietz, W. Vernon. The Indians of the Western Great Lakes, 1615–1760. Ann Arbor, MI: University of Michigan Press, 1865.

Kinzie, Mrs. John H. *Wau-Bun: the Early Day in the Northwest*. Chicago: Rand McNally and Co., 1901.

Kouroubetis, Milton. *The Greeks of Michiana. A Microcosm of the Greek Experience in America*. South Bend: Northern Indiana Historical Society, 1987.

Longstreet, Stephen. *A Century on Wheels, the Story of Studebaker. A History, 1852–1952*. New York: Henry Holt and Company, 1952.

McAvoy, Thomas. *The History of the Catholic Church in the South Bend Area*. South Bend: Aquainas Library and Book Shop, 1953.

McCord, Shirley. *Travel Accounts of Indiana 1879–1961*. Indianapolis: Indiana Historical Society. 1970.

McDermott, John Francis, editor. *The Spanish in the Mississippi Valley, 1762–1804*. Urbana, IL: University of Illinois Press, 1974.

McDonald, Daniel. *Removal of the Pottawattomie Indians from Northern Indiana*. Plymouth, IN: Self published, 1898.

McKee, Irving. "The Trail of Death: Letters of Benjamin Marie Petitt." Indianapolis: Indiana Historical Society Publications. Volume 14 Number 1, 1941.

Merrill, Martha. "St. Joseph County's Black Pioneers: A Survey." *Old Courthouse News*, May 2, 1969. South Bend: Northern Indiana Historical Society.

*Message From the President of the United States, With a Plat of the Survey of the Northern Boundary of the State of Indiana*. December 12, 1827. House Document No. 187, 20th Congress, 1st Session. Washington, D.C.: Sales and Eaton, 1828.

*Michiana: Crossroads of Empires*. South Bend: Longhouse Productions, 1995.

*Michiana Memories. A Selection of Historical Articles from Michiana, the South Bend Tribune's Sunday Magazine*. South Bend: Northern Indiana Historical Society, 1980.

*Michigan Pioneer and Historical Collections*. Lansing, MI: Michigan Pioneer and Historical Society, 1874–1915.

Montgomery, Hugh T. *The Geological History of St. Joseph County, Indiana: as Exhibited by the Glacial Remains, Ancient and Present Waterways, and Stream Changes in this Locality, or The Early History of Our Home*. South Bend: Northern Indiana Historical Society, 1929.

O'Brien, Pat. *The Wind at My Back. The Life and Times of Pat O'Brien*. Garden City, NY: Doubleday and Company, 1964.

Parkman, Francis. *La Salle and the Discovery of the Great West*. Boston: Little, Brown and Co., 1910.

Peyser, Joseph L. *Letters from New France: The Upper Country, 1686–1783*. Urbana, IL: University of Illinois Press, 1992.

Pickrell, Martha M. *Emma Speaks Out. Life and Writings of Emma Molloy*

*(1829–1907)*. Carmel, IN: Guild Press, 1999.

Quimby, George Irving. *Indian Life in the Upper Great Lakes, 11,000 B.C. to A.D. 1800*. Chicago, IL: University of Chicago Press, 1960.

Raffert, Stewart. *The Miami Indians of Indiana. A Persistent People, 1654–1994*. Indianapolis: Indiana Historical Society, 1996.

*Relation of the Discoveries and Voyages of Cavelier de La Salle from 1679 to 1681. The Official Narrative*. The translation by Melville B. Anderson. Chicago: Caxton Club, 1901.

Renkiewicz, Frank Anthony. *The Polish Settlement of St. Joseph County, Indiana: 1855–1935*. Ph.D. Dissertation. University of Notre Dame, 1967.

Romine, Joana. *Copshaholm: The Oliver Story*. South Bend: Northern Indiana Historical Society, 1978.

Russell, Donna Valley. *Michigan Voyageurs From the Notary Book of Samuel Abbott. Mackinac Island, 1807–1817*. Detroit: Detroit Society for Genealogical Research, 1982.

Schlereth, Thomas J. *The University of Notre Dame, a Portrait of Its History and Campus*. Notre Dame: University of Notre Dame Press, 1976.

Seineke, Kathrine Wagner. *The George Rogers Clark Adventure in the Illinois, and Selected Documents of The American Revolution at the Frontier Posts*. New Orleans: Polyanthos, 1981.

*South Bend City Directories*. South Bend: Various Publishers, 1867–2002.

*South Bendi Magyarok, A. 50 Eves Letelepedesenek Jubileumi Emlekkonyve, 1882–1932*. Golden Jubilee Album of the Magyar People in South Bend, Indiana.

South Bend, Indiana Board of Public Safety. *Report of Civil Disorders, Summer of 1967*. South Bend: City of South Bend, 1967.

———. *Transcript of Special Hearings Concerning Civil Disorders of 1967*. South Bend: City of South Bend, 1967.

*South Bend World Famed*. Evansville, IN: Unigraphic, 1922.

*Special Acts Passed at the Fifteenth Session of the General Assembly of the State of Indiana*. Indianapolis: Douglass and Maguide, 1831.

Stoll, John B. *An account of St. Joseph County from Its Organization*. Dayton, OH: Dayton Historical Publishing Co., 1922.

Sugden, John. *Tecumseh: A Life*. New York: Henry Holt and Co., 1997.

*Territorial Papers of the United States, Vol. X. The Territory of Michigan, 1805–1820*. United States Government Printing Office, 1942.

Tipton, John. *John Tipton Papers*. Indianapolis: Indiana Historical Society, 1942.

"Trail of Death: The Story of the Forced Removal of Potawatomi Indians from Indiana to Kansas in 1838." South Bend: Wayne Harvey Video Productions, 1992.

Trennert, Robert A. Jr. *Indian Traders on the Middle Border. The House of Ewing, 1827–1854*. Lincoln, NE: University of Nebraska Press, 1981.

Trojanowski, Ronald E. *Poles at the Polls: Ethnic Voting in South Bend, Indiana*. M.A. Thesis, College of William and Mary, 1988.

Turner, T.G. *Gazetteer of St. Joseph Valley and Michigan and Indiana for 1867*. Chicago: Hazlitt and Reed, 1867.

United States Surveyor. General Record. *Plats and Field Notes for St. Joseph County, Indiana*.

Vann, Johnny. *The Black Americans of the South Bend–Mishawaka Area*. South Bend: Indiana University at South Bend, 1975.

Verslype, Henry A. *The Belgians of Indiana, with a Brief History of the Land From Which They Came*. South Bend: Self published, 1987.

*We the People: Indiana and the United States Constitution. Lectures in Observance of the Bicentennial of the Constitution*. Indianapolis: Indiana Historical Society, 1989.

Windle, Helen Hibberd. *Underground Railroad in Northern Indiana: Based on Personal Narratives and Famous Incidents*. South Bend: Helen Hibberd Windle, 1939.

Winger, Otho. *The Potawatomi Indians*. Elgin, IL: Elgin Press, 1929.

Young, Calvin M. *Little Turtle (Me-She-Kin-No-Quah): The Great Chief of the Miami Nation, Being a Sketch of His Life Together With That of Wm. Wells and Some Noted Descendants*. Fort Wayne: Public Library of Fort Wayne and Allen County, 1917.

## NEWSPAPERS

*Mishawaka Enterprise*, August 1858 to October 1865

*National Union*, August 1865–1871

*North-Western Pioneer*, 1831–1842 (includes *South Bend Free Press*)

*St. Joseph County Forum*, August 1853 to May 1865

*St. Joseph Valley Register*, 1845 to July 1863, 1865–1884 (no known copies exist between July 1863–1865)

*South Bend Evening Register*, July 1878 to June 1885

*South Bend News Times* (Morning Edition), May 1913 to 1938

*South Bend News Times* (Evening Edition), July 1913 to November 1933

*South Bend Tribune*, 1873 to present

## INTERVIEWS

Freeman, Oliver. Conversation concerning Bendix Corporation history. June 10, 2000.

Lavely, Father Charles. Conversation concerning St. Patrick's Church. February 7, 2002.

Palmer, Maurice. Various conversations. Various times.

# INDEX